WITHDRAWN

D1223756

5/99

DANIEL BRUSH: *GOLD WITHOUT BOUNDARIES*

DANIEL BRUSH: *GOLD WITHOUT BOUNDARIES*

WRITINGS BY
RALPH ESMERIAN
PAUL THEROUX
DONALD KUSPIT
DAVID BENNETT AND
DANIEL BRUSH

AFTERWORD BY
ELIZABETH BROUN AND
JEREMY ADAMSON

PHOTOGRAPHS BY
JOHN BIGELOW TAYLOR

HARRY N. ABRAMS, INC., PUBLISHERS

Editor: Harriet Whelchel
Designer: Takaaki Matsumoto, Matsumoto Incorporated, New York

Library of Congress Cataloging-in-Publication Data
Daniel Brush—gold without boundaries/texts by Donald Kuspit . . . [et
al.] ; photographs by John Bigelow Taylor.
 p. cm.
 Includes index.
 ISBN 0-8109-4018-3 (clothbound)
 1. Brush, Daniel—Criticism and interpretation. 2. Brush,
Daniel—Catalogues. 3. Goldwork—United States—History—20th
century—Catalogues. I. Brush, Daniel. II. Kuspit, Donald B. (Donald
Burton), 1935–
NK7198.B75D36 1998
739.2'272—dc21
 97–51377

Printed and bound in Japan

 Harry N. Abrams, Inc.
100 Fifth Avenue
New York, N.Y. 10011
www.abramsbooks.com

The artist's references to Noh theater and Eastern thought were drawn from:

Keene, Donald, et al. *Noh: The Classical Theatre of Japan.* New York:
 Harper and Row, 1978.
Keene, Donald, ed. *20 Plays of the Noh Theatre.* New York: University
 of Columbia Press, 1970.
Snyder, Gary. *Riprap and "Cold Mountain Poems."* San Francisco:
 Four Seasons Foundation, 1977, no. 17, p. 53.
Watson, Burton, trans. *Cold Mountain: 100 Poems by the T'ang Poet
 Han-shan.* New York: Columbia University Press, 1970.
Zaehner, R. C. *Hindu Scriptures.* Oxford: Everyman's University
 Library, 1966.

CONTENTS

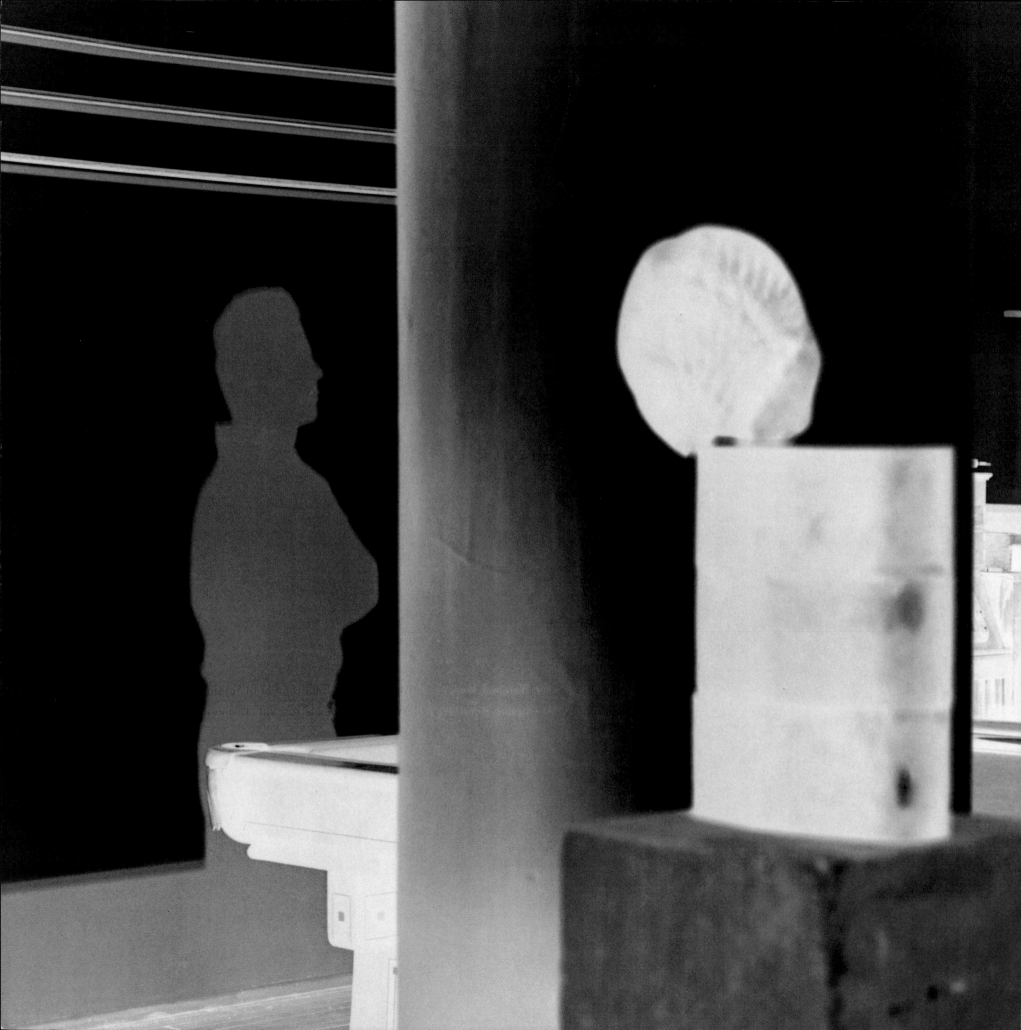

STUDIO

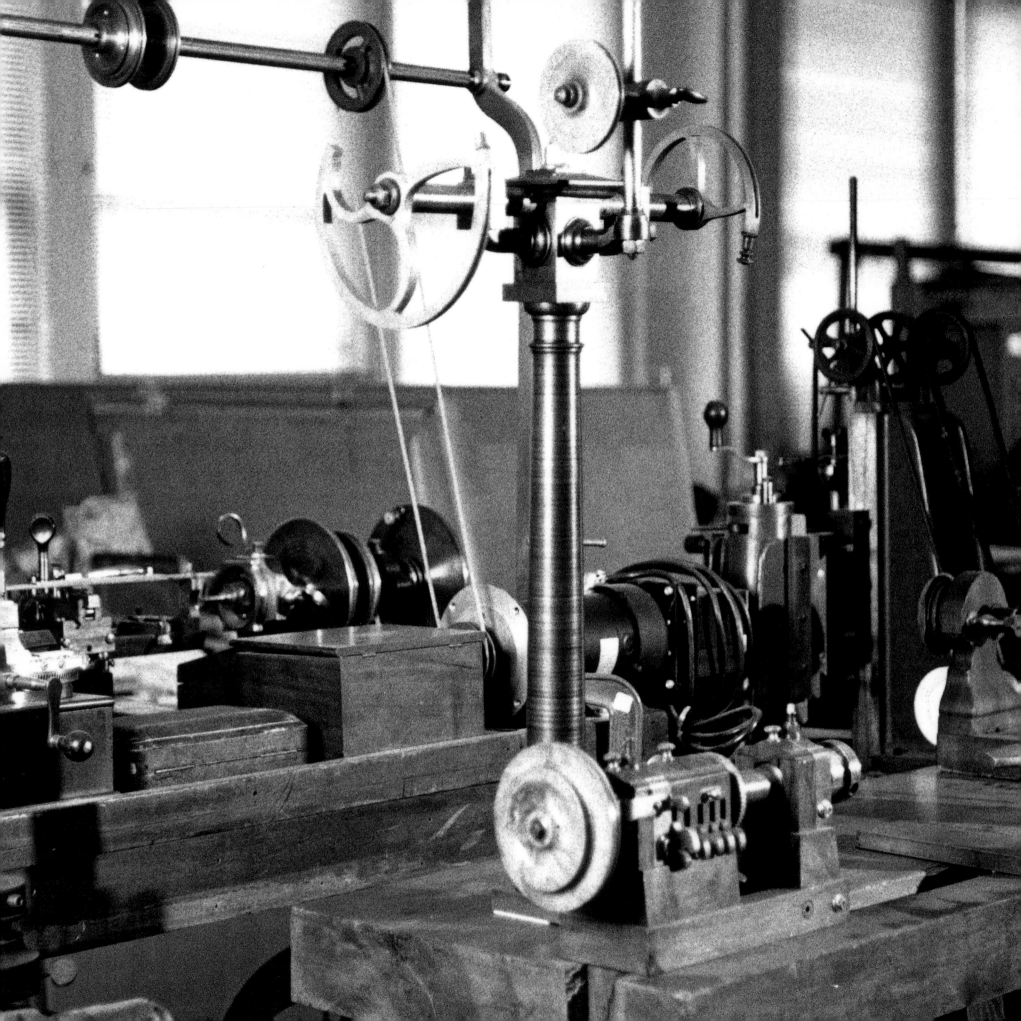

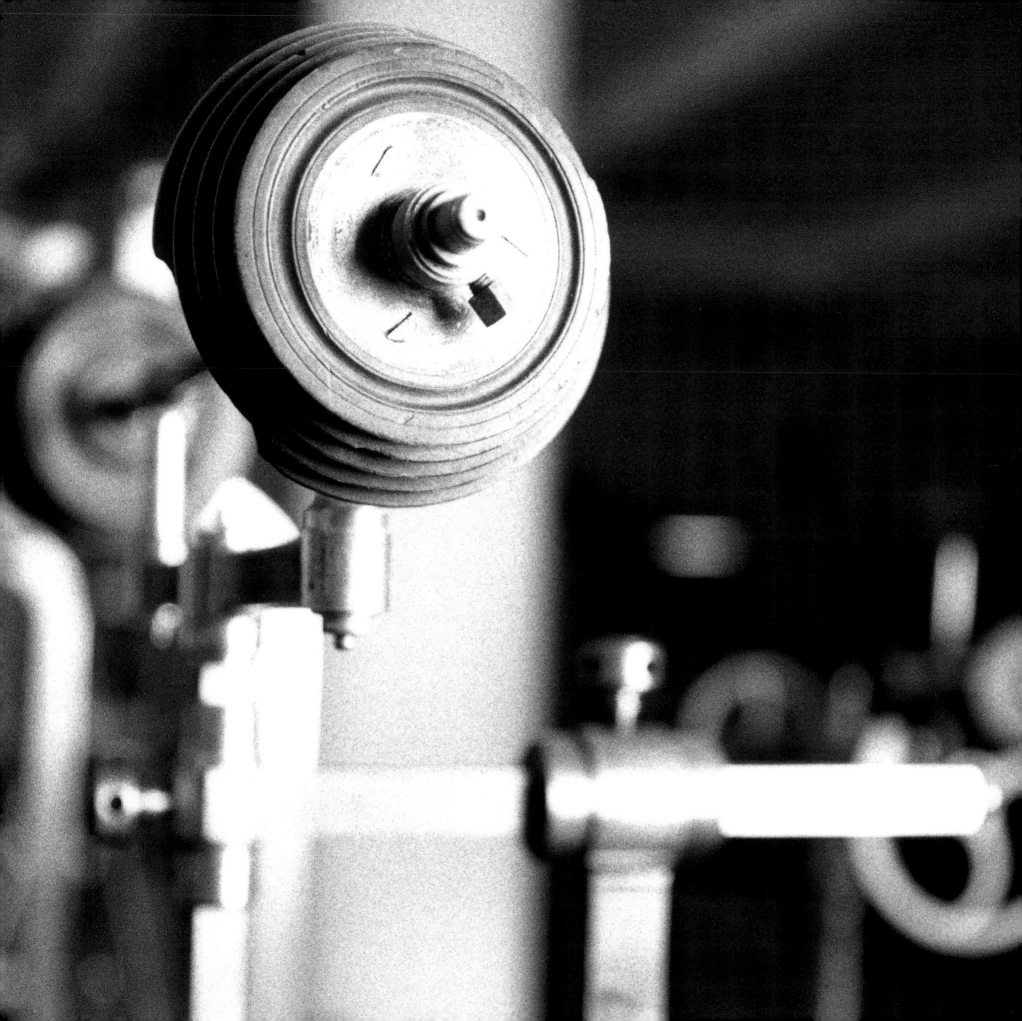

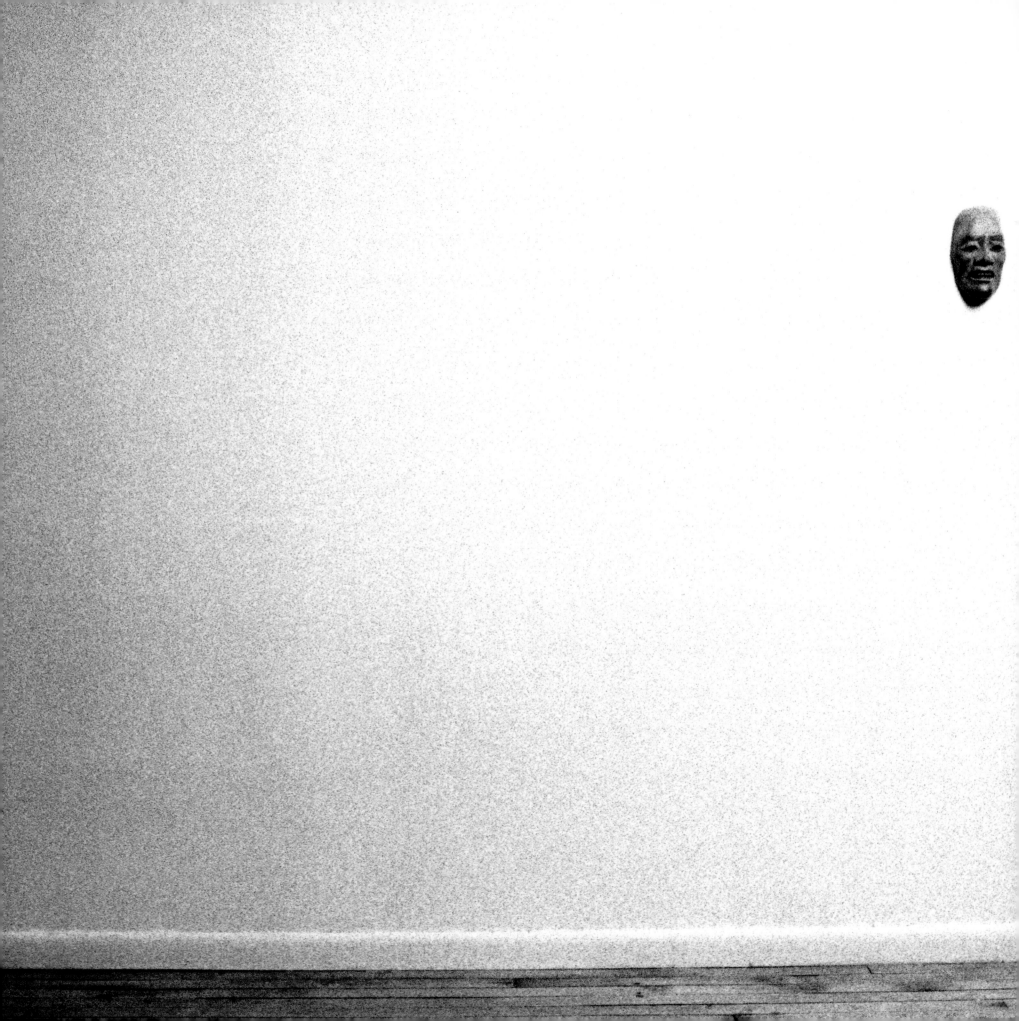

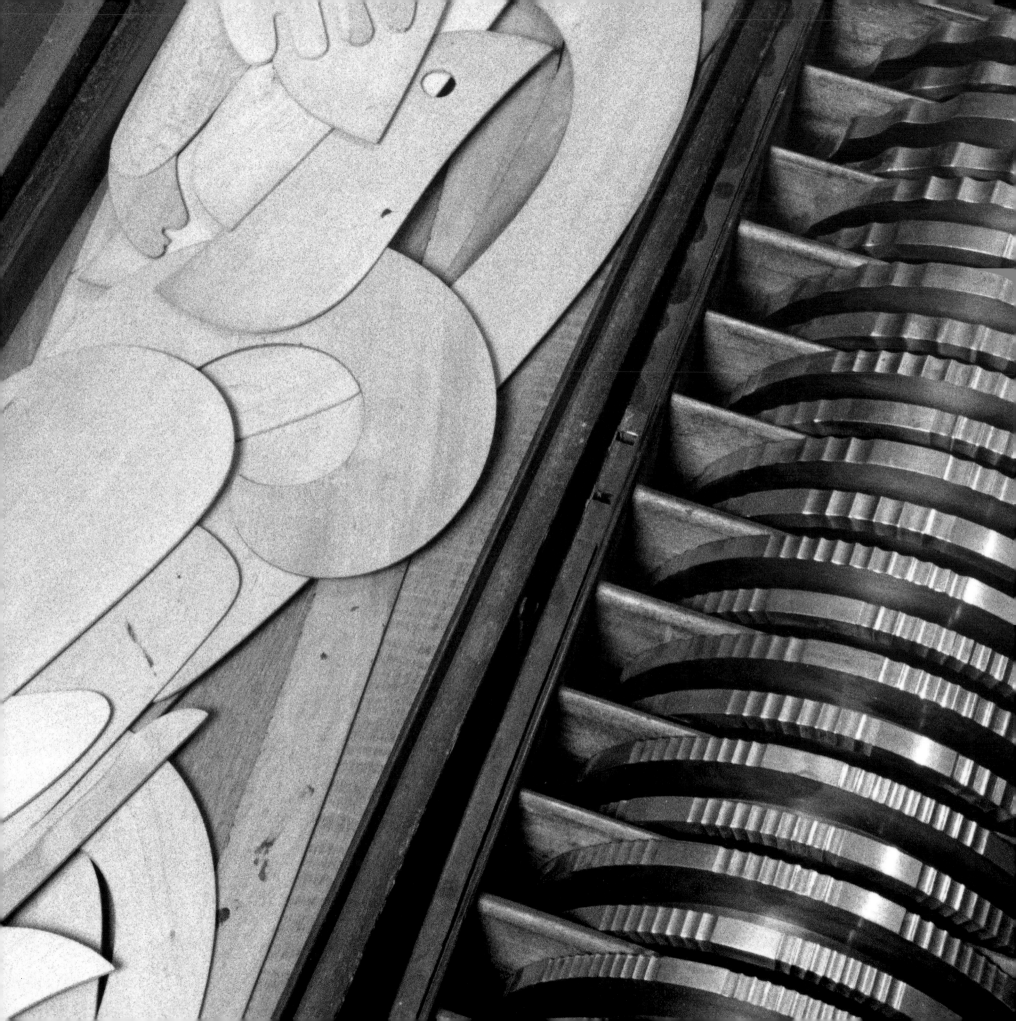

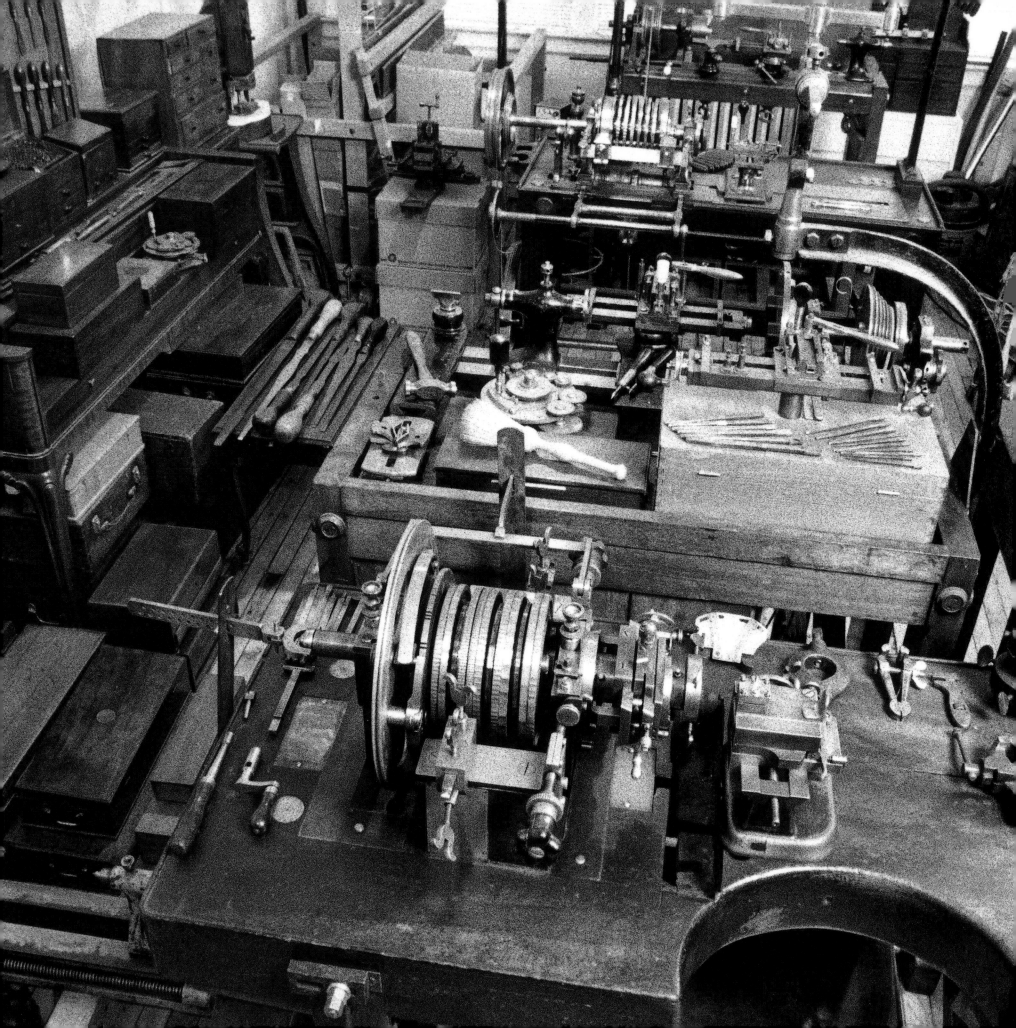

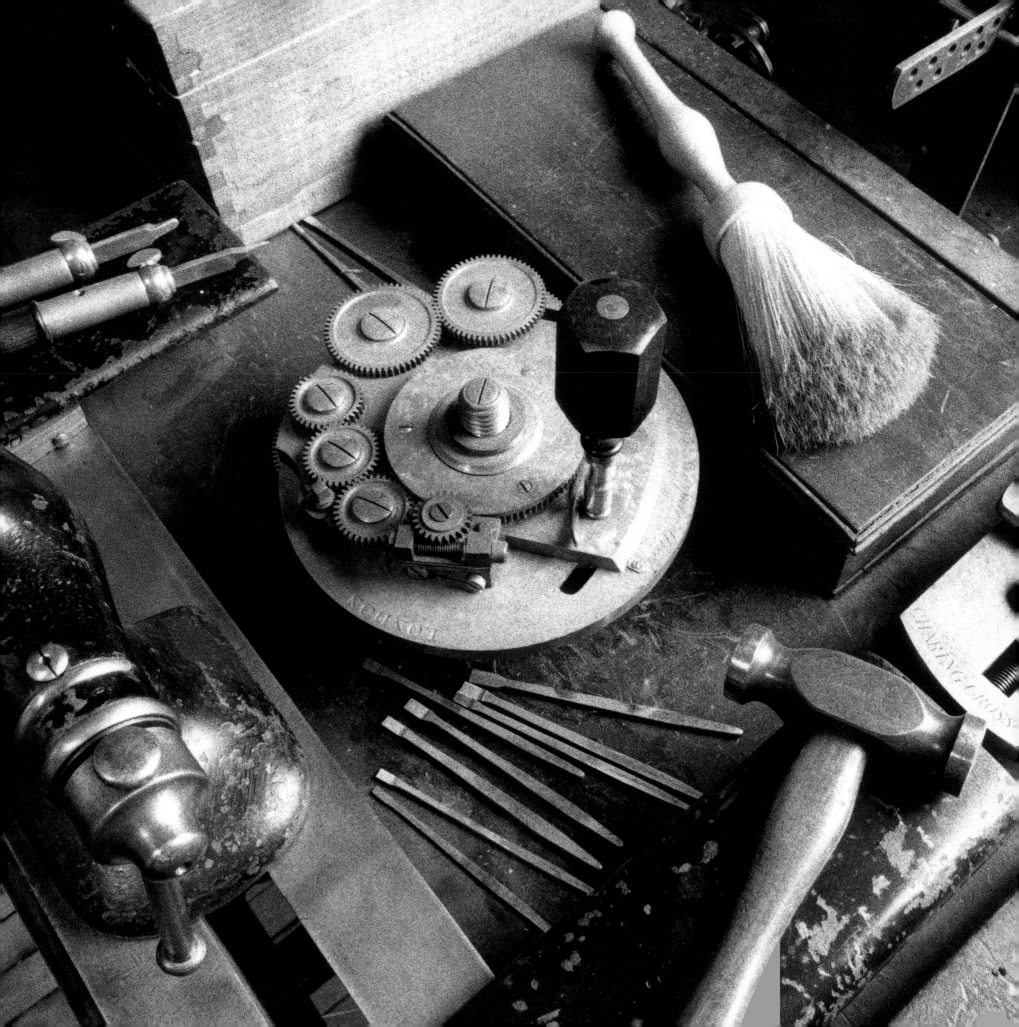

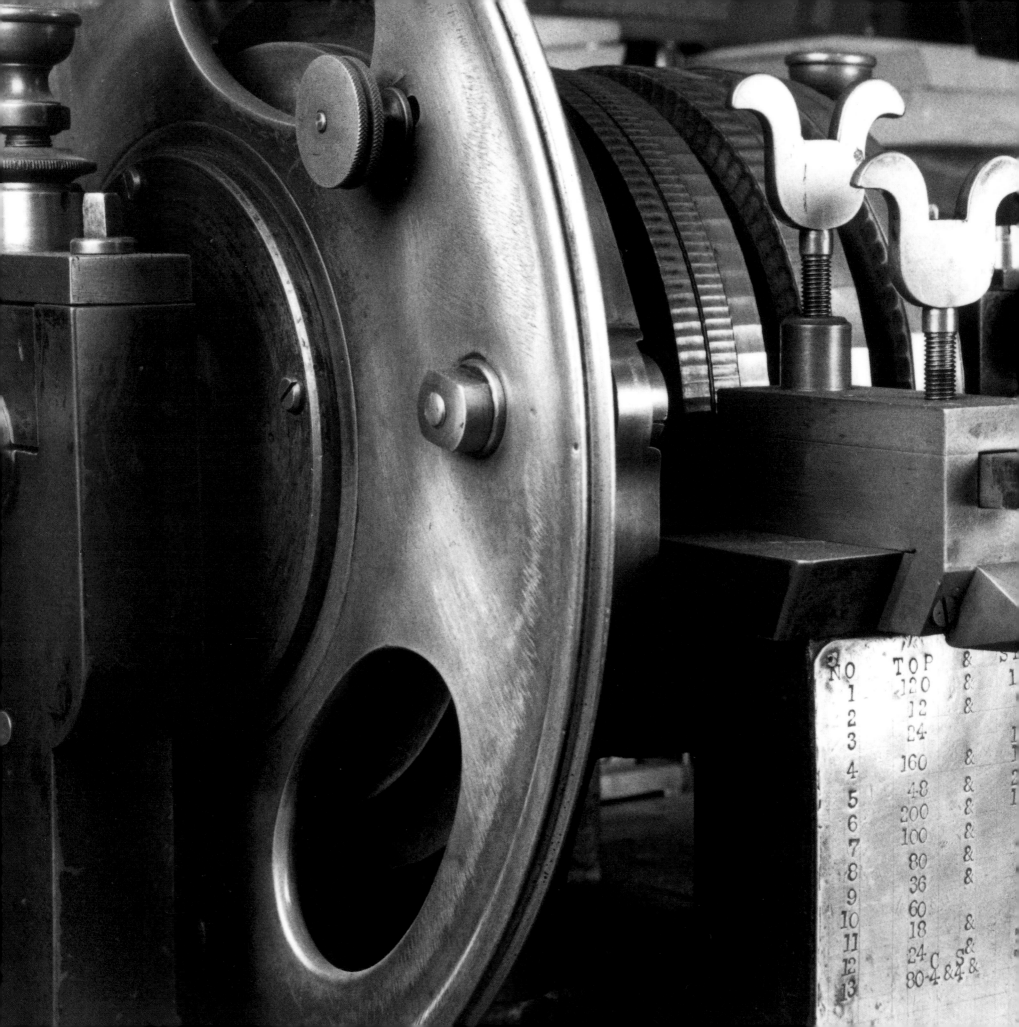

NO	TOP	&	S
1	120	&	1
2	12	&	
3	24	&	
4	160	&	
5	48	&	1
6	200	&	
7	100	&	
8	80	&	
9	36	&	
10	60	&	
11	18	&	
12	24 C S	&	
13	80 4 & 4	&	

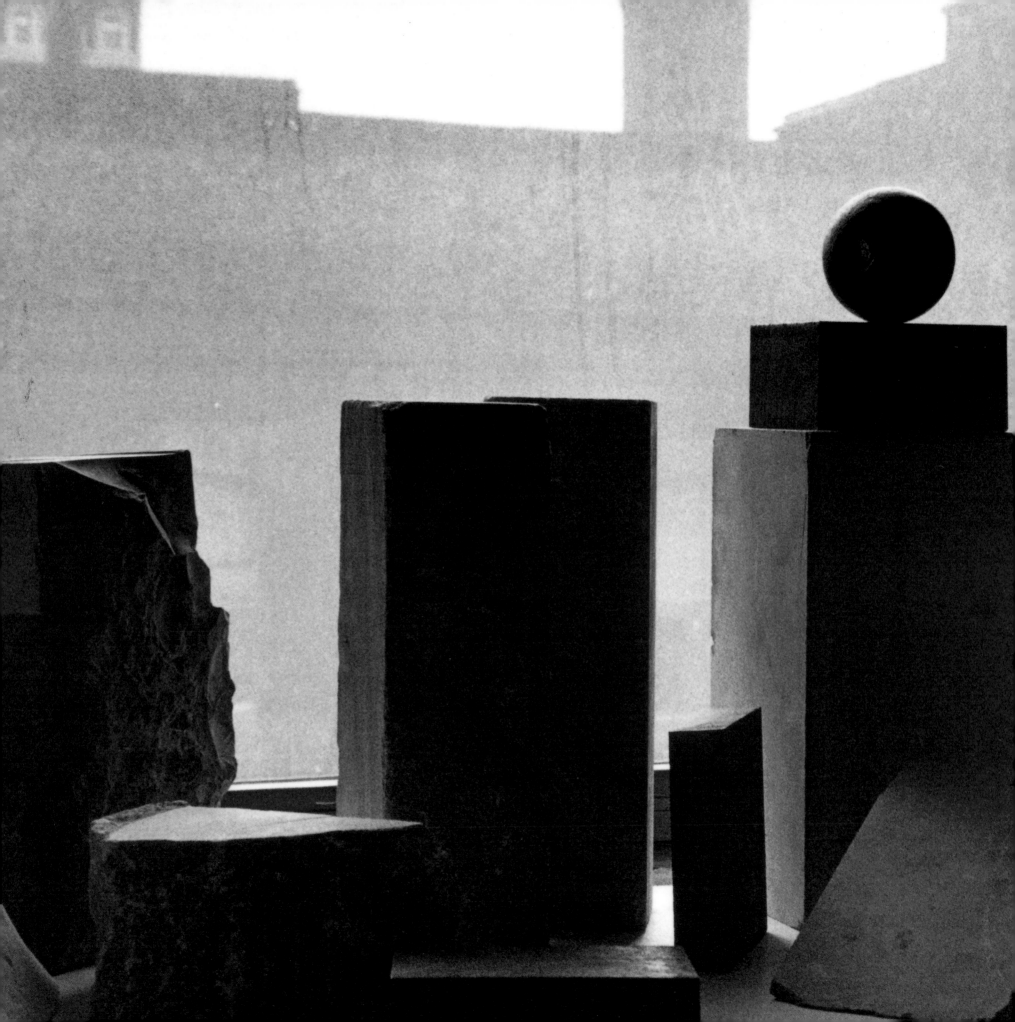

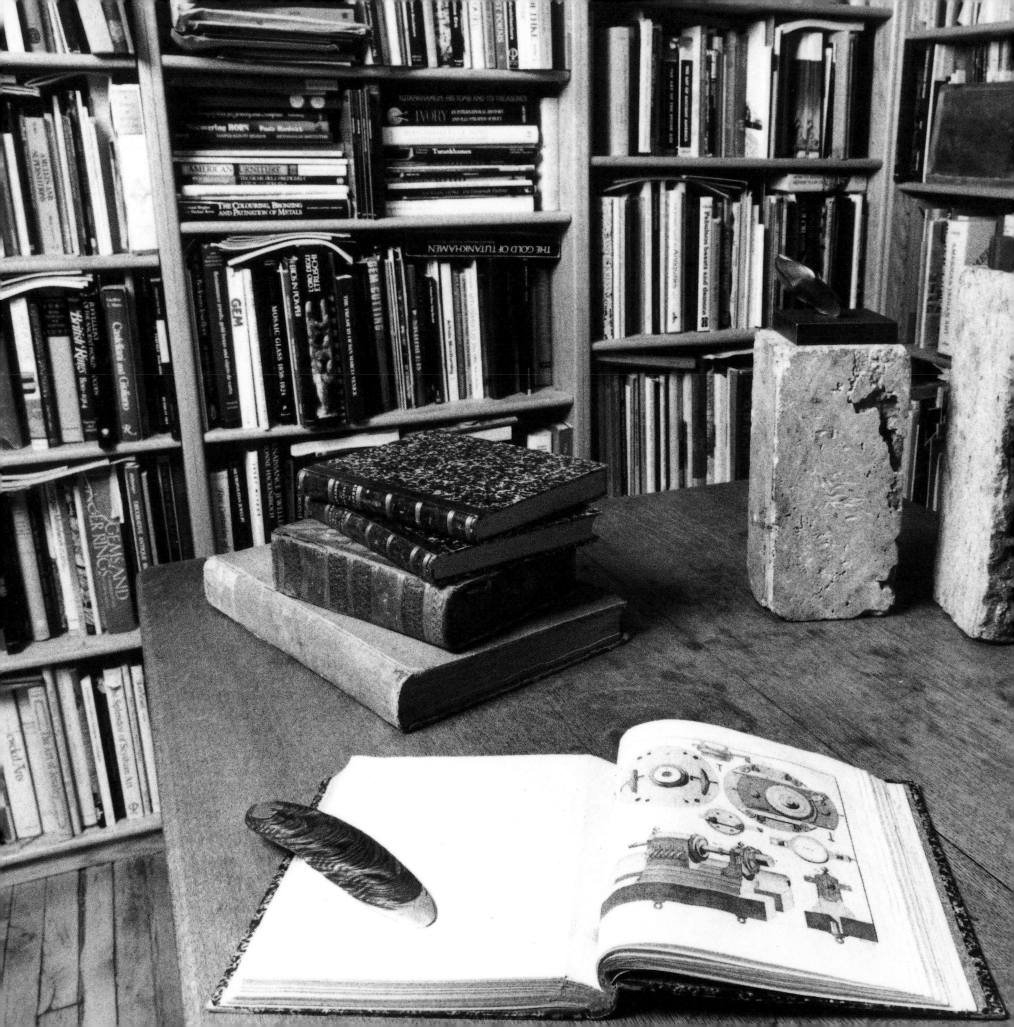

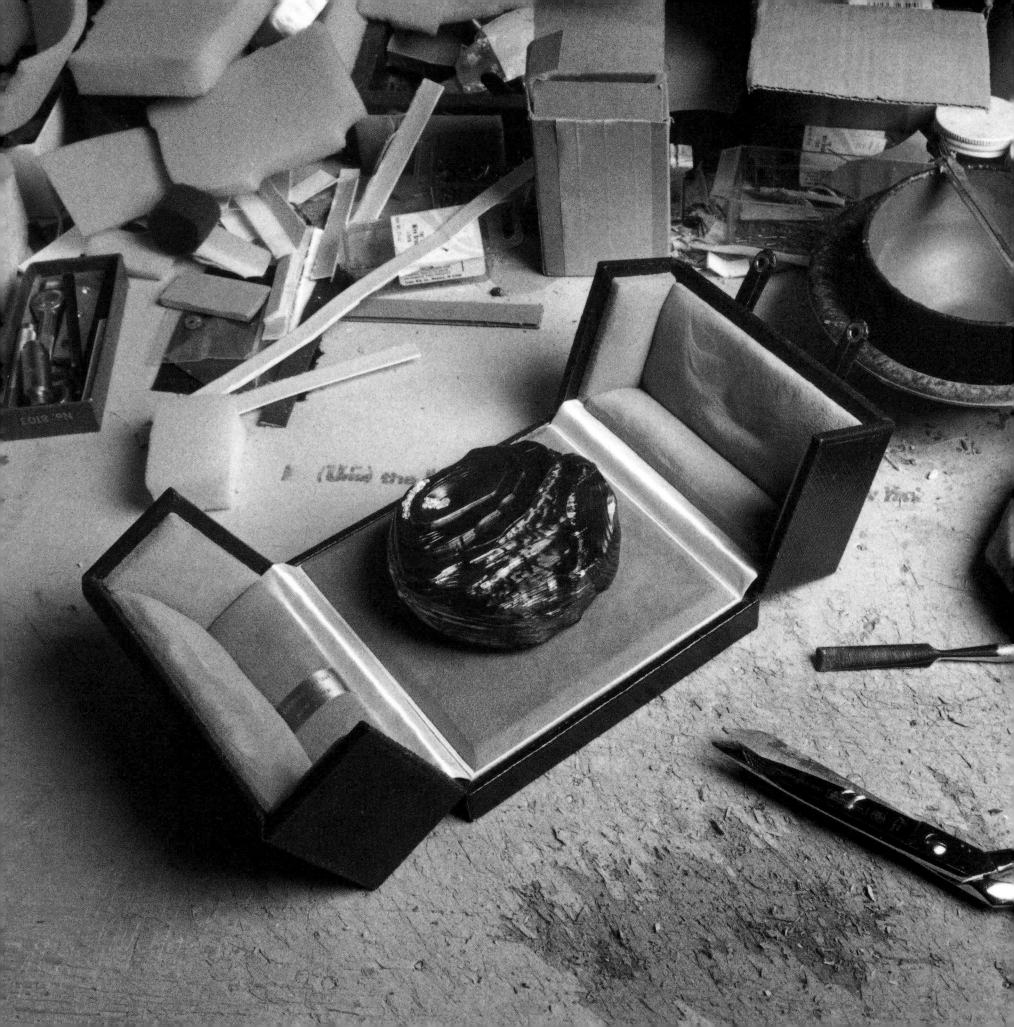

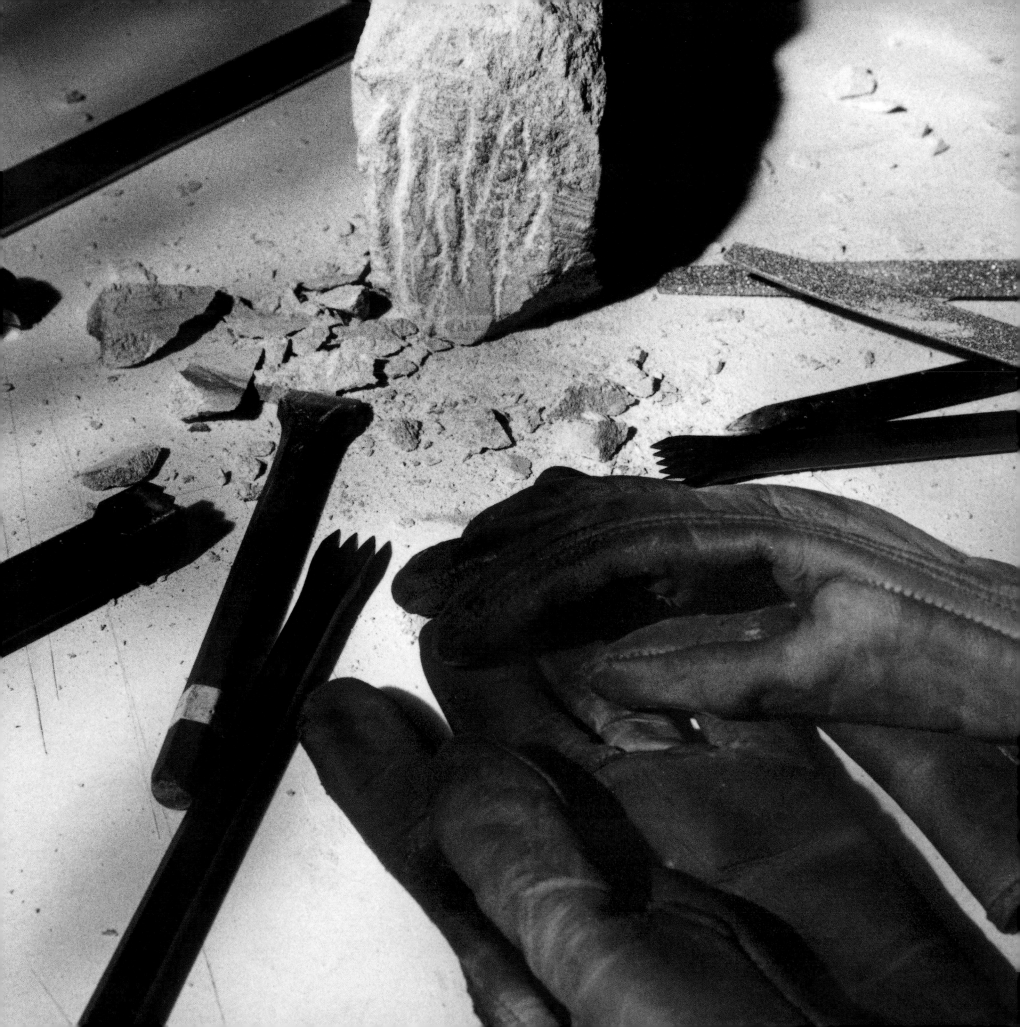

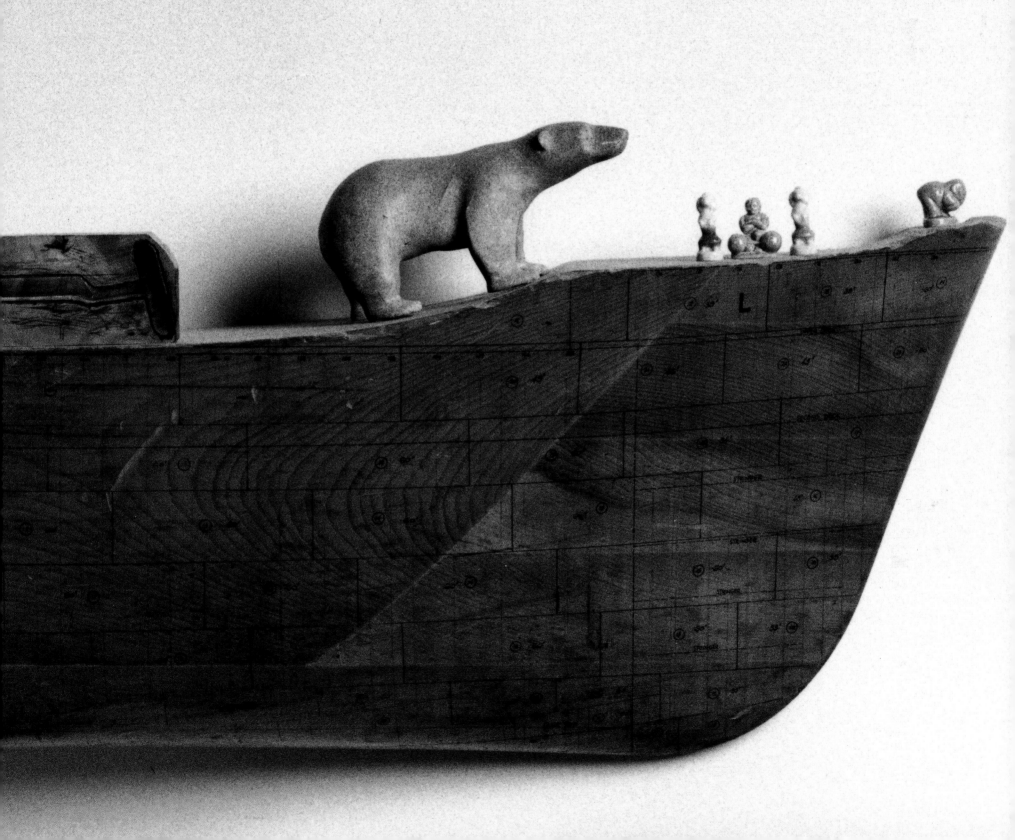

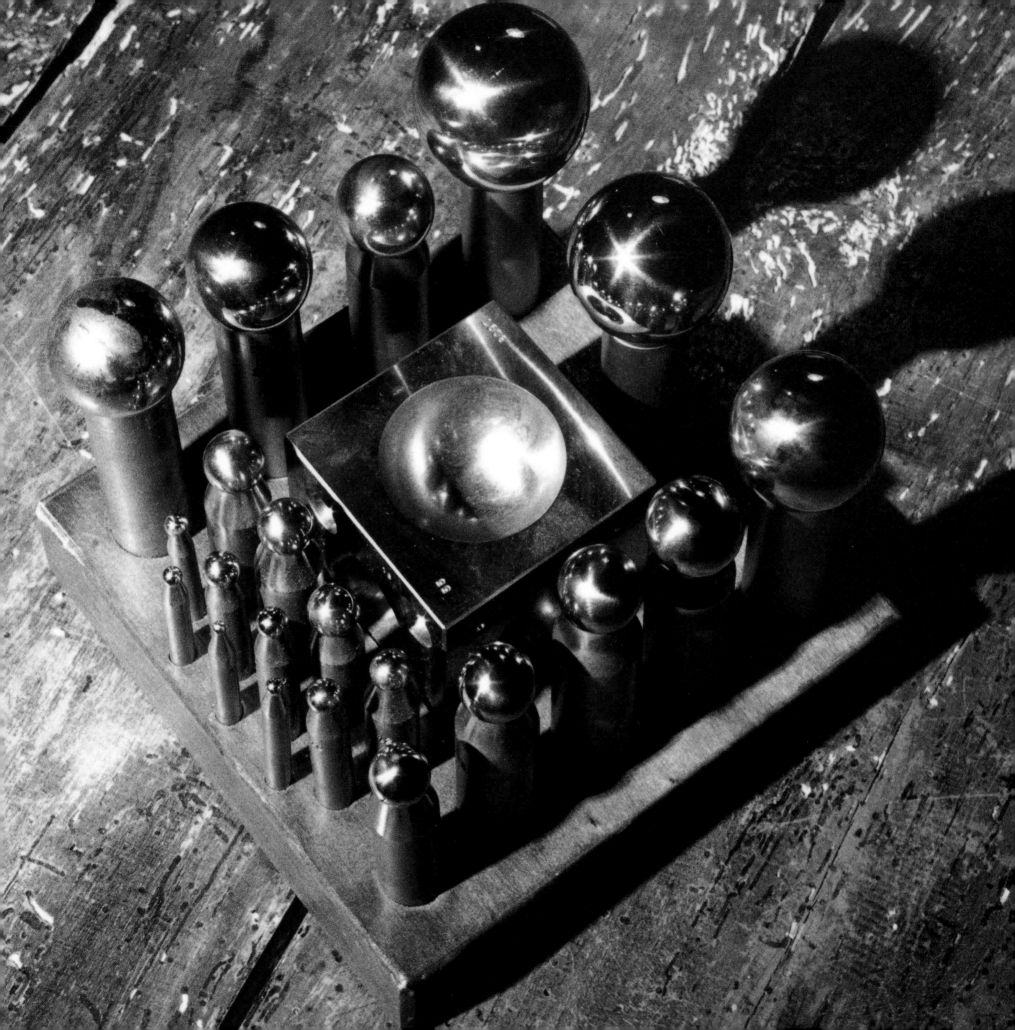

BRUSHFIRE

The Victoria and Albert Museum would close shortly: the dimming of the lights was the first indication, gently directing visitors to the exit doors. Within minutes, security guards snapped out of their walkabout monotony to shepherd stragglers and scholars.

The receding echoes of voices and footfalls brought a still peace to the gallery. But there was no quiet inside the young man—only a pounding, a wildness he had never felt before and could not understand. Earlier in the afternoon he had walked into the gallery and managed a quick glimpse at the case, in spite of all the people milling about. So crowded. He would come back at closing time—it would be quieter. As he wandered through the museum halls, he feared the object would no longer be on view at this hour.

The gold bowl was still there, and it was all his. He circled the case slowly, but his gaze never strayed. How beautiful. He longed to hold it in his hand, close his eyes, feel the texture of gold and the shape of details. How to describe the piece, the creative process, the technical terms? The label read HELLENISTIC, THIRD CENTURY B.C. So few clues. Couldn't the museum have done more research? By now the scholars must have artists' names and places—they had had two thousand years to find out—surely such an object merited special attention since its discovery.

He looked up suddenly, his concentration broken by a new thought. Perhaps divine hands had worked this gold object. In classes he had learned about ancient civilizations and mythology; his teachers had even talked about the theories that the Pyramids and Stonehenge might have been the work of extraterrestrials and deities. If gods had assembled stone blocks and boulders, then certainly they had guided the hands of the artist who fashioned this microscopic goldwork. Just before leaving for London, the young man had watched a violent summer heat storm from his home in Cleveland. With his newfound knowledge of mythology, light-

ning had a name and a history. He saw Prometheus crackling across the night sky, celebrating his actions of millions of years ago when he delivered humanity from darkness. In the humidity of that evening, he had understood that Prometheus could scorch the earth. Now, in the coolness of the museum, he wondered if gods could temper fire and work gold with such infinite detail.

The moment was his to hold. He knew he would revisit time and again the memory of this glorious shock to body and soul.

"We have a full house—five hundred people in the auditorium right now. In another couple of minutes we will dim the house lights, and you will be introduced, Mr. Brush."

An audience of five hundred did not faze Daniel Brush: over the years he had spoken as an artist to various groups in America and Europe, and early in his teaching career he had lectured to art and philosophy majors . . . it was how he had met his wife, Olivia, thirty years before. While addressing fellow students at the Carnegie Institute of Technology, he had become aware of a young woman in the audience. Her thoughtful questions, calm manner, and physical charm had sparked him to seek her out after class. That same day, they had walked through the campus and sat at the student center. As they talked, Daniel realized that he had found his human anchor: the person who understood him instinctively, who could listen, advise, provide a bridge to that outside universe that so exasperated him, and, most important, be loyal to their inner world.

Daniel knew that he had personalized every important aspect of his existence. It was Silla, born sixteen years before, who had sharpened his focus on the eternal tension. Daniel and Olivia had extended their idealism to the naming of their newborn son. *Silla* was the ninth level of understanding in the Noh theater: at midnight, the sun shines brightly. The clarity of the vision always came first. Within a society wallowing in familiar surfaces and concepts, how do you explain such a romantic name as Silla?

Daniel had derived emotional fortitude from his wife and son during his artistic journey. Hellenistic and archaeological jewels had been his first models. He had devoured picture books and treatises on early jewelry and mastered the techniques of the ancient craftsmen. He had quickly become aware that making precious objects demanded special skills: designing a piece, working the gold and other metals, selecting and setting stones, polishing the finished article. Each was a separate task calling for a team of experts. Realizing that he barely had enough patience with his own humanity, Daniel had known immediately he "couldn't have another cook in the kitchen." He would have to learn all skills required.

This night, Daniel was in Geneva. The European audience would view his sculptures in the gallery, then file into the auditorium for his lecture. His appearance alone would provide no clues into his work: a strong, compact build, muscular hands, straightforward manner—none of these created a visual link to the precision, delicacy, and pure focus his art represented. His lecture would be that link, projecting his very private thoughts on his creativity. Daniel's clarity in describing techniques and philosophies would charge the room with his passion and humanity.

As he waited in the semidarkness of the wings, he thought back to his experience at the V&A so many years before. It was then he had first become conscious of "soaring"—conscious of what truly touched his emotional insides. The sight of that ancient gold had grabbed him as no words or sounds ever

could. To his astonishment, the object had gone on to challenge his mind and ability. It embodied the eternal tension between the idea inside and the work on the outside necessary to achieve it. Internal clarity was essential, but so was acquired knowledge and application. In our age of instant gratification, an artist's vision did not automatically turn into a finished reality. The birth of the object would come about only with unlimited time, tools, knowledge, discipline, and the clarity of the creator to maintain his original idea.

It was a real challenge to do the work himself. Restrictions of time or money, integral to marketplace activities, held little importance for him. Yet, as he spoke about his work in Geneva, as elsewhere, the facts and figures surrounding his achievements caught people's attention. The slide of a sensational object inspired a buzz in the hall, and, when Daniel announced that he had had to make 11,700 new drills for the 11,700 encrusted gold granules, the buzz turned to gasps. He enjoyed the delighted reaction of the children when he pointed out that a box he had made was of mastodon ivory—40 million years old, and the awed silence of the adults as he announced that he could choose from 5,223 varieties of steel when he wanted to work with that metal. Best of all was the fascination people had with time—how long to make this object? Calculating time had never been his priority, and here he estimated the months, days, hours. He could imagine the business people among the listeners quickly computing their hourly wages accordingly.

After the years of study, experimentation, and application, Daniel knew he had met the challenge of the Hellenistic bowl. A new set of intellectual and emotional muscles had to be flexed. Along with the romantic vision of the individual artist sweeping through centuries, desperate to learn from the past, was also his reality of standing alone to digest and convert knowledge into his own language.

Over the course of thirty years, working in virtual seclusion from the mainstream, Daniel Brush has created a body of work unparalleled in the history of contemporary art. Daniel's remarkable strength rests in his ability to embrace an idea, capture the scholarship required, and maintain his vision on the creative journey. Ancient gold technology formed a crucial stepping stone, as did contemporary painting and modernist thought, the domes of Byzantium, the mosaics of Ravenna, the levels of enlightenment and understanding as expressed in the Japanese Noh theater, the modernity of both Bakelite and aerospace technologies. All have led him to the present. He has crossed the centuries and human civilizations, learning from each, becoming a part of them. Daniel's philosophical search, along with the materials and techniques he has mastered, serve his passion to create, to make his heart pound, and to allow others to soar.

Ralph Esmerian,
New York City

ESSAYS

BY PAUL THEROUX

DONALD KUSPIT

DAVID BENNETT AND

DANIEL BRUSH

DANIEL BRUSH: "IT'S ABOUT TIME"

Paul Theroux

A creative person knows that what he or she calls work is nothing of the sort. It is a process of life. So, to understand what Daniel Brush does, it helps to consider the whole of his existence: his dedication bordering on obsession, his rituals and routines; his stimulations—reading Zen to do sculpture, sweeping the floor to find a mood, eating the same meal every day for twenty years to find comfort, seeking solitude to find enlightenment. That way, knowing the obliqueness of the artist's life, and even his apparent dysfunction, it is possible to approach an understanding of what the word *creation* means.

Of course, we should need nothing more than to meditate upon the enigma in a glittering object—a work of art is often a work of art for its ambiguity and its secrets. But I find it satisfying to know how it came to be, to talk with the maker in his own studio. For me there is no greater fascination, because I am a maker myself, and I know that, because of my preoccupation, I seem odder than other people. I take it as a mark of distinction in him that Daniel Brush seems much odder than me.

Superficially, at least, Daniel Brush is indistinguishable from many madmen in New York City. I emphasize the place, because a New York nutter is world-class—something to do with the way the city, so cellular, so like an asylum, an island of vertical compartments, isolates people and intensifies psychosis. With a mad cackle, Daniel Brush cheerfully acknowledges this, that he is like a Japanese *furabo*—a lunatic spirit.

Brush has lived the same obsessively simple life, for his twenty years in New York, in obscurity, in a vaultlike loft in the toy and flower district.

"Where have you been?" a curator asked him.

"I've been here," he said.

After a time, if a person has lived and meditated in one space, that space begins to take on the character and contours of his mind, and the artifacts and creations, the furniture, the colors—even the shadows—have counterparts in that person's mind; it is as though the person is roosting in his own skull. Brush's loft is like that: a kitchen, a machine shop, a gallery, with a gleaming floor, and more like an enchanted cave than any other place I have seen in any city. The living and working spaces are interchangeable. It seems doubtful that any other person would find it habitable. It is in every sense a workshop and a refuge.

Inspiration is in Daniel's terms "the ritual of ordinariness." If you ask him what he has been doing lately, he might say that he has been taking pleasure in the unexpected effects of time passing. It excites him to see paint dry, or to see dust gather on a Japanese mask ("That mask has been on the wall for nineteen years. I haven't dusted it all that time. I like it—it gets older with the dust on it"). He takes pleasure in the soft blooms of oxidation on a piece of metal, little unexpected lotus blossoms of rust. He loves to sweep the floor. The last thing he talks about is his work. Or he might not talk about it at all. He is enthusiastic about the floor of his loft. "Look how the light hits it. These are my foot marks walking on it over twenty years. I like that." But that respect for the way a simple thing acquires characteristics, the quintessential illustration of the Japanese philosophical concept of *wabi-sabi*, is also a way of talking about time. His life and his work are about time.

Here is Daniel Brush waking in the morning. He eats his Cheerios. He insists on Cheerios. He has eaten them every morning for twenty years. After his Cheerios he sweeps the floor. The sweeping takes a minimum of two hours. "And if I am really unnerved or on edge I'll sweep it again—more than two hours." It can take all morning. "It's comforting—I like it, I'm good at it, I enjoy it. There's something so soothing about these boards warping out of shape. I like looking at them. I like sweeping. It's very important to me. It has nothing to do with litter or dust. And I always go around the same way. Left to right, top to bottom."

By then it is time for lunch. Lunch is always pea soup. It has been pea soup for twenty years. "I don't have to think about it. It's pea soup. There's a comfort in it."

"What do you do?" his son asked him for a form he has to fill out at school. Daniel said, "Say, epistemologist."

Anyone seeing him sweeping, or insisting upon his Cheerios, or nose-to-nose with a Noh mask, studying its dust, might consider Brush crazy. He would eagerly agree, Yes! Because that is the embodiment of the *furabo*. "It's the monk living removed in tattered dress, with the wind blowing through it." He sees something noble and romantic in such a figure—the Tang poet, the recluse, the eremite. "They wander and they wander and they think. But they're passionate!"

Passion is the distinguishing emotion in Brush's life. He has rejoiced in and been comforted by his obscurity. He is fifty; Cleveland-born. He is small and sturdy, with a blacksmith's build, for his work requires tremendous physical effort. A painter for most of his life, he has had few exhibitions—the last one was in 1987. In 1967, at the age of twenty, and already greatly admired as a painter, he also turned his hand to working with gold. He finds painting exhausting and problematical. One year he did not paint at all. He decided to make gold fibulae—the sort of fifth-century stickpins that were used as fasteners in the togalike

garments of upper-class Etruscans. They were, he says, archaeological in inspiration but not based on anything specific and certainly not copies. No one was making fibulae, so he thought, "I'm going to go for it."

"It kept me from being driven crazy with my paintings. This for me was the *New York Times* crossword puzzle. I could learn to be a goldsmith."

The technical problems fascinated him. The main one was that hollow tubes had not been successfully shaped since Mycenaean times. He was working with tubes that were three times thinner than a piece of cigarette paper. Gold was $35 an ounce and not much was needed. There wasn't much gold in these lovely objects.

"That was the mystery of the ancient goldsmiths. There's virtually nothing. But this is pure gold, not plated. It's been hammered and made into laminae to form over the other structures, just the way the ancients did it."

He came to understand that the problems associated with working gold into such shapes were compounded by the fact that he kept thinking like a contemporary goldsmith. The ancients had virtually nothing in terms of technology. They had cow dung, plaster, and alluvial gold. Daniel deliberately simplified his approach. He made all his own tools. "Wood and bone, small pieces of metal. Stone, brick clay, stone. Hand hammered. I cast nothing."

His fibulae he regards with detachment. "They are wonderful technical exercises, but they didn't come from my heart." Such gold fibulae were made in Mycenae, he says, but not with this much finesse nor with the regularity of the granules. To illustrate granulation he showed me a marvel he had made twenty-five years ago, a gold domed vessel about four inches high. Thousands of gold granules patterned the dome.

"Each one of these is .008 of an inch in diameter, plus or minus .0001 of an inch. I made them all. Individually placed them all. I don't use tweezers. I use a brush. I pull all the hairs out except one, then pick each one up and place it. If you eat pea soup, there's enough viscosity in your spittle to adhere it to the surface. I do that with thousands of granules." This is months of work. And then he picks up his torch. "I have one shot. I have thirty seconds; at twenty-nine it fails, thirty-one I've melted it like a mercury ball. One shot." That, too, is about time.

What was the original impulse for his gold work? He said, "It probably started when I was thirteen years old, when I was so taken by a bowl I saw in the Victoria and Albert Museum in London. It was done by humanness that was ethereal—it was effortless. It wasn't made as artwork. There was no ego in it. And it was just this wonderful delicate bowl, probably by an eight- or nine-year-old girl, an Etrurian. It touched my heart because it was light and transparent and without bound wrists. It was just part of the culture, part of everyday."

He made that first domed container on his kitchen table. At the time he was living and working in Washington, D.C. He had traveled to Georgetown from Los Angeles, where in the late 1960s, he had gone on a fellowship. Admiring Utamaro and Hiroshige, the delicacy and "excruciating beauty" of the *ukiyo-e*, he was awarded a fellowship as a printmaker and painter. He made woodblocks, which he titled *Placemats for Paranoids* and the *Flying Goddess Series*, and finally self-portraits, about a thousand of them. He did them standing over the wood panels, "ripping the wood right out."

"I started out trying to get the pearwood and the fruitwood, and all that, and then I just used

what I could find. My wood, rough stuff, wood that I found on the street—anything that I could find to print with. When I got there they wanted me to build the printmaking department—but I didn't want to do that. So I moved away and lived in Watts on top of a grocery store and started doing my paintings."

He had remained in Watts, through the riots, for two and a half years, living on fellowships and grants. In the first year he did little work; in the second year he started painting, but rejected every picture. He eventually got a job at Georgetown University. He was young, in his early twenties; his students were nineteen. But he says he was restless, he couldn't think. Still, he was a successful painter, with exhibits at the Phillips Collection and the Corcoran Gallery of Art; a tenured professor of art at Georgetown. At that point he began to work in gold. What was in his mind? I wondered.

"That I'd never have to make another painting, so I could have a release from the enormous tension of my paintings. It was never in my mind to sell the gold work. I just didn't know how to sell things, and as time went, a few people heard and a few people collected and it just let me not think about it some more. And then what happened was thirty years passed and now there's a lot of them."

Only a select few people have ever been aware of his work, and the greater part of his work no one saw. It seemed to me like writing poetry of an intensely private kind, working for decades in seclusion, with the purest of motives, like a Tang poet.

"That's it exactly. When I was teaching, I thought it was important to arrest time."

As a teacher, too, he had tried to devise elaborate ways to arrest time, to make each moment live and mean something. He taught a class, "The Relationship of Structure to Meaning." On the first day, the forty students in the course arrived and saw a six-inch-wide strip of paper, seventy-five feet long, on the floor. Daniel was hidden among the students; they did not know who he was. Daniel had previously arranged for a nude model to walk the length of the paper. "I told her to enter the room, walk in a very attenuated way to the end of the seventy-five feet, for about an hour and a half; she would turn and then take an hour and a half to walk to the other end."

She showed up. All the students looked around and saw a statuesque woman, a ballet dancer. Without a word, she slowly began her trek down the strip of paper. The students were either laughing, in shock, or fidgeting. The woman was sweating. She got to the end after about an hour and a half. It took about forty-five minutes for her to turn around to take the walk back.

"I couldn't breathe from it! I stood up and in the most dominating way I said, 'It's done!' And she saw me for the first time. The students recognized me as their teacher for the first time. She collapsed. I collapsed. I said to the students, 'Ask a question on a piece of paper for tomorrow.'"

Next day, half the class had dropped out. "I knew that something had happened that had occupied a chunk of time. It was beautifully, intensely erotic, sensual and risky, but it affected lives. It was ferocious and passionate."

Time was always on his mind. "About a year later I felt so troubled in my own work that I gave the students a conceptually immense project. I wanted them to cut a two-dimensional shape in paper that they would be comfortable standing on for the rest of their lifetime."

In his last year as a teacher, as a sort of "Ode to Autumn," he gave another startling assignment: "I wanted them to rake every leaf in Rock Creek Park for today forward, thirty years, and show me the piles

at the thirtieth year. I wanted them to look down like a drunken dog and say, 'Gee what's that?' So that something had passed through them, something occupied them when they least expected it. They could make something called an a priori intuition. It would be so pure, so beautiful. At that point I stopped teaching."

In a deliberate attempt to find something like his own voice, rather than preoccupying himself with the crossword-puzzle aspect of this extravagant sideline, he remembered specifically those sights that had so moved him. "I had visited Galla Placidia's tomb in Ravenna. So I did Placidia, Theodora, and Justinian. Just as a way to catalogue it for myself." He made no drawings, no sketches.

The domes in the Middle East and the great churches in Europe were the initial impetus for a series of golden granulated domes. He made five. Two of the five were destroyed. "I needed the gold. I made them into something else. It allowed me a distance from the paintings. The paintings were so difficult, so confusing. I needed my mind to be clear and clean."

Inspiration came from the oddest sources: from the gold bowl he saw as a boy at the V&A; from an unfinished obelisk in Aswan; from the young women he saw in the streets in Bangkok. More powerful than any of these experiences was the memory of a woman who came to his parents' house. He was eight. He knew her only as "Rabbi Seligman's wife." She was small of stature, modest, deferential to her husband. "But I saw a tiny number on her arm. I didn't know what it was. There was extraordinary power in the woman. She didn't have to come out too loudly and say anything. I knew it touched me. I thought about it. It's now forty-two years later and I still think about it. But there was something about her—it came from worlds of experiences and many years and she had probably what people would call wisdom and compassion at the same time. So you read about the Holocaust, and I thought if I was ever going to be noble or what people call an artist, it had to be more than just skillful manipulation of materials and hard work. It came from somewhere else, and I keep thinking that the ritual of ordinariness makes it so special."

The repetition of the same meals, the sweeping, the reading, the meditation make it all possible, he says. And then the day came, on the completion of the last dome, that he said to himself, "I know I can do it."

After one of his exhibitions at the Corcoran Gallery in Washington, the curator came to his house and said, "What do you do here?" and he showed her the gold domed containers.

"You could make a living doing this." the woman said.

"I took that to heart." He came to New York City and, one day in 1978, he carried a suitcase with his gold work in it up Fifth Avenue to the fancy stores—the ones with the doorbells and the security guards. Inside he saw a man trying to sell things to the shopkeeper, and struck up a conversation with the shopkeeper and showed her his work.

At the sight of Daniel's work, the older man closed up his suitcase and became very offended. But the shopkeeper said, "I'll buy everything you have."

Instead of feeling vindicated and triumphant, Daniel became anxious. He fled to the Hotel Pierre, so nervous he had to compose himself. And in that moment he changed his name. "I wasn't prepared, I felt violated, I didn't know what I wanted." He changed his name to Delphin Broussailles. "Delphine was my grandmother's name, Broussailles means 'sagebrush' in French. That was my *nom de bijoux!*"

The fancy store implored him to work for them. He refused and went home. Afterward, another store heard about him and offered him a show. He wanted an exhibit, and it happened. But the fast-paced

commercial venue—the marketplace group show—was not appropriate for the work. And the mishandling of his pieces destroyed them. "I retreated. From that one point I was holed up for three or four years."

His name was known to a few people but he refused to show his work. He refused to sell. Jewelers in New York, Paris, and Geneva offered him jobs as designer, goldsmith, foreman, head of departments. He was offered $250,000 a year by one of the best jewelers. He turned it down without hesitation.

"Another man said to me, 'Don't waste your time—put this on the mantelpiece, have security for your family—be a shop foreman. Forget this and make a living for your family.'"

Some years later, the same person exclaimed in wonderment when he saw one of the domes.

"You know how to do this," Daniel said. "There's no technical mystery."

"Of course not, but your work has jeopardy," the man said. "Business moves forward, linearly, there is no jeopardy in business. I design, I have a team, I work toward something, I sell. But at any one time in your work, the piece can be ruined."

Daniel said, "Yes. It is truly on the edge."

He was still painting. This was around 1979. He was hardly making a living. His mother helped a bit, but not long after, she died. His father was already dead. There was no inheritance. At last, in the early 1980s, someone took a substantial interest in his work. "The way the woodcutter sometimes passes by," Daniel describes it using folktale imagery. "And not too much was said, other than, 'What have you done? Can I see it? It's beautiful. Can I be its custodian?'"

Daniel could now live and work undisturbed for a period of time, without having to engage in exhibitions or commerce. The man was the classic Maecenas—a patron without questions or demands; patient, intelligent, tasteful, flush.

"It's a matter of warm hands extending to my warm hands. It's a practical matter. This costs money—serious money to make," Daniel says. "My ideas are coming faster and faster. I try not to think of it as commerce, because I don't see myself in a job, having commercial activities. Now the collector base has grown, and I continue to require from potential custodians sensitivity and courage, as well as financial ability. When a collector engages in a strong synergetic way, we both learn about time, over time."

The very shortage of gold and other material was a challenge that forced him to master other sorts of innovation. Necessity made him frugal and imaginative. His problem was the problem of the ancients, and so his solutions were also those of the ancients: the old problems impelled him to embrace old techniques.

"I would buy tiny amounts of gold, a few ounces of gold," he says. "I read that you could stretch one ounce of gold into a five-mile strand. It was fascinating. I understand that in the astronaut helmets gold was so thin it would become transparent and at the same time remain a heat shield. I learned to do all of this by hand. My things are all handwrought. They're thin. There's an illusion of thickness in the archaeological-style works. Other techniques come into play. These are not the techniques of a commercial jeweler."

The quest for gold remains an issue. Gold is for him like paint or plaster or clay, a raw material. "I need gold of a certain fineness. I am an established business. I buy it from a legal assay house, where I call up and ask for so many 9's fineness, and they'll send me what I require. But I have all the appropriate documentation."

The paradox of his art is that the work is not categorizable. Truly, it is the Latin term *sui generis*, constituting a class alone. Gold is not the stuff of painters and sculptors, but of jewelers. It puzzles him that

certain museums, because of their narrow guidelines, will not show the work, It is a strange, even irrational discrimination and, given the fact that much of what he does is brilliant sculpture, it shows how unenlightened museums are, I would say. I suppose that is why they are called museums, essentially moribund and morguelike, consensus collections, repositories of agreed-upon works that startle no one. Also, the museums rely heavily on celebrity status, so for the remote genius, the doors, too, are heavy to open. It also means that such a place would reject Benvenuto Cellini, whom Daniel Brush much resembles in confidence and mastery.

"Am I a decorative artist because some things I do are precious?" Daniel asks. "Or, have I redefined the meaning of preciousness? Gold is a material that has a beautiful light and you can't understand it and it has a history about it and it becomes transformed and it's just like red paint and every other material in the hands of an artist. I find myself being captured by it and needing it and wanting to use it. Do museum restrictions bother me? Yes."

From way back, it was Daniel's idea to show all his work in one space—indeed, he wished to create both the work and the space, the objects and the museum. He wished—still wishes—to show his gold work alongside his paintings. An artist planning for all his work to be shown in a single space is an idea that goes back to J.M.W. Turner—and perhaps farther. Turner's wish was granted with the Turner Bequest and the Turner Galleries at the Tate in London; and the Van Gogh Museum in rural Holland has something of the same notion in it. In the event, Daniel Brush has shown his paintings only rarely.

He cannot talk about his work, or his life, without talking about his paintings: he is a man who does not make plans or diagrams for his gold work, but in effect his paintings are mirrors for his gold work—in their apparent precision they resemble granulation, and in their controlled striations they look awfully like the steel he chisels, tapping away, blunting the chisels, sharpening the chisels again, adjusting his surgical binoculars and continuing.

I mentioned that Brush's loft suggests the inside of his head. There are many paintings in his loft—many more in his head, I imagine. The paintings share his living space with the machines—the lathes, the cutting machines, the antique turning machines, the priceless eighteenth-century Holtzapffels— the library of rare books about metallurgy and Zen Buddhism, the Cape buffalo horns, the mastodon tusks ("There's a lot of mastodon ivory. . . . There's a bureau in Russia that sells the stuff. . . . It's been in the Siberian tundra for 41 million years!"), the fossilized walrus penis bone (called an "osik"), the Japanese Noh mask, the thumbtacked newspaper picture of Dr. Oliver Sacks. There is also an epicycloidal generator, the complete set of handcut gears for an epicycloidal generator, the antique thread-chasers, the half-worked chromium steel ball: "It's driving me crazy. One hit—it breaks; one hit—it breaks. I keep sharpening. I might use a thousand chisels. They just break endlessly."

Some of the paintings are stacked against the wall. Many are rolled up and packaged and look for all the world like bundled up carpets in a warehouse.

Paintings are so revealing; being shown them is always a moment of truth—if they are junk it is obvious; if they have genius, that too is plain. Daniel Brush's paintings are at once startling, original, evocative, entirely new.

"Look at this," he says, grabbing the end of one and unrolling it on the floor—a sequence of motions that seem to parody a Turkish carpet dealer. "These canvases are 114 inches by 84. There are 105 of them, okay? They were done top to bottom, left to right, in one time frame."

Composed of horizontal lines of varying lengths, they are close-up like seismographic printouts, but at a little distance they suggest the subtlest landscapes set out like lines of free verse. They are also strongly reminiscent of Chinese scroll paintings, and they could be mounted and exhibited as distillations of the masterworks depicting the Li River and Guilin.

No sketches preceded them; only mental discipline, concentrated thought. Because they demanded monumental physical labor—each painting done in one time frame—they also required Daniel to be in the best of health.

"When I paint, I am in shape. I think right. I work. I have in my mind when I am working where I am going. The paint makes itself. I mix it up ahead of time and I let it get moldy, and mature—so at some point when I am bursting and I can't stand it, and I have prepared myself for a month, I say, 'Fine. It's moldy! Begin painting!'"

The empty canvas is on the floor. He bends over and works top to bottom, left to right. "I just keep moving down the thing." He is seeking "the threshold of my possibilities." To deal with the tension he feels when doing a painting, he studies Eastern philosophy, especially Noh theater.

"I am a Western person. I struggle, but I find myself reading about Eastern things that give me great comfort. And I think the struggle and the tension when I am painting is to be the accompanying actor in the Noh theater. It is to be able to come out, accept my role, accept my uneasiness, and wander. At the time when I showed the paintings, people said, 'What does Mr. Brush do besides lines?'"

He insists that he is not a modern painter. "This has nothing to do with painting. This has nothing to do with lines. This has to do with the passage of time. To go from there to there"—from the top of the canvas to the bottom. Like his gold work, it is a physical and mental act. He mimics the effort. "I was crouching. There's a kind of movement—like so!" He coils and springs. "It's the same as granulation. But if I somehow can have my control and acceptance I can go to that romantic zone in my mind called Transparency. That's what I am working for. I am still working for it."

When his paintings were shown at the Corcoran, the curator said that such work would totally change the concept of modern painting in the United States. Yet Daniel has no such goal. He merely wishes to paint. The nagging question of "What do you do?" he finds easier to answer by saying he is a painter. "I'm not a goldsmith, I am a painter. I have trouble saying I am an artist. I like the idea that writers talk about voice. I like that. There's something very nice about that. Voice."

In another, later sequence of paintings, he used both hands simultaneously, working from the edges and creating a sylphlike figure that is at once a brushstroke and a ribbon, something approaching calligraphy.

"No one has ever seen these paintings. Its not that I don't want anyone to see them. I want an incredibly exquisite room that's maybe 68 degrees, second floor, all white, and I want to show sixty-eight paintings on sixty-eight consecutive days, one at a time, the way I painted them."

There are one hundred five paintings altogether, but, as many are multiple canvases, there are

considerably more images than that. He sees it as all one work, an almost seamless creation of painting and sculpture. "It's the same work. I work, I dream, a lot of work happens."

It is a dream realized, and in an unusual way. Because he works entirely alone and to an enormous degree is helped by his loving and obviously devoted wife, Olivia, he has been able to maintain the purity of his original vision. Nothing he has ever done has been for the market; nothing for commerce; nothing at the suggestion of a patron, no commissions, everything one-of-a-kind, no copies. Criticism has never entered into his thinking: the critics do not exist for him. From time to time people have visited, but their reactions have made him only more reclusive. "People come to my studio and look at my work. Often they want to come and snatch and conquer and destroy. Others are more sensitive and respectful."

To the people who visit in a hurry, he says, "Wait. Let's take time and savor this together. Let's work through this. Forget about connoisseurship. Forget about ability and craft." Or they say, "How much is it?" Daniel says, "Wait a minute. Let's look, let's consider. Let's touch and handle."

Let your heart beat a little bit slower, he says, and it is like a mantra. It has allowed him to work and think for thirty years and to resist the pressure of celebrity. In that whole time he did not seek any public notice at all. This interests me greatly because it is the same mood of James Joyce toiling over *Ulysses* for years; of Elias Canetti in his thirty years of writing *Crowds and Power*.

In the way he notices the burnishing of his floor with his broom, Daniel sees a development in his paintings. Seeing how time has entered into his work has given him patience and a measure of satisfaction.

Showing me one of his more recent paintings, he said, "I don't think I could have done that when I was twenty. When I was twenty years old I was powerful and arrogant, I was pleased in my ability."

The chronology of his painting parallels the chronology of his gold work. The completion of his first domed container has as its counterpart a painting called *Ribbons*.

"When I was a little boy," he explained, "women would walk by and say, 'Kene hora!' and throw a ribbon in a basket, whether knowing your family or not. It was basically an Orthodox Jewish tradition of throwing these red ribbons to ward off the Evil Eye. I remember a red ribbon being thrown into my buggy. Although this was when I was a little baby, I thought about it for years."

One month to the day after *Ribbons* was finished, his father died. "And that day all my arrogance went away."

He immediately set to work and painted seven black paintings, all titled *Reluctance*. Reluctance—because it is Jewish tradition to stop seven times on your way to a burial. After those paintings were done, he prepared himself for one year, for an exact day, an exact moment—probably superstitiously, he thinks—for a painting: a year's preparation, all thought, no sketches. He says that he prepared himself for his whole lifetime in that one year.

"Probably it comforted me to have a plan—who knows? But I worked, thought, did nothing, sat, looked at the water towers, polished the floor, and, when the day came, I would paint the one painting to get me over it. Before then I sat, walked, looked out. It was like *Nanook of the North*. Get up, eat food, go to sleep; day after day. But I felt I was sinking to the lowest possible place and wanting to get there, so that I could come out. The painting would be called *Cold Mountain*. That's where Han-shan lived, and I felt he

was comfortable living there. He was a friend, a companion. I liked the phrase that said, 'If your heart was like mine/You'd get it and be right here.'"

He didn't know what the painting would look like. He didn't know whether it would take ten minutes or many hours. But the day came, and after all that preparation, he painted the painting in ten minutes. "That was it. I got on, got off, exploded right out of me." It was a mystical experience. "This painting *Cold Mountain* let me have the companionship of myself to be an adult."

The drama, the mortification, the suspense of mysticism are all a part of his plan and they help explain how a man can live in such a space—working, thinking—like Han-shan on Cold Mountain.

"The years went by and there were so many paintings and sculptures that no one had seen. And that's why Olivia made a call to the Smithsonian. I didn't do it. She made the call." It was about time.

The curator came and asked him where he had been.

"I have been working here."

"Someone should see your work." He said that Daniel was the most Asian of any Western artist he had ever come across. Daniel liked that.

Like many another recluse he finds some aspects of human society painful and awkward. Invited to a fancy lunch to discuss the characteristics of steel, he is plunged into dilemmas of dressing and eating; the ritual of lunch is not just ridiculous but disturbing: the plates are too small, the food too rich, the arrangement of fruit on dish so asymmetrical as to give him indigestion. It is quite funny as he describes it, but there is a serious point: "Over here there were strawberries and papaya, crabmeat, lobster, and there was another strawberry over there—and that really bothered me. I finally said to them, 'Look, I eat all my strawberries, and then I move to the papaya.'

"So the person next to me says, 'Ha ha ha, you're not a grazer when you eat.'

"I'm not! It bothered me! I could not eat the damned thing."

The way a cup is presented can make the difference between his drinking or not. The handle should be presented this way and not that way. He is not a fanatic, he is merely someone who understands the complex relationships in the tea ceremony, which has nothing to do with drinking tea and everything to do with the meaning of life and the nature of the universe.

Understandably, he has trouble in restaurants. "Someone took me to this very elegant restaurant in New York. I wasn't too keen on it. I'd rather eat bread and pea soup. It was so uncomfortable. I got very agitated. I tried to contain it. Because I'm practicing *ma*. A sense of *ma* might be described as understanding your own space and equilibrium to the extent that you can walk briskly and directly into a crowd exiting from Madison Square Garden and avoid touching anyone—that you can interact without dominating. I used to observe and rearrange. Now I observe and interact. I'm accepting—I want to accept. I don't want to control."

He says he goes out a bit more these days, that he is developing what is called in Tibetan writings a "mindful awareness"—the ability to see everything, not reject it. This same awareness extends to others' perceptions of his own work. "I think if someone looks at my work it thrills me if, nonstop, with no words said, endless amounts of words are said. It energizes that work into threads I've never thought about. That lets me have a bigger adult awareness."

I wondered how he felt, after all this time, to be on view—in a book, in a museum.

"What I am very concerned about is that people will say, 'You're categorized. You're catalogued. You do this kind of work or that kind of work.' I would prefer that none of that happened. I would prefer that they said, 'He works' or, 'This is his work.' The book will show that here is a person who has done obsessively his own work."

He thought a moment. He said, "People might walk out and say, 'He should have stuck with the gold boxes.' That's fine. Others will see the progression."

He had promised me that, in order for me to understand the nature of working with gold, we would make a gold ring together. And so we did, in the cubbyhole of his workshop, which is a room just off the great open space of his loft. And the whole time, I felt like the Sorcerer's Apprentice.

He wanted to show me the amount of physical work that is involved—the real effort on the arms to move the handle of a rolling mill; the timing of the blowtorch on gold, the drawing of the gold successively through dies, as the gold wire becomes finer and finer. He insisted that I put on a leather apron and dirty my hands on the charcoal as I prepared the gold by snipping it into fragments. It was pure gold. He had made the charcoal crucible from beech wood. He had bought the tree, had it quartered, contacted a furnace, had the furnace cook it. The gold melted in the indentation in the charcoal, puddling under the heat of the blowtorch, going golder, then fiercer orangy-red.

"I have never had any apprentices," Daniel said, busying himself behind me, making me hold the blowtorch. "We're going to melt this beyond melt. We're going to go beyond red hot to white hot."

We stirred the molten gold with a piece of wood ("just like the ancients might have done"), and then dunked it into water, quenched it, annealed it, and set it between two steel rollers in a rolling mill and rolled it flat. It was like making a superior 24-karat, museum-quality pasta.

Daniel became active again. "Run it through there. . . . Crank this down. . . . Put it in there again . . . and again. . . . This is a rolling mill. . . . It's getting harder . . . we're going to anneal it. . . . Heat it up . . . get it red hot. . . . Now quench! Quench! Dry it off. . . . Roll it again. . . . See how much softer it is?" We rolled it again, and it hardened again. "It's unfriendly. Heat it again. Quench. Now feel it—see, you've realigned the molecules in a friendlier state, so they're all in planes now. . . . Beautiful."

Heat, anneal, quench, roll again. Then repeat. We were at it for hours, just making this gold wire. All the while Daniel was talking about the precedents for what we were doing. "Gold was first worked in 3000 B.C. but the high point was Etruria, fifth century B.C. High Greek gold work appeared by the fourth century B.C. and it changed. It didn't become less beautiful. By the Byzantine it became less fanatically technical, at least in terms of the granulation. But, strangely, there was great granulation in Southeast Asia and in India."

The handles on the rolling mill became harder and harder to push, and it was like the most demanding exercise machine.

"I have done this for hours, just to build up my muscles," Daniel said.

Then we drew the gold through a die: inserting the end of it through a small hole in a piece of steel and pulling it to make it thinner. Every step of this goldsmithing was an echo of the past; it was the

simplest technology imaginable, depending upon strength and calculation and timing, and what was emerging was the loveliest, slenderest, most finely wrought piece of gold.

"You could draw this out to a mile," Daniel said. After four or five pulls through the die, Daniel said, "That's a nice size for a ring."

We shaped the ring, cut off the excess gold, heated the cut ends of the ring and watched the two ends glow, and, in a little moment of drama, the two cut ends bonded—met and married, without any sign that they had been separate. The ring was made.

"That's it," Daniel said. His face was radiant with the reflection of the fire and gold, and the pure joy of having made this lovely object. Then he said, "Craftsmanship becomes incredibly spiritual when it's all gone—transparent. When it's your heart that is pounding, out of its own need for survival, the piece happens. Your heart, your mind, your spirit—the beauty of the materials—it all comes together."

SATORI THROUGH ART

Donald Kuspit

> When you have satori you are able to reveal a palatial mansion made of
> precious stones on a single blade of grass; but when you have no satori,
> a palatial mansion itself is concealed behind a simple blade of grass.
> —*Zen Master*[1]

> Thus the miniscule, a narrow gate, opens up an entire world. The
> details of a thing can be the sign of a new world which . . . contains
> the attributes of greatness. Miniature is one of the refuges of greatness.
> —*Gaston Bachelard,* The Poetics of Space[2]

Daniel Brush makes small, precious, exquisitely nuanced objects, some ostensibly ornaments, all
"intimate sculptures," as they have been called. And that is just the point: the objects' intimacy, which is
a matter of scale as well as detail. Each object cries out to be held by a caring hand, as caring as the hand
that made it. And it demands that one fine-tune one's attention to its details. One cannot just take in one
of Brush's objects with a sweeping, instantaneous glance: one must attend to the minutiae of its making.
One must change the scale of one's perception to match the scale of its conception and to realize its
subtle grandeur. If, as the architect Mies van der Rohe suggested, the true test of a work of art is whether
"God" is in the details, then God seems to be in the details of Brush's objects. But if the sum of the
details must add up to a greater architectural whole—to a structure that reveals the greatness of God as
well as suggests intimacy with an indwelling God—then the architecture of Brush's objects is also divine.

The objects are paradoxical: made of precious materials, their value seems worldly, but they are otherworldly in import.

One remarkable example is *Second Dome* (see colorplates, number 48), a box of steel and granulated gold. It is, in Brush's words, "the second-largest granulated dome in history inlet into a steel cylinder"—a tour de force of 78,000 hand-fashioned, pearllike gold granules, hypnotically arranged in an age-old geometric pattern of curves, some concentric, some intersecting, thus creating a design at once symmetrical and asymmetrical. (Michelangelo made a design that is related in both its complexity and unity: an ancient symbol of the cosmos on the pavement of the Campidoglio, once the spiritual as well as political center of Rome.) Brush crowns the dome with what is in effect a gold lingam, surrounded by a circle of gold granules—a masculine center within a feminine one, that is, an apotheosis of the originary center.[3] The perfect circle, a quiet presence in the midst of the dynamic curves—the unmoved mover confirming the perfection of the whole structure—is at once their source and climax. They seem to emanate from it, as though the lingam were a stone thrown into a pool of liquid gold, which shattered into an infinity of particles that nonetheless cohered in ripples that echo the shape of the lingam. Everything leads to the central, unifying, navellike lingam, from the primitive zigzag pattern—deriving from archaic pottery[4]—that forms the base of the dome to the more sophisticated curvilinear pattern that forms its ribs. The overall structure is a macrocosm, the repetitive details form a microcosm, and the two become one at their center and apex, their convergence suggesting a kind of epiphany. The whole piece conveys ecstatic ascent to an absolute.

Brush's cosmic vessel is intensely erotic, by reason of the forceful "swerve" of the angles and curves on its surface. Their motion is ceaseless and excited and can be understood to signify the creative action of Venus, herself a symbol of the elemental spontaneity that flows through all things, as Lucretius argued in *De Rerum Natura*. Indeed, if we regard Brush's granules as atoms charged with erotic energy—Lucretius referred to his *minima*, or "least things," as *primordia, elementa*, or *semina* (seeds)—and the surface on which they move as a rendering of cosmic space, flattened like a map, then Brush can be said to have encoded the seminal moment of creativity, when Venus causes the seeds of being—elemental matter—to "deviate" in space and come together in a fundamental shape, that is, take their primitive place in a primitive pattern of being. In fact, the difference between the bright gold and the black band that forms the rim of the vessel—that separates the container from the dome that covers it—suggests the biblical moment when God divided the light from the dark, day from night, which is the originary moment of the world and a metaphor for enlightenment, or inner illumination.

What are we to make of this marvelous, consummate object? Its materials are not simply precious for the sake of preciousness; the temple of God must be adorned with the most precious materials in the world, as the Abbot Suger said, following the Bible.[5] Such materials are inherently beautiful and miraculous—enigmatic—they encapsulate the essence of creativity. Each one of Brush's granules of gold is such a precious essence. Pure gold embodies and affirms the sacredness of being; it is a traditionally sacred material—the materialization of the aura of God, as it were, the sun brought down to earth in as pure a material form as possible. Brush is an alchemist, distilling raw, impure *prima materia*—represented by steel—into refined *ultima materia*, traditionally represented by pure gold. Brush is the

Vulcan who, as Paracelsus described, by "the art of alchemy" is able "to carry to its end something that has not yet been completed." He is able to transmute the "original [profane] stuff" of being into its "final [sacred] state" of reality.

Brush has created a precious, splendid temple of God in miniature, as though that is the only way to preserve it (and the faith it represents) and the only authentic form it can have in a secular world. The temple has shrunk yet maintains its significance. Nothing really has been lost—nothing essential has changed: size has been sacrificed, but material richness has been gained, not in compensation but in confirmation. Meyer Schapiro has noted that "rapture of the eyes and heart" were "a formula of artistic power" in the Middle Ages, and sometimes they existed at the expense of "religious content or consequence," so that the "ornaments of the cathedral" became important for the "preciousness of the[ir] materials" and especially "the skill of the craftsmen" who made them. For Schapiro this "anticipates the future divergence of the status of artisanship and fine art," that is, the difference between a knowledgeable manipulator of materials and an artist who can make them resonate with a "fine" meaning (finer than they are). Brush's art reunites what modernity has torn asunder, the skill of the artisan and the vision of the artist—artisanship and fine art—and also aesthetic and religious experience. For him both are equally precious, and they converge in precious objects—ornaments whose material preciousness can reveal spiritual preciousness when they are finely made.[6] Thus, Brush's ornaments are sacred relics, that is, reminders of the sacred. Whatever is placed in his cosmic vessel—covered by its dome—becomes as holy and magical as its container, as fraught with cosmic significance.

The dome, as Ananda Coomaraswamy writes, represents the "palace" and "vehicle" of the gods, "the revolving universe."[7] It lays out the "abodes of cosmic order" and "measures out the chthonic regions" simultaneously and, as such, signifies "the act of creation." The dome is a mystical but precise structure, to be meditated upon (worship is a form of meditation) in order to understand the complexity, or dividedness, yet underlying and enduring unity of creation. It involves both primordial differentiation and the harmonious integration of differences—the establishing of boundaries and the maintenance of the overall structure that they define. In short, the dome is a symbol of transcendence, which involves, as Mircea Eliade writes, the ecstatic realization that there is more to the cosmos "than the little represented by man and his environment."[8]

The dome, by reason of its height, breadth, and circular shape—its grandeur in all directions—conveys the infinite "more" of the cosmos. Brush's ornamental object puts the height of the dome, indeed, puts the cosmos—puts transcendence—in our hands. It makes transcendental experience tangible—graspable and intimate—or at least enables us to "feel" the possibility of discovering a greater perspective on our existence than that afforded by our everyday environment and concerns. In short, the "intimate immensity" of Brush's object, to use Bachelard's term, "promotes us to the dignity of the admiring being."[9] We in effect hold the cosmos in our hands, supporting, admiring, and contemplating the subtlety, fineness, and grandeur of its creation.

The spiritual uniqueness and function of Brush's objects is made particularly clear by *Scholar's Table Piece* (99). Like all of Brush's pieces, it is meant to be held and touched: its perception is incomplete without

one's fingers sensing every nuance of its surface—in effect, ranging over its terrain. Indeed, it has the restless texture of a traditional Chinese landscape, full of complicated differences—contradictory forms— and overall harmony. It is like a meteor from an emotional world other than our own, at once more dramatic and more intimate—utterly uncanny and strange yet peculiarly touching. It is in perpetual, indeed, vehement flux, however self-contained. And yet, for all its resemblance to a traditional Chinese scholar's table piece, Brush's table piece is radically different. The difference takes us to the heart of Brush's art, disclosing its intention with a vengeance.

As Eliade tells us, the fashion for such table pieces developed among Chinese intellectuals in the seventeenth century.[10] The pieces were ambiguous or, as Eliade says, "confused or contradictory" in character: they conveyed both "the sacrality of nature" and its "desacralization." They embodied "the memory of a debased religious experience" of nature. That is, what was once a religious experience has become "debased" because nature no longer seems sacred, even as it retains, in memory, an aura of sanctity. They were meant only for aesthetic contemplation, but, according to Eliade, " 'esthetic contemplation' still retains an aura of religious prestige" in the Far East. The "religious dimension" could not be expunged, however much the pieces were meant to be an objective correlative for a purely "esthetic emotion," compensation, as it were, for a detached, scientific attitude to nature. The pieces were paradoxical: they signified a certain disillusionment with nature, even as they created an aesthetic illusion of it, which retained religious resonance in that it conveyed what was supposedly the illusion of the sacred.

Seventeenth-century Chinese scholar's table pieces were initially "gardens in pottery bowls. . . . The bowls were filled with water, out of which rose a few stones bearing dwarf trees, flowers, and often miniature models of houses, pagodas, and human figures; they were called 'Miniature Mountains' . . . and 'Artificial Mountains.' These names suggest a cosmological signification; for . . . the mountain is a symbol of the universe." They were "mystical" in import, as Eliade writes: "The mountain in the midst of the sea symbolized the Isles of the Blessed, a sort of Paradise in which the Taoist Immortals lived." The table pieces were thus "*a world apart*, a world in miniature, which the scholar set up in his house in order to partake in its concentrated mystical forces, *in order, through meditation, to re-establish harmony with the world*." It was in effect a "secret [mental] retreat," as the caves and grottoes that ornamented the mountain suggested. They are "dwellings of the Taoist Immortals and places of initiation. They represent a paradisiacal world and hence are difficult to enter," and as such are symbols of the "narrow gate." In other words, the scholar's table piece represents "*the perfect place,* combining *completeness* (mountain and water) with *solitude*." It may have been the scholar's way of privileging himself, more particularly, of sublimating his sense of isolation and difference, thus making the best of them.

Now Eliade's point is that this aestheticization of nature desacralized it, however much the artistic illusion of nature that resulted remained spiritually evocative. Moreover, when the locus of the sacred became art rather than nature—when art came to seem more perfect than nature—the sacred as such became less convincing. It became a theory rather than a conviction—a speculative idea rather than a spontaneous feeling—a subjective illusion rather than an objective truth of being. It lost its innocence, as it were, and became an epistemological problem. Thus, while the "sanctity of the closed world is still discernible" in the scholar's table piece, it is not exactly a "cosmic hierophany."

But the most crucial difference between the religiously "privileged space" of nature and the aesthetically privileged space of the scholar's table piece is that nature reveals "the mysteries of life and cosmic fecundity" while the symbolic nature of the scholar's piece—miniaturized, aestheticized—is sterile. To aestheticize nature, however unwittingly, is to strip it of its fecundity, which is to strip it of its mystery. In short, to conceive of nature aesthetically, as the seventeenth-century Chinese scholar did, is to devitalize and desexualize it. The scholar's table piece is an elegant, static icon rather than an evocative description of the inner dynamics of nature. It civilizes nature, and thus mutes its cosmic, originary character. The table piece affords a certain autonomy, but it is has lost contact with the primordial.

Brush's *Scholar's Table Piece* is quite different—much more evocative, indeed, provocative, as though the artist wanted to raise nature from its aesthetic tomb. Brush's Miniature Mountain is as far removed from the aesthetically blessed nature of the seventeenth-century scholar's table piece as it is possible to be. Nature has changed a good deal since the seventeenth century, which was when its modern exploitation began. It has lost its enchantment—a vestige of religious value, as Eliade suggests—although we are not entirely indifferent to its "charm" or "magic." We no longer metaphysicalize nature—it has become too physical for that—but we still, with a kind of vulgar sensitivity, acknowledge its majesty. We think we have the cosmos at our technological fingertips, and so we need do no more than tip our social hat to its grandeur. Nature is no longer mysterious, but it remains intriguing enough—we subliminally recognize that we originate in it and remain part of it, however much it becomes ghettoized in national parks. They may seem at first to be a refuge from the world, but they are simply a slice of natural life, socially zoned and appropriated as a leisure-time memento mori. They exist on the horizon of the world rather than in the sky beyond its horizon.

The *Scholar's Table Piece* presents a more dynamic, compact, double-edged nature—nature in a pressure cooker—than appears in either the seventeenth-century miniature gardens or our own ecological ghettos. It is a nature that has been abused almost beyond endurance—it is no longer even conceivable as a paradise. Brush's piece embodies this devastation; at the same time, it offers a radically elemental and thus peculiarly fresh nature: the *Scholar's Table Piece* is an image of raw magma, erupting and burying civilization in a torrid, erratic flow of raw energy. In Brush's piece, nature is both a flaming pyre and the phoenix reborn from the flames: his singular object-image—at once a chunk of nature and a fantasy of it—conveys a sense of apocalypse and resurrection, both equally explosive. There are no little models of houses and human figures—signs of civilization—such as appear in the seventeenth-century scholar's table piece. Nor are there any pseudo-pristine specimens of nature—nature under scientific wraps, grown like a culture in a petri dish—such as we preserve in national parks. Instead, Brush renders primordial nature in upheaval—nature as it existed before civilization and as it will exist after it—nature that overwhelms and has never been overwhelmed by civilization. In a society with little or no sense of the sacred, Brush reconsecrates nature by conceiving it in all its primordial vigor. He offers an expressionist vision of nature, implicitly as an antidote to the scientific vision of it—a sacramental vision, which brings together two mainstays of expressionism, awareness of man-made apocalypse and refuge from it in liberated instinct.

But the *Scholar's Table Piece* is not simply an expressionist tour de force. It is a vision of nature, but also a vision of enlightenment: for Brush, primordial cosmic nature is a vehicle of enlightenment, not an

end in itself. One can only "recognize," intuitively, the cosmic, primordial character of nature—grasp its "suchness," as the Zen Buddhists call it, or fundamental concreteness—after one has experienced enlightenment, gone through the terror of becoming enlightened. D. T. Suzuki writes that "the essence of Zen Buddhism consists in acquiring a new viewpoint on life and things generally." Brush's object-image embodies this new viewpoint, and the sense of freshness and depth that follow from it.[11] Its expressionism—primordialism—makes more than one spiritual point: the "acquirement of a new point of view" is "really and naturally the greatest mental cataclysm one can go through with in life," and Brush's piece represents this cataclysm—a major spiritual change in attitude and orientation to life. Indeed, the language with which Suzuki describes it can be applied to Brush's piece: "It is no easy task, it is a kind of fiery baptism, and one has to go through the storm, the earthquake, the overthrowing of the mountains, and the breaking in pieces of the rocks." This is exactly what one sees in Brush's visionary work—the overthrowing of the mountains, a fiery baptism—an existential earthquake, the breaking in pieces of the rocks of ordinary reality. Brush condenses the moment of psychic transformation and the new sense of concreteness that results from it in a single, paradoxical, exclamatory object-image. Brush's piece is thus a special kind of Zen koan—a visual catalyst and embodiment of spiritual revolution. It conveys the "abrupt experience of satori," which "opens up in one moment an altogether new vista," as well as the vista itself—"the whole [of] existence" as it is "appraised from quite a new angle of observation." It is necessarily "expressionistic," for it is a basic expression of a basic change in being, more particularly, a sea change in the sense of what it means to be a subject and what it means to be objective.

As Suzuki says, "A koan is generally some statement made by an old Zen master, or some answer of his given to a questioner," who is "uninitiated." The answer seems absurd in contrast to the apparently rational question, but the effect of the answer is to put rationality itself in doubt. The purpose of the koan is "to make the calculating mind die, . . . to go beyond the limits of intellection" by exhausting it. "Logic then turns into psychology, intellection into connation and intuition. What could not be solved on the plane of empirical consciousness is now transferred to the deeper recesses of the mind." This traditional exercise of question and answer—of laborious inquiry and sudden enlightenment—has been codified, and become standard practice. Brush revitalizes it—restores its essential idiosyncracy and expressiveness—by giving it intense, dramatic visual form, thus renewing and strengthening its original sense of purpose. His *Scholar's Table Piece* seems to penetrate and picture the deeper recesses of the mind. It articulates the spontaneity that transcends calculation and the mental depth beyond empirical consciousness.

Perhaps nowhere is the Zen import of Brush's art—its character as a fresh, unique embodiment of the difficult, dramatic process of enlightenment—more self-evident than in his paintings. They are an ironic dialogue of question and answer: a seemingly irrational gesture—the koan—is put on the empirical space of the canvas, dramatically changing our consciousness of it. The space turns inside out: a finite surface becomes an infinite depth, emblematic of the secret recesses of the mind. The blank space seems to question the spontaneous gesture, but the gesture brings the space into question. Losing its objective character, the space becomes as subjectively resonant as the gesture, however different in character. The painting becomes a spiritual epiphany—a magical union of gesture and space. One has a new, enlightened experience of painting and, with that, of the self.

Brush himself is aware of the Zen character of his paintings. It seems no accident that he calls them Koald Paintings, as though in oblique allusion to *koan*. (The preparatory drawings are called Cantos, invoking another spiritual poet.) As Jane Livingston writes, paraphrasing Brush, they have "nothing to do with composing or planning forms on a pictorial field."[12] They are "devoid of both representationalism and 'abstract values.' . . . Nor can one exercise usual aesthetic faculties in the sense of delectation." While they involve "systematically applying line after line onto canvas after canvas, with of course certain parameters—the one particular color for each canvas, the size of the color, the distance between lines—determined in advance," they represent "the artist's state of mind as he works within those parameters." Thus, the paintings are never exactly the same. "If the length of each line on a canvas is fairly uniform from left to right throughout the work, it might indicate a fairly even temperamental and physical rhythm during its execution; if there is extreme erraticism in the length of the lines, some other state—a positive, freed, exploratory mood, or contrarily a disturbed and anxious one—might be postulated." Brush's paintings are thus a form of self-inquiry as well as self-expression. They also indicate a struggle for self-control: what looks like obsession—compulsive repetition—is spiritual discipline. Repeating the lines is not unlike repeating a mantra—a way of achieving, as Brush says, "the state that in Zen philosophy is called 'no mind.'" Indeed, Brush makes the paintings in such a state: "holding his breath with each stroke, he begins each line immediately under its predecessor, scribbling with the pen along the straight edge to the right, and lifting the pen (and ending the line) unpremeditatedly with the end of his breath."[13] A Buddhist breathing exercise—a kind of meditation on breathing, so fundamental to human being—becomes a painting technique.

Thus, the "utterly concrete" and momentary character of the paintings, which are "without much visual or metaphoric incident," convey, indeed become, a form of Zen "suchness—a grand affirmation" of being.[14] They embody the primary concepts of Zen, which are, in Suzuki's listing, irrationality, intuitive insight, authoritativeness, affirmation, sense of the beyond, impersonal tone, feeling of exaltation, and momentariness. Brush is not simply trying to be personally expressive; his paintings are impersonal seismographs registering the "impulses," or spontaneity, of the deeper recess of his mind. This explains what to me is their most remarkable Zen quality, what the Buddhists call "*kshanti*, 'patience,' or more properly 'acceptance,' that is, acceptance of things in their suprarelative or transcendental aspect where no dualism of whatever sort avails."[15] And acceptance, also, of whatever comes along mentally: Brush is practicing acceptance, when he accepts both the even and erratic lines, the good and bad moods, that may come along in the course of painting—accepts whatever is idiosyncratic in his identity. The paintings show Brush "wondering/wandering," to use his own language, show him "in a mirrorless room reflecting my self." They are a "quest for enlightenment," and as "saturated [with] innocence . . . [as] unworldly and majestic"as the jewels he uses.

Brush, then, is ultimately concerned with the state of his soul, and it is the soul that is represented by the butterfly that appears in many of his works. Sometimes it is alone, sometimes it multiplies extravagantly, forming a virtual cosmos of butterflies. The butterfly is an ancient symbol of the soul, and the golden butterfly signifies an enlightened soul—the soul that has been illuminated and thus has become sacred, that is, saved. In one work, a cluster of large golden butterflies rest on the rim of a kind

of chalice, whose cover is a miniature dome. In another, giant golden butterflies perch on a black Artificial Mountain, dwarfing it. In yet another, two golden butterflies perch on a kind of nest, with a narrow opening suggesting the "narrow gate" to paradise. Brush also serves up a kind of dish of golden butterflies, and a whole magic mountain of them. Other exotic creatures appear in some works—a flamingo in one, a bee in another—but the spiritual meaning is the same. Similarly, the cosmic geometry reappears, sometimes as the mystery revealed when one opens the vessel, sometimes latent in the eccentric mosaic pattern that covers its surface.

I have already noted the interweaving of and gnostic tension between soft luminous gold and hard black steel surface in Brush's work, perhaps its most prominent feature.[16] Their dramatic contrast is evident in many vessels—the eccentric terrain of one startling pitch-black vessel is draped in what are in effect dazzling gold, jeweled necklaces—and seems particularly intense in some of the butterfly works and scholar's table pieces, as well as in a number of works in which gold seems to grow like an embryo—the amorphous larval state of the butterfly?—in a black womb. But it is also evident in Brush's geomorphic sculptures, resembling those of Brancusi in their combination of raw base, intermediate structure, and polished higher element. The relationship between the parts changes, as does the size, texture, and coloration of each part—they are like stops on an organ, which Brush plays with a virtuoso combination of abandon and precision—but each totemic sculpture as a whole is a tense unity of highly finished form and elusive formlessness, awesome gold and ominous black, the numinous and the phenomenal. Of all Brush's works these seem to best exemplify his assertion, "I find the spirit only in the elliptical paths of confusion." These elliptical paths—the ellipse is a self-contradictory, unstable, paradoxical geometrical figure, for it combines centralizing and axial features—are startlingly evident in the black, labyrinthine strata of many of the surfaces, on which an unexpected glint of gold suddenly appears, like a perfect pearl in a misshapen oyster: a metaphor of satori in action.

At the same time, Brush's intricate, irregular, bravura surfaces, as well as his ingenious play with concavity and convexity—his endlessly elliptical paths of confusion and fusion—suggest a mannerist outlook. It is this that also makes them quintessentially, if perhaps reluctantly, modern. Arnold Hauser remarks that "a certain piquancy, a predilection for the subtle, the strange, the over-strained, the abstruse and yet stimulating, the pungent, the bold, and the challenging, are characteristic of manneristic art."[17] Every one of these terms can apply to Brush's Zen terrain—his sense of suchness—and the object-images in general. Particularly fitting is *piquancy*, which Hauser describes as "a playful or compulsive deviation from the normal, an affected, frisky," and sometimes "tormented" quality. Indeed, mannerism "emphasize[s] the tension between conflicting stylistic elements," a conflict that "expresses the conflict of life itself and the ambivalence of all human attitudes . . . the permanent ambiguity of all things," which "finds its purest and most striking expression in paradox," and Brush's intimate sculptures are pure paradox. Brush may thus be more mannerist than modernist, for mannerist "paradoxical form" offers a semblance of integration—a *discordia concors*—while, in modernism, paradoxical form weighs more heavily toward discord than concord; indeed, reconciliation is rarely in sight.

Zen Buddhism, and the koan in particular, are also mannerist, as Suzuki suggests in his emphasis on the transcendence of dualism—a transcendence that does not so much abandon opposites

(conflict) or find some resemblance between them as join them without denying their difference and separateness, which affords a new outlook on them. The master and the uninitiated are initially in conflict—the one seems absurd, the other naively rational—yet they eventually understand each other, and converge toward the same goal. Each has to find a way through the gate; it may always be narrow, but it is never the same for anyone. In one ingenious work by Brush, a cosmic globe, idiosyncratically patterned, rests on a gold leaf, as though on an open palm. The two images seem irreconcilable, but they are both golden, however much the globe is crisscrossed by black hatching.

I want to conclude with a word about Daniel Brush's truly astonishing workmanship, about which a good deal has been written, by Brush and others. It has been what is most admired about his art—such craft is extremely rare in modern art—but I think its spiritual character has not been fully appreciated. Brush is a perfectionist; he demands unconditional surrender from his materials and persistence from himself. "I carve steel like wood. I use hammers and chisels of my own making; and, they are tempered in virgin olive oil. . . . Every three hammer blows, the chisel breaks. I sharpen the tools thousands of times." He has a sensuous feel for material as well as tools. "I once bought one hundred ounces of gold and dug my fingers into it." He is as attentive to the details of technique as he is to the details of the object he is making, as his description of the creation of *Second Dome* indicates. *Second Dome* took more than six hundred hours to produce—a sublime amount of time to make a sublime object. But it took two years from the initial preparation of the granules before he had the courage to take the final step, to make "the damned thing fuse with perfect tangential fusion and perfect clarity around all of the spheres." For he "had one chance at about thirty seconds" to succeed, and he did, in one deft act.

All of this suggests a sophisticated master craftsman, aware of the peculiarities of his materials, the possibilities of his tools, and the creative risks he is taking. But, as Brush says, "It took [me] fifteen years to stop thinking like a modern goldsmith when trying to do ancient technology." Eliade writes that, for its ancient practitioners, "smelting represents a sacred sexual union, a sacred marriage . . . the mixture of 'male' and 'female'" materials and procedures, and the connection of "fire and fusion with the sex act."[18] Brush is speaking the language of ancient technology when he says that "progressive die sinking with wood, leather, rubber, and, finally, steel male forces was applied." Brush's art keeps alive these ancient connotations as well as ancient techniques, however refined by modern instruments.

Similarly, Brush compares the connoisseurship of his works to "Japanese blade connoisseurship," which also points to their sacred meaning. "In Japan," Coomaraswamy writes, "the sword is . . . 'derived' from an archetypal lightning. . . . The Japanese sword . . . is in fact the descendant or hypostasis . . . of the sword of lightning found by Susa-no-Wo-no-Mikoto . . . the 'Shinto Indra,' in the tail of the Dragon of the Clouds whom he slays and dissevers, receiving in return the last of the daughters of the Earth."[19] All of this may seem like far-fetched myth to our modern ears, and rather remote from Brush's intimate sculptures, but in fact such myths of sacred origins and heroes are the works' substratum, giving them a meaningfulness beyond their materiality. Their integration of craft and spirituality—their restoration of the spiritual meaning of craft—is a crucial part of their artistry. The rugged expressive terrain of Brush's archetypal mountains even looks like a series of lightning flashes, reminding us of primordial creation. Like

the Japanese sword, Brush's lightning terrain concentrates cosmic power in itself. Brush is a Prometheus, stealing lightning from the gods to make objects as miraculous as they are. Moreover, while today a *connoisseur* is someone who can distinguish special objects from the mass of things—find the proverbial needle of the unusual in the haystack of the usual—the term originally referred to an initiate in a mystery, one who *"knows . . . the mysteries,"* as Eliade says, who "has had revelations that are metaphysical in nature."[20] Something of this clings to the modern meaning of connoisseurship: to pick out and appreciate the one from the many—to have a sense that certain things are imbued with mystery—is to realize that there are metaphysical mysteries among the physical commonplaces.

Brush's golden temple is a sacred space, where time stops and "communication with heaven" is established, and as such it is the "navel of the earth" or the "Center of the World."[21] If, as Eliade writes, "every religious man places himself at the Center of the World,"[22] then Brush is a religious man, and his intimate sculptures are sacred objects. His Miniature Mountains reflect the religious man's "desire to live in a pure and holy cosmos, as it was in the beginning, when it came fresh from the Creator's hands." For him, as for ancient technology, metallurgy is a "ritual purification . . . the sins and faults of the individual and of the community as a whole are annulled, *consumed as by fire.*"[23]

The scrupulous care with which Brush's works are made, his intense investment in them, the way they are presented as objects to be venerated—the ornaments are displayed in specially made cases, as one of a kind and refined as they are—confirms their transcendental character. It may seem that I am overstating my case, out of my own wish to restore a sense of the sacred in a profane world, and to find a contemporary sacred art among so much profane art. It may seem that I am investing Brush's objects with more meaning than they deserve, and thus overestimating their importance, but to do anything less is to sell their beauty short, and especially to miss the point of their inner sublimity, that is, their intimate immensity.

Notes

1. Quoted by D. T. Suzuki, *Zen Buddhism* (Garden City, NY: Doubleday, 1956), 108.

2. Gaston Bachelard, *The Poetics of Space* (Boston: Beacon, 1969), 155.

3. Peter Webb, in *The Erotic Arts* (New York: Farrar, Straus & Giroux, 1983), 75, points out that, in Hindu religion, lingams are "metaphors for the root of the world, and perfect objects of worship. Since creation involves a female aspect as well as a male aspect, one can revere the female emblem as well as the male." Thus the most common image is "the combined form of lingam and yoni [vulva]," that is, a "round-topped" form in a "shallow circular" form, which is what we find on Brush's dome. "For the Hindu, worship of the source of creation [symbolized by the lingam] is a sure way to enlightenment."

4. Brush is acutely aware of the archaic sources of his art—of its continuity with ancient tradition. His model, technically speaking, for the *Second Dome* is an Etruscan pot, less than seven inches in height—a miniature—with 137,000 granules attached to its surface. Granulation, as he comments, was used by almost every ancient culture—Egypt, Syria, Crete, Persia, Greece, Rome—but the Etruscans brought it to perfection. Using the file, they were able to make the finest particles—so-called dust granulation—sometimes less than .014 millimeters in circumference. Brush's jewelry also owes a debt to ancient and especially Etruscan jewelry, both in its design and method. Brush notes that he is technologically more sophisticated than Etruscans, who had only charcoal and blow pipes, while he has a blowtorch, as well as nineteenth-century ornamental turning lathes. He in fact has the largest collection of such lathes, which represent the research and fine workmanship that inform his visionary art, and that also, in their own way, have a spiritual character.

5. Meyer Schapiro, "On the Aesthetic Attitude in Romanesque Art" (1947), *Romanesque Art, Selected Papers* (New York: George Braziller, 1977), 1:14, writes that for Suger "the enchantment of the beautiful building [the new church of St. Denis], with its incomparable treasure of precious stones, dispose[d] him to a high mood of spiritual contemplation."

6. Shapiro 1:14; Ananda K. Coomaraswamy, in "Ornament," *Traditional Art and Symbolism, Selected Papers* (Princeton: Princeton University Press, 1997), 1:244, states that traditionally an ornament furnished something "essential to the validity of whatever is 'adorned,' or enhances its effect, empowering it." As he writes, "jewels are not ends in themselves but enhance the efficacy of the person that wears them. Ornaments are the necessary accidents of essence, whether artificial or natural." Or, as he also writes (p. 245), "the values of jewelry were not originally those of vain adornment in any culture, but rather metaphysical or magical." Thus the Vedic "Brhaspati wears a jewel, or let us say a talisman, 'in order to have power.'" Indeed, the jewel was a way of "glorifying" or "magnifying" himself, that is, "strengthening" and "nourishing" his being. It is only in our secular society, where we have come to think of a "decoration" as an "empty honor"—but we still speak respectfully of "decorating" a hero with a medal—that "it takes on purely aesthetic values," that is, becomes merely "fashionable."

7. Coomaraswamy, "Symbolism of the Dome," *Traditional Art and Symbolism*, 416.

8. Mircea Eliade, *The Sacred and the Profane* (New York: Harper & Row, 1961), 118.

9. Bachelard, 183–84.

10. Eliade, 154. This and all subsequent Eliade quotations are from his chapter "The Sacredness of Nature and Cosmic Religion" unless otherwise noted.

11. Suzuki, 83. All subsequent Suzuki quotations are from this book.

12. Jane Livingston, *Five Washington Artists* (Washington, D. C.: Corcoran Gallery, 1976).

13. David Tannous, "Daniel Brush at Fendrick," *Art in America* (May 1980): 157.

14. Suzuki, 83.

15. Ibid.

16. In alchemical fashion, the opposition of pure luminous gold and other, impure materials—all implicitly as dark as earth—can be conceived in metamorphic terms. As Mircea Eliade writes in *The Forge and the Crucible* (London: Rider, 1962), p. 50: "The peasants of Tonkin [China] have a saying: 'Black bronze is the mother of gold.' Gold is engendered naturally by bronze. But this transmutation can materialize only if the bronze has lain a sufficiently long period in the bosom of the earth." A Western alchemist writes: "Nature would always complete what she wished to produce. . . . That is why we have to look upon the births of imperfect metals as we would on abortions and freaks. . . . Although she wishes to produce only one metal, she finds herself constrained to create several. Gold and only gold is the child of her desires. Gold is her legitimate son because only gold is a genuine production of her efforts." Eliade (pp. 51–52) comments: "The 'nobility' of gold is the fruit [of nature] at its most mature; the other metals are 'common' because they are crude; 'not ripe.' In other words, Nature's final goal is the completion of the mineral kingdom, its ultimate 'maturation.' The natural transmutation of metals into gold is inscribed in their destiny. The tendency of Nature is to perfection. But since gold is the bearer of a higher spiritual symbolism ('Gold is immortality,' say the Indian texts repeatedly), it is obvious that a new idea is coming into being: the idea of the part assumed by the alchemist as the brotherly saviour of Nature. He assists Nature to fulfill her final goal, to attain her 'ideal,' which is the perfection of its progeny—be it mineral, animal or human—to its supreme ripening, which is absolute immortality and liberty (gold being the symbol of sovereignty and autonomy)."

17. Arnold Hauser, *Mannerism: The Crisis of the Renaissance and the Origin of Modern Art* (London: Routledge & Kegan Paul, 1965), 12.

18. Eliade, *The Forge and the Crucible*, 60.

19. Coomaraswamy, 434.

20. Eliade, *The Sacred and the Profane*, 188.

21. Ibid., 37–38.

22. Ibid., 65.

23. Ibid., 79.

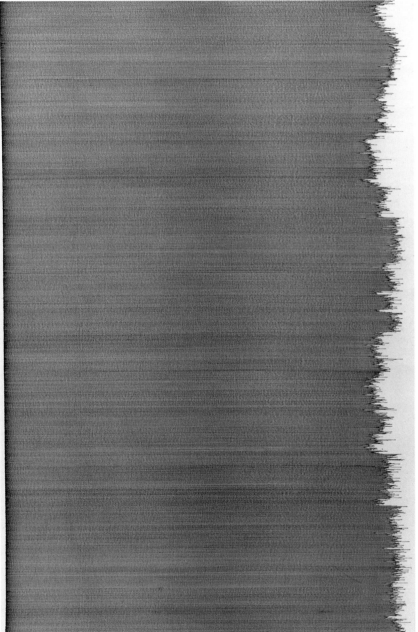

Blood-Bird

Third Finger Muse, Facing Scorpions and Fools

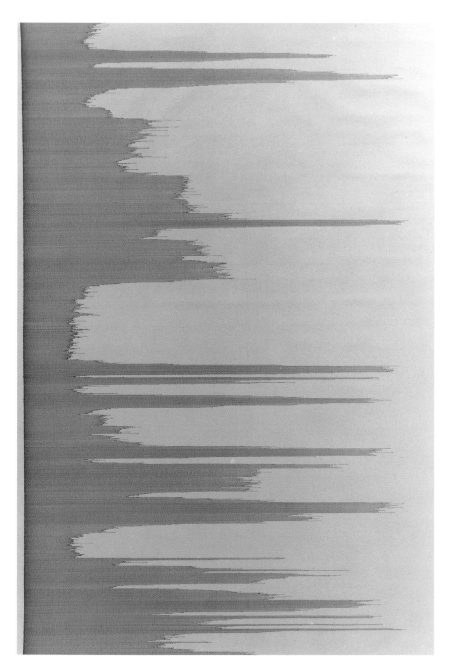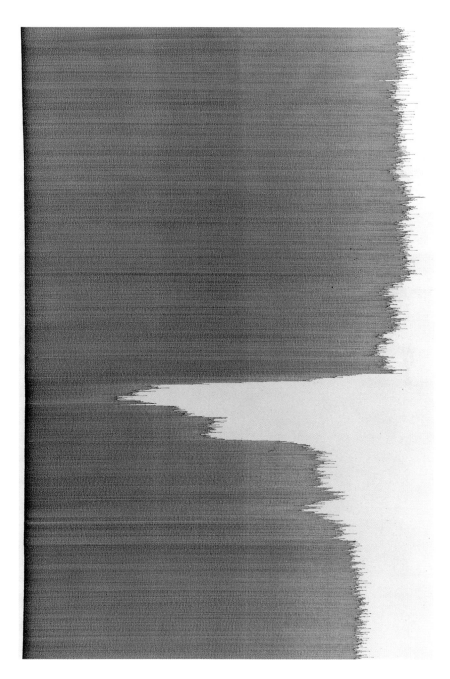

Wondering/Wandering with Polyhymnia's Sound *Pan(ic)'s Japa*

Koald Paintings: 1973 to 1997

1. *Pisces Begins to Become Clear*
2. *With the Smell for 8 1/2 Years*
3. *Butte*
4. *Black Waves*
5. *Frozen Poems*
6. *Cows and Women*
7. *African Violet*
8. *1967*
9. *Pisgah*
10. *Twelve Years without Delphine*
11. *Dead Orchid*
12. *Without Mirrors*
13. *My Penumbra*
14. *Livia's Umbra*
15. *Tongues*
16. *The Scrupulously Delicate Smile of Jim*
17. *Four O'Clock Rose*
18. *Pumping Circus*
19. *Lateef*
20. *In the Rock I Saw a Seal*
21. *Out of Umber, A Moist Breath*
22. *Black Tulip*
23. *In a Garden of Damp Grey, Gray*
24. *Upright in the Wind*
25. *Blossom of Fire*
26. *(After Wright) My Bones Have Turned to Dark Emeralds*
27. *Five Sprouted Breaths*
28. *Shadow Side of Shepp*
29. *Blind Voice*
30. *Warm Skin for the Gods*
31. *Voice Shadow*
32. *A Breath for Roethke*
33. *All in Their Place, Those Writhing Leaves, and Again Cold*
34. *Sitting Still with Running Water*
35. *I Remember with Stones*
36. *Alone, Whispering Your Song*
37. *White Mirrors, Hands of Water*
38. *Mask for a Blind Man*
39. *Blood-Bird*
40. *Dream for ISE*
41. *Alford Breeze*
42. *Dream without Voices*
43. *Tears for a Purple Martin*
44. *Down River with the Sun*
45. *Külm*
46. *Father, Father, Keep the Rocks from Heaving*
47. *Judah Löw, Sa'Ham*
48. *Sitting, Standing, Drifting*
49. *Valge öö*
50. *Mute Kachina/Hand Echoes*
51. *Mantle for an Estonian Spirit*
52. *(From the Hospice) The Great Mountain*
53. *With One Blink This (Green) Room Placidly Sighs*
54. *A Man/Lucent Fingernails/A God*
55. *Whose Heart on the Carved Saarde?*
56. *Reflections of Jewels and a Grass-Mowing Sword*
57. *Moments Before Dhurna—Hours/Noons*
58. *Third Finger Muse, Facing Scorpions and Fools*
59. *Wondering/Wandering with Polyhymnia's Sound*
60. *Pan(ic)'s Japa*
61. *Gamn/Without Questions*
62. *So Arioso, Syrinx, Pulsing Loode Sterre*
63. *Synchronal Pyrrhic/Breathing Alcaeus' Breath*
64. *Bread and Wine from the Horse's Fountain*
65. *TI-M/Wordless Murmurs*
66. *Visional Shrill (Berceuse), Half Brother of a God's Son*
67. *Kamm-Enal—Speeding to Collect Cool Winds*
68. *Ever Jyotih*
69. *Amárantos-Nada*

MUSINGS

Conversations between
David Bennett and
Daniel Brush

About five years ago I was introduced to Daniel Brush in New York by a mutual friend, Eric Nussbaum, the curator of the Cartier Collection. I knew that Daniel and I shared an academic background in philosophy, and I had heard of his unique skills as a goldsmith; otherwise his work was unknown to me.

I was not prepared, therefore, for the response his sculptures would provoke from me. These works are profoundly challenging and enigmatically beautiful objects of extraordinary immediacy and power. Quite simply, I became confused, but gradually I began to draw parallels with my own studies in the labyrinth of the hermetic tradition.

Daniel and I began to explore his ideas and my own at his loft in New York, by telephone from Geneva to New York, once by cellular phone from the Pantheon in Rome, and often at my house in Burgundy over a game of boules.

David Bennett, *Geneva*

We have spoken on many occasions of both the Western and Eastern traditions. Central to both is the image of the warrior—the hero who determines to stand against the flow, sword in hand, gaining courage to pass to the far bank. It is this notion of the virile, *in the truest sense, that seems to me embodied in your sculptures. Esoterically, in the Western tradition, iron, and more specifically steel—iron forged in fire through water— once grasped, represents this fundamental vertical aspect in the human soul. The sculptures speak to me*

eloquently of the struggle toward a lived realization, toward its highest aspiration, which is traditionally represented by gold.

What interests me is the genesis of this upward movement—expressed in the early sculptures—which may be seen as the soul beginning its journey on the Road of Return.

The "scene" filled my mind in the late sixties: stories of the Cedar Bar polemics, the Namuth photographs, the ever-increasing size of the canvases, the "downtown spaces," the illegal industrial lofts, and New York itself. Merce Cunningham, Pop Art, Kabalistic mysticism, the war, consumer culture were all rhythms as strong as Leni Riefenstahl's underlying beat. It was intoxicatingly romantic to be a part of it all. However, the "nonlectures" of E. E. Cummings, Rilke's letters, Suzuki's lectures on Zen Buddhism, Balanchine's choreographed Jewels, and the transliterations of Zeami's plays and writing on the Noh theater pointed me away from it all. Why did Toshiro Mifune's yell scare me? Was it the *anticipation* of his sound that sent the chills? I don't clearly know why I felt close to the excruciatingly subtle gesture in a Yamabushi mask. Perhaps it was the legend that a Yamabushi could be either male or female, of undiscernable age, and that these ascetics lived totally apart on the mountains with their eyes ablaze in the difficult quest for enlightenment. By the mid-seventies I found myself totally apart, my paintings unrelated to a movement, with few interactions, lonely, reflecting and accepting every nuance of my voice. My mind was confused and on fire, a totally uncontrolled fire, looking for the "quenching" of enlightenment.

Level Five for a Noh theater actor describes The Art of Versatility and Precision. It is generally characterized by the ability "to describe the clouds on the mountains." The precision and extreme difficulty of gold granulation took my mind off the paintings. It was a path that I could follow in a linear way instead of the ever-increasingly elliptical confusions on canvas. Every day I scheduled time to learn to speak the language of a goldsmith. In short order, I had worked through ten years, one hundred ounces of gold, and more confusions as I became obsessed with "describing with ultimate precision every cloud." I could make virtually every archaeological example extant but had not yet composed my own intuitive phrase. With this realization (your reference to gaining courage), I pressed into work that would be, by its very nature, assiduously laborious, technically uncharted—in essence, work that contained jeopardy. At every step, all the previous work, whether it required one day or one thousand hours to complete, would be in a position of peril if my nerve was lost. I deliberately worked this way for ten more years, training myself to *obviate the need* for courage. Within the notion of the *heroic sublime* is the Name Saying Place. I think it is a disarmingly subtle place, arrived at with no warning. Yet, in an instant, a recognition that passes as quickly as it is had reminds of the difficult journey in preparation.

The early sculptures were my nerves exposed, speaking with a quiet, ferocious whisper, leaving all my ego behind and stretching for a deeper level of understanding.

Once the precise path has been chosen, there can be no turning back without encountering the greatest danger; the sword, once withdrawn from the stone, cannot be returned. And this realization gives rise to

periods of great anguish and tension that are, I think, in their core intensely creative and productive. Can you relate your work to these battles?

I will give you an indication of the precise path that was required to make the second-largest granulated dome in history, later inlet into a steel cylinder:

A high-chromium steel billet was machined with progressive hemispheres ranging from five inches down to the dome's finished maximum width of three inches. The concavities were polished with ceramic forms and micron diamond powder.

The gold alloy was determined and tests were conducted that arrived at 22.75 percent gold with .9999999-test copper purity added along with silver of .999 fine.

The pickled alloy was hand hammered and continuously annealed to a finished thickness of .022 of an inch, with a plus-or-minus tolerance to the sheet of .001 of an inch.

Progressive die-sinking with wood, leather, rubber, and, finally, steel male forces were applied to press the gold sheet into the prepared female mold for the dome. Care was taken to have the correct radius to the uppermost edge of the die to facilitate the removal of the gold sheet.

The dome was filled with rotten stone and burnished until all crystalline imperfections were removed. The finish reflectivity was achieved with polished steel balls and checked in reference to a surface gradient scale.

The dome was depletion gilded fifty times in nitric acid and subsequently fire gilded and quenched twenty times in distilled water.

All granules were ground in an orbital grinding device and graded through specially prepared sieves until uniformity was achieved with a plus or minus tolerance of .0001 of an inch. The granules used were .008 of an inch of 22.5 percent gold and were flashed with cupric oxides.

Using a two-haired sable brush dipped in one part gum tragacanth to twenty parts water, 78,000 granules were placed on the surface of the dome, taking care not to get any of the adhesive on the unwanted polished surface.

Under forty-power surgical binoculars, the granules were placed in *polviscolo* fashion onto the surface of the dome over a period of two months.

At this point I had spent approximately six hundred hours on the piece.

A charcoal brazier was filled with specially prepared beech charcoal, and a foot-operated bellows with an omni-directional orifice was built and attached.

The dome, with 78,000 gold granules, was elevated into position and muffled with sifted and graded charcoal powder and reflectors of pure gold.

I lost my nerve, knowing that I had one chance, at about thirty seconds, to have the damned thing fuse with perfect tangential fusion and perfect clarity around all of the spheres. I let the preparation sit for two years.

It stared back at me with defiance, taunting me with my incompetence, my fear, my arrogance even to attempt it. Why did I need to prove that it could be done? Or was it simply to keep me from painting?

Every morning at seven, I swept the five thousand feet of red maple floor in the studio. The activity was a release from the dome's presence. For seven months, I did nothing but sweep the floor during my work hours.

The polishing of the maple became obsessive, being the most tempting during the gray of February. I was on my hands and knees repairing the floor with a polished plane iron when Olivia, ever so gently, said, "Why not try it today?"

At this critical point we again run straight into the iron and the hermetic tradition, for within this lie the keys to the Regulation of the Fires central to the Great Work. I have already referred to the positive, virile, upright nature of the metal, but there is an underside that is all too familiar—raw masculinity, brute force, ignorance or forgetting, impatience and bad timing. Perhaps you could discuss the materia, *the steel and its "discovery," the sense of the sword's movement through the air, which produces those lightning flashes that are the moments of creation and transmutation.*

Whether or not the following is a dream or an actual occurrence that I experienced I still am unclear: In 1971, near Long Beach, my friend Hu ordered me to stop the car, pull over, and look toward the sunset, saying that this one would never be seen again. The smog filtered the glare into a golden glow, with a brilliant, purple halo surround to the sun, or perhaps in my retina. The moment had been without time, excruciatingly whole, yet I could not complete the retelling in my mind. A grand play was being enacted to my left that took weeks for me to once again hear and experience with a clear specificity of focus. Had I only looked for an instant to my left for it to have disappeared from my mind? Or, had I become transfixed with the action and, only for an instant, looked up toward the glow?

Huge billets of cylindrical steel, each about twelve feet long and six inches in diameter, were being unloaded by derricks from a convoy of vintage 1950, flatbed trucks. The steel fabricator's yard bordered the bay, the bobbing and twisting hoists fighting with the seagulls; the noise from the clanking cable cords, the squealing from the vintage engines, the incessantly yelled commands between the operators and the hands, all added up to a "tough guys" play. These were huge, gruff men sweating and swearing in choreographed precision. The reflected pools in the gravel and dust were grand puddles of Big Red, ever increased in size from the huge cheek wads. I admired and envied these men. The work was hard work. A two-thousand-pound length of "hot rolled" lifted easily but dropped with dangerous arrogance onto the huge stacks next to the inventory shed while the Macks, all in unison, swayed and rocked into the dust on their worn rubber. Everything was on fire and burned: the ground was dry, the old trucks were used up and rusted, the steel covered with a scale of brilliant orange, and the heroes sun-scorched red with no relief from the glow. From every angle, floods of sparks shot out of the open buildings when the mills' "cutoff" saws dimensioned the stacks. To this day I can feel the perspiration from the cold Buds handed out at the end of the unloading.

The masculinity, the dominance over the *materia* is precisely the "underside" to which you alluded. The processes added up to a seductive workout, with the delivery of huge billets, the lifting and

impatience, brutality, and sweat. Probably because of that chance sunset, I trained myself for twenty years to focus on *impatience*. I spent days at the steel mills in Pittsburgh and I worked as a machinist in New Jersey. I became fascinated with mechanical accuracy. I turned my mind away from the seductive activity of ordering and personally moving tons of steel by training myself to be a master toolmaker. I learned to locate a hole of .118 of an inch plus or minus .0001 of an inch at precisely the xy coordinates in a plate of 6061T6 aircraft-grade aluminum, .500 of an inch thick, isolated from the vibrations of the earth's surface at 68 degrees Fahrenheit, surveying with a light-beam sighting table the accuracy of the bored diameter. I have made drills that can accurately bore a hole smaller than the eye can see.

The five volumes of John Jacob Holtzapffel, nineteenth-century arguments over screw-thread standardization, and modern engineering treatises detailing guidelines for mechanical accuracy led my "voice" to the inlet cylinders that form the houses for the domes. The cylinders were mathematically plotted for bore locations, and thousands of individual drills were fashioned to permit the inlet for each gold granule. Perhaps those pieces were the technical masterworks necessary to free my mind/voice. What I needed was impatience and patience simultaneously.

Ten years later, I like the smell when "cold-killed" steel is vertically quenched in virgin olive oil. I wear goggles that wrap my eyes and ear protectors fashioned from old headphones. Because of the fine steel chips and splinters that fly upward from the chiseling, I wear a leather shirt, leather apron, leather gauntlets, motorcycle chaps, spats, and welder's boots. Every day that I carve, my hands and chest are covered with steel splinters and blood. These are splinters so fine that they can only be found when the rust appears under the skin. I love the sounds of molybdenum, chromium, low sulfur; the smell of sulfur; fire-blued steel, and chilled fine-grain cast iron. I have compressed steel with 300 tons of pressure to watch it rise to 700 degrees Fahrenheit and explode with the stress, and pared chips on ten-horsepower-engine lathes that blued two-inch-deep chips in seconds. I dominated the steel with my patience all those years ago, but now I look to the steel to teach me of the time before it was born. I want to find its moment of becoming, its ever-so-fragile state that will let it become imbued. Can I find that moment of forward movement that combines the men at Long Beach, the casual glance toward the evening sun, the edge of my mind's sword, and the golden glow of its transparency?

Camille Saint-Saëns once said that he composed music rather in the same way that an apple tree produces apples. This curious analogy reminds us (unintentionally perhaps) that the apple tree does not produce pears or peaches; it also links the creative process to ideas of seasonal increase, the momentum of spring to summer to autumn—ripening and "rightness"—and the repose and fermentation of winter. I know you are acutely aware of the cycles that bend both toward and away from what you describe as "the precious moment," but do you also have a sense of harvesting with your work?

Nineteen cedar-strapped water tanks on neighborhood roofs are visible from the nine studio windows that face south to the financial district. The twentieth one is visible only when I hang from the ceiling steam riser.

After the regular February steam cleanings, the tanks are burnt sienna, with highly reflective metal conical tops; the welded iron ladder stringers make a geometrical map up the sides. When the August air is heavy with afternoon humidity and smogged glare, the tanks shimmer and shake under the accumulated black dust of six months. By December the sienna has become umber, the cones are topped with caps of gray snow, and verdigris is barely visible at the edges of the copper gutters. Just as that scenario will alter, one year from each February, the stacks of paintings and "landscape" of sculpture will be changed in the studio.

I have been busy for thirty years, twenty in New York City, not knowing precisely what I am doing. But I have put in very long and hard days of fourteen hours. I feel comfortable in the toy and flower district, with the daily deliveries, countermen, the buttons and needles in the loft floor, and the silence of winter. Except for springtime runs around Madison Square, I stay inside most of the time, pacing. Every day I eat the same thing for breakfast and lunch so that I don't have to think about it. Until five years ago, I never thought about the years, but the loft had become stacked with unseen work.

My "orchard" has been cross-pollinated with the seeds from art history, science and technology, Eastern and Western philosophical treatises, and the blushing chroma of one hundred carats of pink diamonds. At one and the same time I play marbles with Colombian emeralds and dream of W. O. Bentley's piston design, Masumune's blades, Emily Dickinson's melancholy, and Barnett Newman's *Stations of the Cross*. It is the folded and unfolded mosaic of complexity that has kept me pacing yet has always caused my productive movement. With all that input, I found myself in a labyrinth, three dimensional and multidirectional, pressed to embrace and investigate every spark of an idea—without restriction. I had no goal of finding a way out, but rather the compulsive need to find some measure of clarity with everything.

Was it my need to understand that moment of "precious perceptions," when tears and smiles overlapped? My son's summer monarch butterfly harvest started a collection of "remembered childhoods," "domestic scenes," "beautiful shadows," "adult proportions," "lyrical gestures," and "precious things." I traveled to see Chinese vases of "one thousand butterflies" and carefully read the haiku of Basho and Buson. Lalique's brooches became as familiar as the science of flight in the *Gossamer Albatross*. The process that my son started flowed as the Tang-dynasty poet Han-shan described how "days and months slip by like water." Quite unexpectedly, after eleven years, the collected bits fermented into the butterfly pieces. And the more that I accepted the referential context and the charm of the drama, the more abundant the production became. What I harvested was my uneasiness with the play. On one level I was making "butterflies," and yet on a deeper level I felt enlightened. I did "look out at all the young girls, dancing with golden butterflies swinging from their hems, and dream about the smell of the persimmon trees." It all removed me from the everyday. I am sure it appears to be an uneven, eccentric journey, yet it is one that is unedited, with all the original momentum, pauses, and eccentric blossoms intact. Does the Katha *Upanishad* describe "an aching smile" as well as "without inside and without outside, a space woven, warp and woof"?

I find that I arrive at my art rather in the same natural way that an apple tree produces peaches.

The most recent sculptures have moved up in scale (and, I think, also in pitch). As a result, the dynamics of the relationship between the object and the observer has changed. The sculpture is no longer "discovered," or revealed in the hand; instead, the observer must move within the object's own space. This vital reversal of polarity has a direct parallel within the Tantric Mysteries, where it is embodied in the union of the god Shiva and Shakti, his consort; here, the active male principle is motionless while the passive, female principle "moves" over his body. The place where this creative exchange occurs is for me best expressed by the Platonic notion of temenos—*the sacred enclosure, which is, both materially and spiritually, the tranquil center. Is this the Name Saying Place you speak of?*

Chikuzan, a blind bard from northeast Japan, appeared in traditional robes with his *shamisen* and played melodies for twenty minutes before the intermission. He smiled, ever so discreetly. His protégée, a lovely young woman, played next, roaming up and down the scales with absolute deftness and precision. In the final duet, she amazed with her command, but, at some point, Chikuzan's instrument played itself.

The Name Saying Place is, indeed, sacred. Perhaps it is a moment when an a priori gesture instantly materializes into a coalesced reality. Perhaps at that pause the ego is divested, the maker becomes metaphorically transparent, and all the "within and without" of referential context passes through.

From the Katha *Upanishad:*

Beyond the senses are the objects,
beyond the objects is the mind,
beyond the mind, the intellect,
beyond the intellect, the Atman,
beyond the Atman, the non-manifest.
beyond the non-manifest, the Spirit,
beyond the Spirit there is nothing,
this is the end, the Pure Consciousness.

In our discussions, you often return to the notion of the pure act—the single sweeping gesture that empties the ink from the pen in a continuous, eloquent movement that ends in completion. Am I right in seeing this at work in the recent sculptures?

Quite unexpectedly, when I was twenty-three years old, I happened on a demonstration by a famous Chinese calligrapher. For about three hours his attendant, who was the second most famous calligrapher at the time, worked quietly and purposefully preparing the paper and ink. The older man sat with his elbows on his knees, eyes downward, not watching the younger man (about sixty years old), who was carefully positioning the twelve-foot sheet of hand-made rice-flour paper on the mat-covered floor. An eighteenth-

century Qing dynasty ink stone of shalelike material, about ten inches long, with a beautiful rubbed patina of stained bluish black, was placed a determined distance from the paper, perhaps giving room to the delicate engraved bird swooping against the edge of the stone. A large, rectangular, black-ink cake with gold seal marks was rubbed, in a straight up-and-down movement, on the stone. The abrasion and small additions of distilled water produced a thick, viscous puddle—a virtual pond of rich inky black.

The younger man occasionally emitted a guttural sound, not so much of approval but one of recognition that a stage had been completed with continued silence from the elder. The audience had thinned after two hours, but the few who had remained were at this point silent. From a silken, heavily embroidered cloth tied with delicate cords, a massive bamboo-handled brush was removed and placed with its tip pointing toward the edge of the stone. It appeared to be twelve inches of a horse's tail, cut and trimmed to a gently swollen tear shape. At four hours, the attendant stood, picked up and placed the brush hair into the ink pond, then sat motionless near the stone, legs bent under himself, and silent. At about six hours, the two men's eyes met, no words were exchanged, and the younger rose and stood behind the stone. The elder walked slowly, deliberately, almost with imperceptible movement, to the brush, never taking his eyes from it. He stood, motionless, not breathing, not swaying, ageless, ancient, transparent, for minutes, then hours. In one moment/movement, he lifted his left foot, stamped it hard on the floor, bent and grasped with both hands the brush, which had drunk the entire pool, stared at the twelve feet of white in front of him, yelled a terrifying screech, raced to the edge, entered the space and flung the brush in a great circle around his body, slapping the tail onto the paper. He immediately became erect, paused at the "moment," then turned and walked quietly away. The brush had become bone dry; all of its voice, the master's voice, had passed through the gesture.

From that day, the ink passed into my heart, into my voice. I have been drunk with that ink all these years. If you see that gesture, that eloquent screech in the recent sculptures, it simply is that I have been preparing myself diligently, for thirty years, to release my voice in one piercing, screeching, whisper of a moment.

Thirty Years

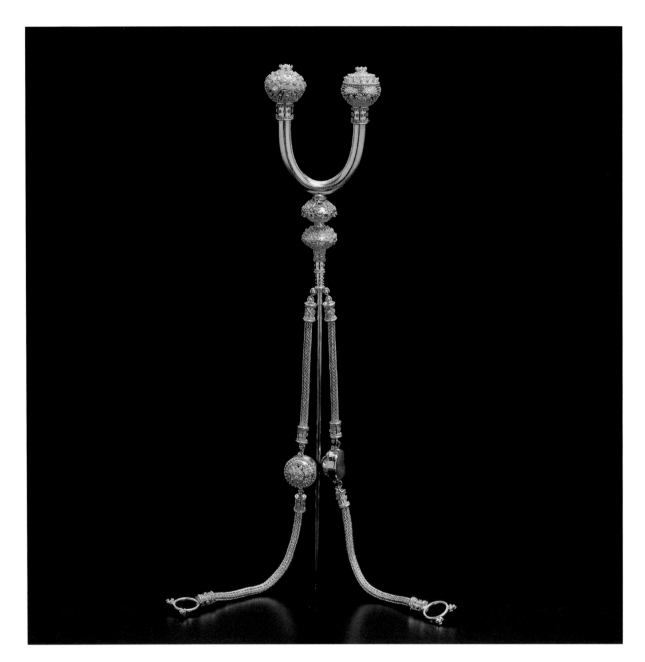

1. *"U" Fibula.* 1974

Twenty-two-karat gold, Sassanid intaglios

12 x 1 ³/₄ inches (30.48 x 4.45 cm)

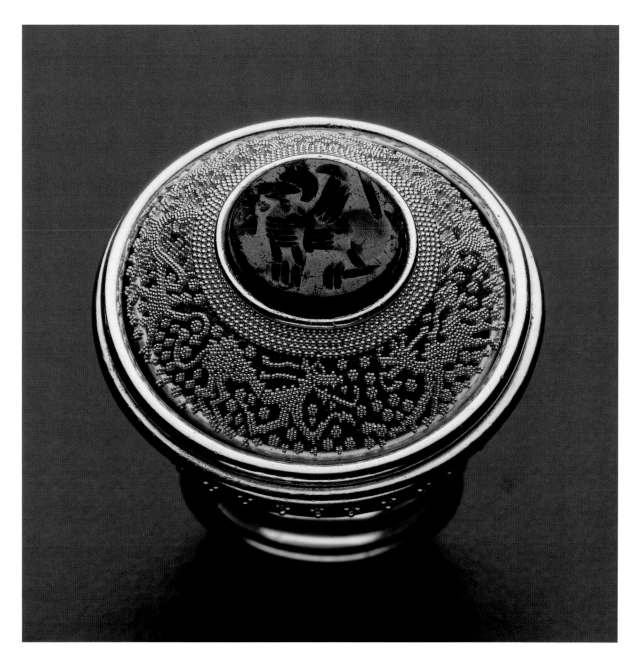

2. *Seal Ring.* 1974

Twenty-two-karat gold, engraved hematite Sassanid seal

1 ³/₁₆ inches in diameter (3.02 cm)

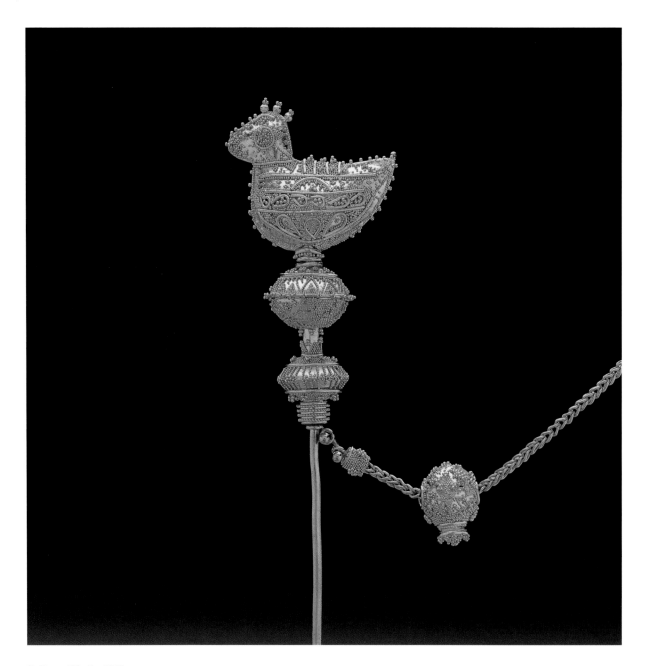

3. *Dove Fibula.* 1973

Twenty-two-karat gold

7 x 1 inches (17.78 x 2.54 cm)

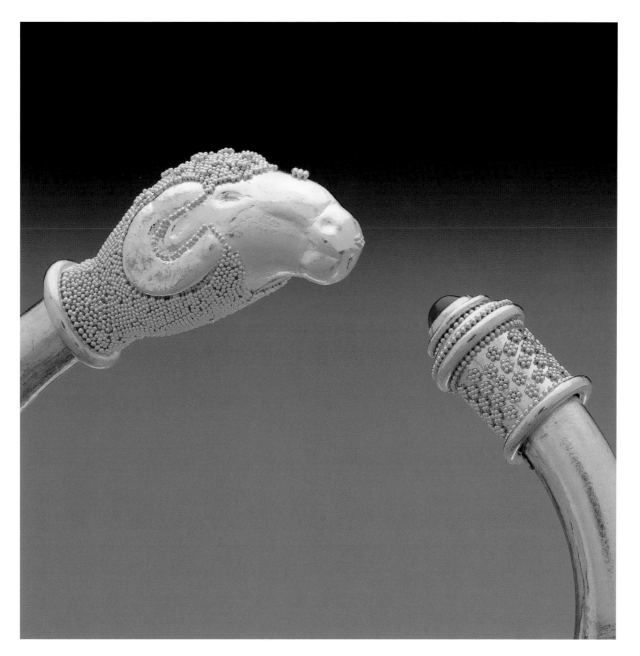

4. *Ram Bracelet* (detail). 1976

Pure gold, twenty-two-karat gold, ruby

3 x ¹/₂ inches (7.62 x 1.27 cm)

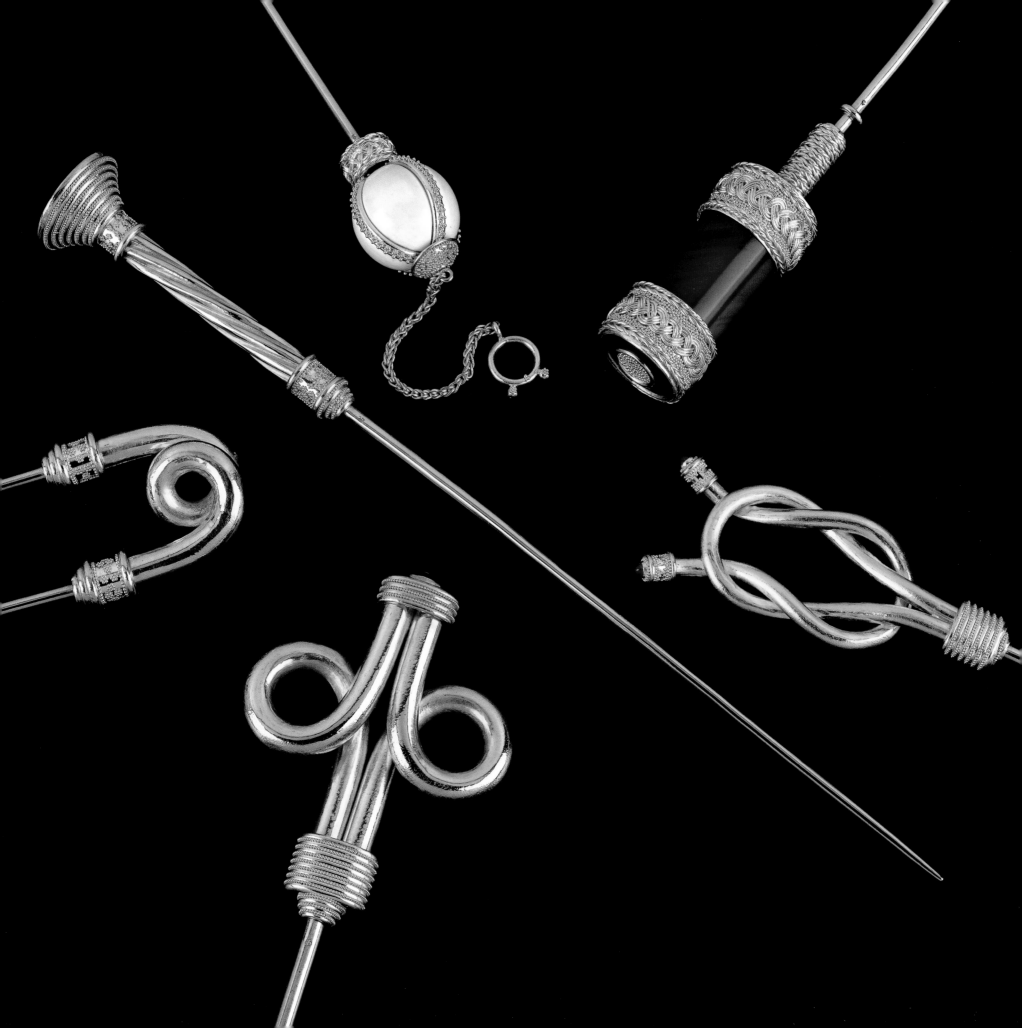

Six Fibulae (clockwise from top)

5. *Ivory Flutes.* 1973

Pure gold, mastodon ivory

5 x 1 inches (12.7 x 2.54 cm)

6. *Braid.* 1979

Pure gold, twenty-two-karat gold, carnelian

8 x 1 inches (20.32 x 2.54 cm)

7. *Hercules Knot.* 1977

Pure gold, twenty-two-karat gold, rubies

8 x 1 inches (20.32 x 2.54 cm)

8. *Double Curve.* 1978

Pure gold, twenty-two-karat gold, sapphire

7 7/8 x 2 inches (20.00 x 5.08 cm)

9. *Single Curve.* 1977

Pure gold, twenty-two-karat gold

5 x 1 inches (12.7 x 2.54 cm)

10. *Twist* (in center). 1977–78

Pure gold, twenty-two-karat gold, sapphire

8 x 1 inches (20.32 x 2.54 cm)

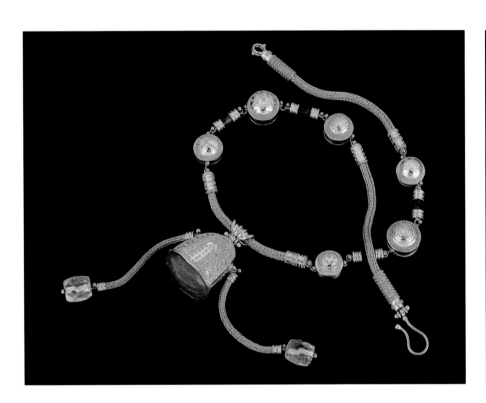

11. *"Connoisseur" Parure.* 1977

Twenty-two-karat gold, engraved Sassanid seals, Neo-Mesopotamian stamp seal

8 1/16 x 4 3/4 inches (20.48 x 12.07 cm) arranged in case

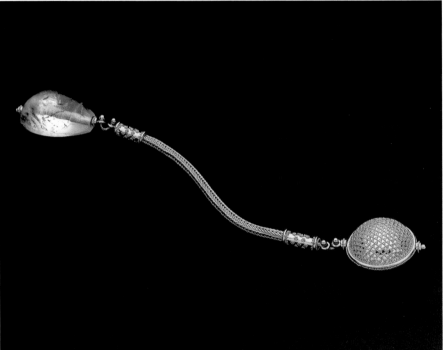

12. *Psychiatrist's Toy.* 1979

Twenty-two-karat gold, rock crystal (Roman, 3rd century A.D.)

5 x 1 inches (12.7 x 2.54 cm)

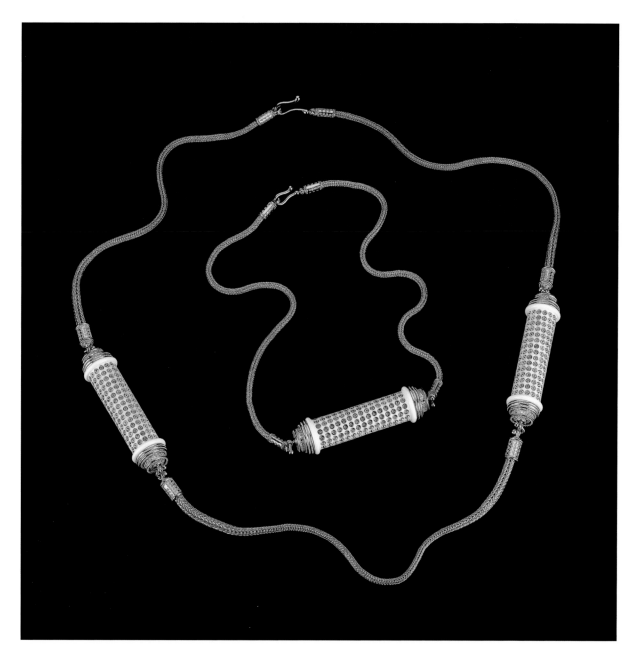

13. *Rosette Necklaces.* 1982–83

Twenty-two-karat gold, mastodon ivory

34 inches (86.36 cm) and 22 inches (55.89 cm)

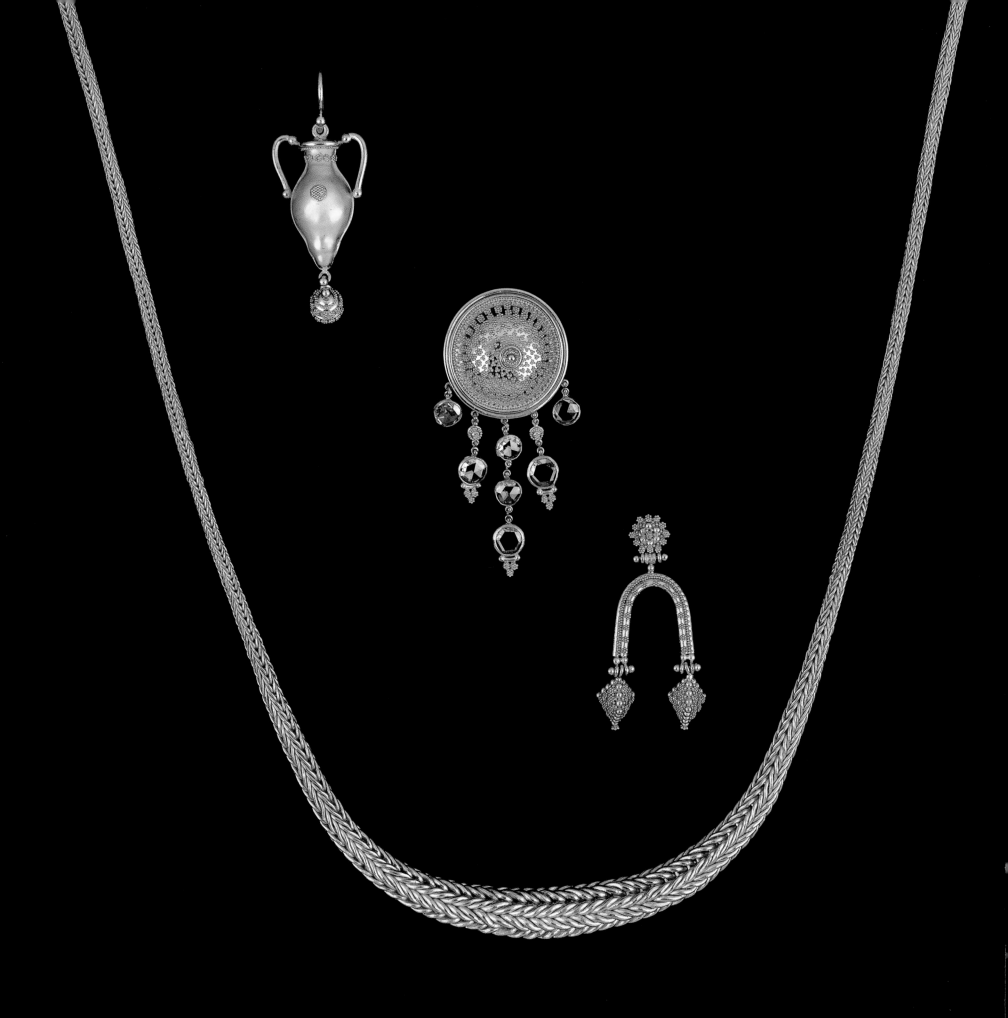

Necklace and Earrings (top to bottom)

14. *"Clay Amphorae."* 1980

Pure gold, twenty-two-karat gold

2 1/8 x 3/4 inches (5.40 x 1.91 cm)

15. *Moghul Diamond Earrings.* 1978

Twenty-two-karat gold, Moghul "rose-cut" diamonds

2 1/8 x 1 1/4 inches (5.40 x 3.18 cm)

16. *Double Pyramids.* 1973–75

Twenty-two-karat gold, eighteen-karat gold

1 1/2 x 1 inches (3.81 x 2.54 cm)

17. *Graduated Loop and Loop Chain.* 1980

Twenty-two-karat gold

26 inches (66.04 cm)

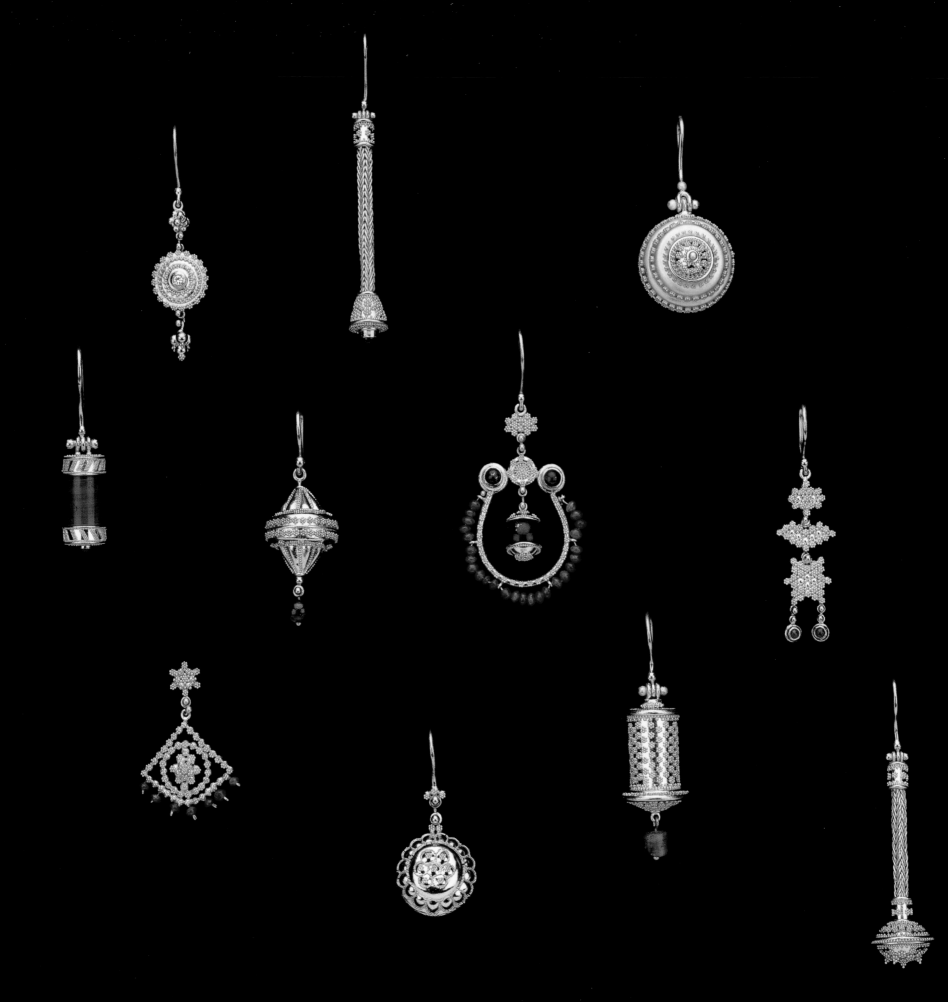

18. *Earring Collection.* 1973–80

Pure gold, twenty-two-karat gold, eighteen-karat gold, diamonds, rubies, emeralds, malachite

1 $^1/_2$ x $^1/_2$ inches (3.81 x 1.27 cm) approx.

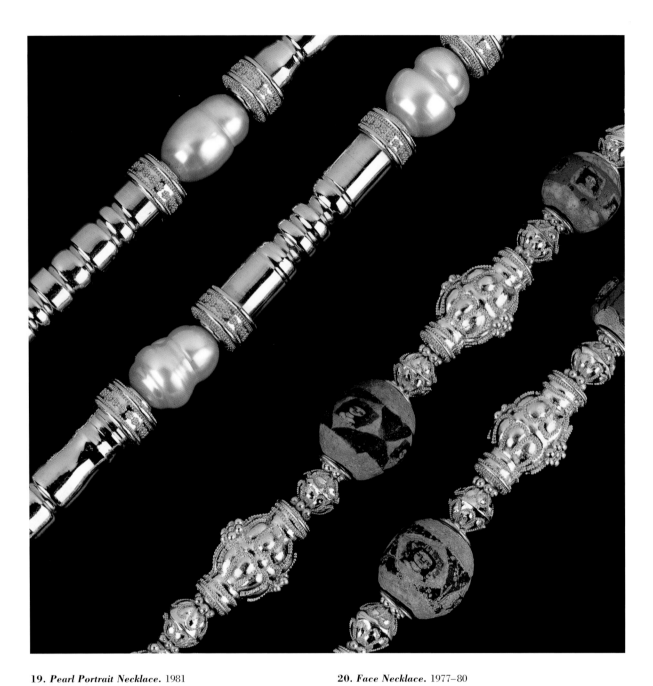

19. *Pearl Portrait Necklace.* 1981

Pure gold, twenty-two-karat gold, Baroque pearls

54 inches (137.16 cm)

20. *Face Necklace.* 1977–80

Twenty-two-karat gold, Phoenecian glass mosaic beads

20 inches (50.8 cm)

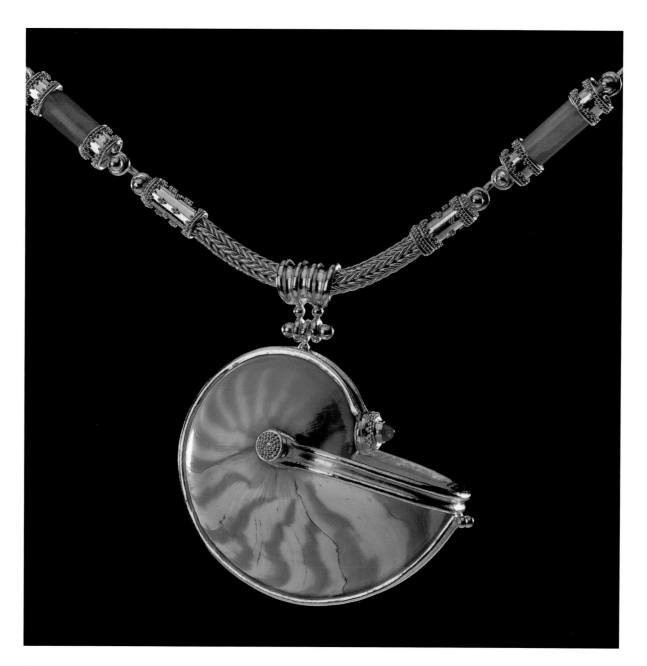

21. *Nautilus Necklace.* 1975

Twenty-two-karat gold, chambered nautilus shell, carnelian cylinders

17 inches (43.18 cm)

22. *Silla's Rattle.* 1982

Twenty-two-karat gold, mastodon ivory, Burmese sapphires

4 x 1 inches (10.16 x 2.54 cm)

Top to bottom:

23. _Top._ 1982

Twenty-two-karat gold, mastodon ivory

1 ¹/₄ x 1 inches (3.18 x 2.54 cm)

24. _Traveler's Toothpick._ 1981

Twenty-two-karat gold, mastodon ivory

3 x ¹/₂ inches (7.62 x 1.27 cm)

25. _Traveling Sticks_ (two parts). 1980

Twenty-two-karat gold, mastodon ivory

3 x ¹/₂ inches (7.62 x 1.27 cm)

26. *Walking Stick.* 1983

Twenty-two-karat gold, mastodon ivory, goncalo alves (hardwood)

38 x 1 $^1/_4$ inches (96.52 x 3.18 cm)

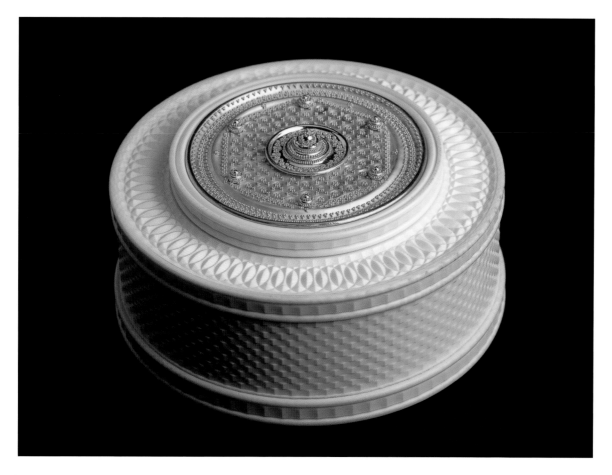

27. *"Barleycorn" Box.* 1984

Twenty-two-karat gold, mastodon ivory (ornamentally turned in barleycorn patterns)

1 1/4 x 4 inches (3.18 x 10.16 cm)

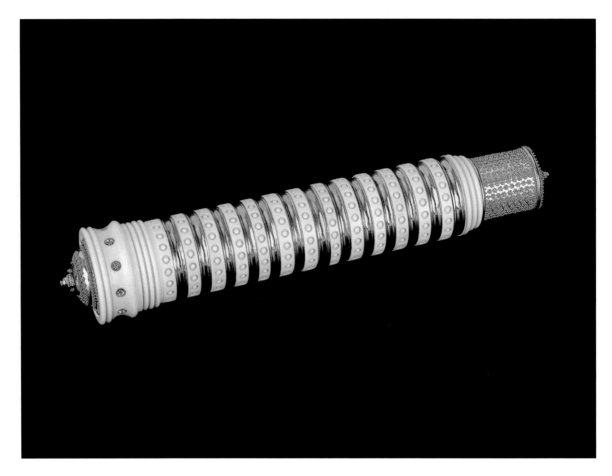

28. *Container Within.* 1982

Pure gold, twenty-two-karat gold, mastodon ivory, Burmese sapphire

4 ⁷/₈ x 1 ¹/₈ inches (12.40 x 2.86 cm)

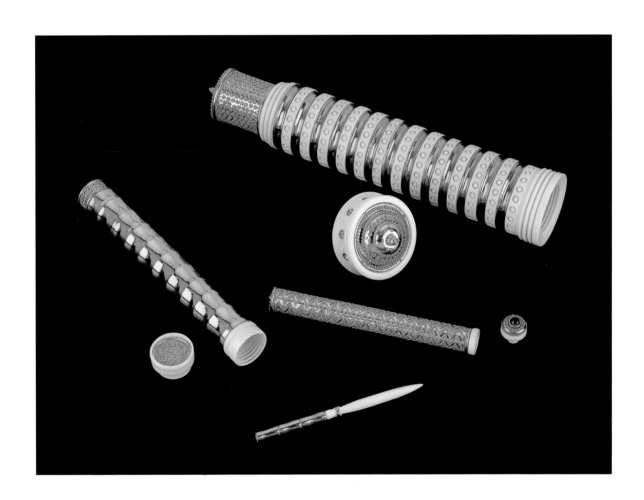

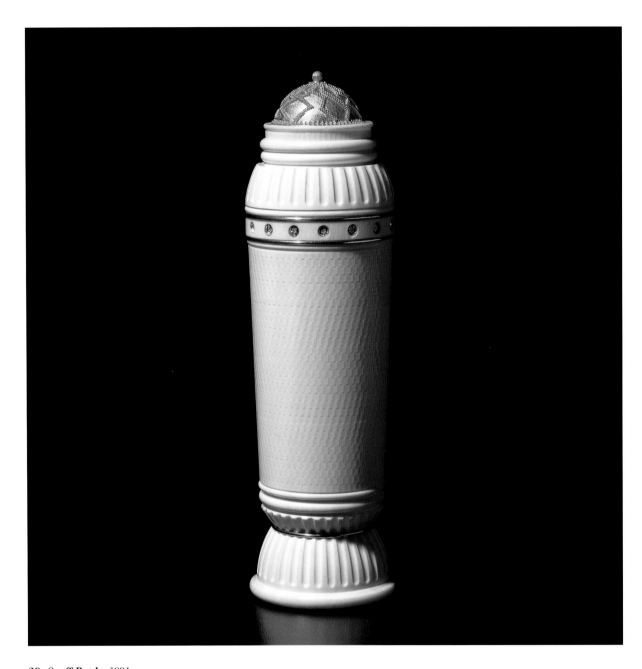

29. *Snuff Bottle.* 1984

Twenty-two-karat gold, mastodon ivory (ornamentally turned)

5 ¹/₄ x 1 ⁷/₁₆ inches (13.34 x 3.66 cm)

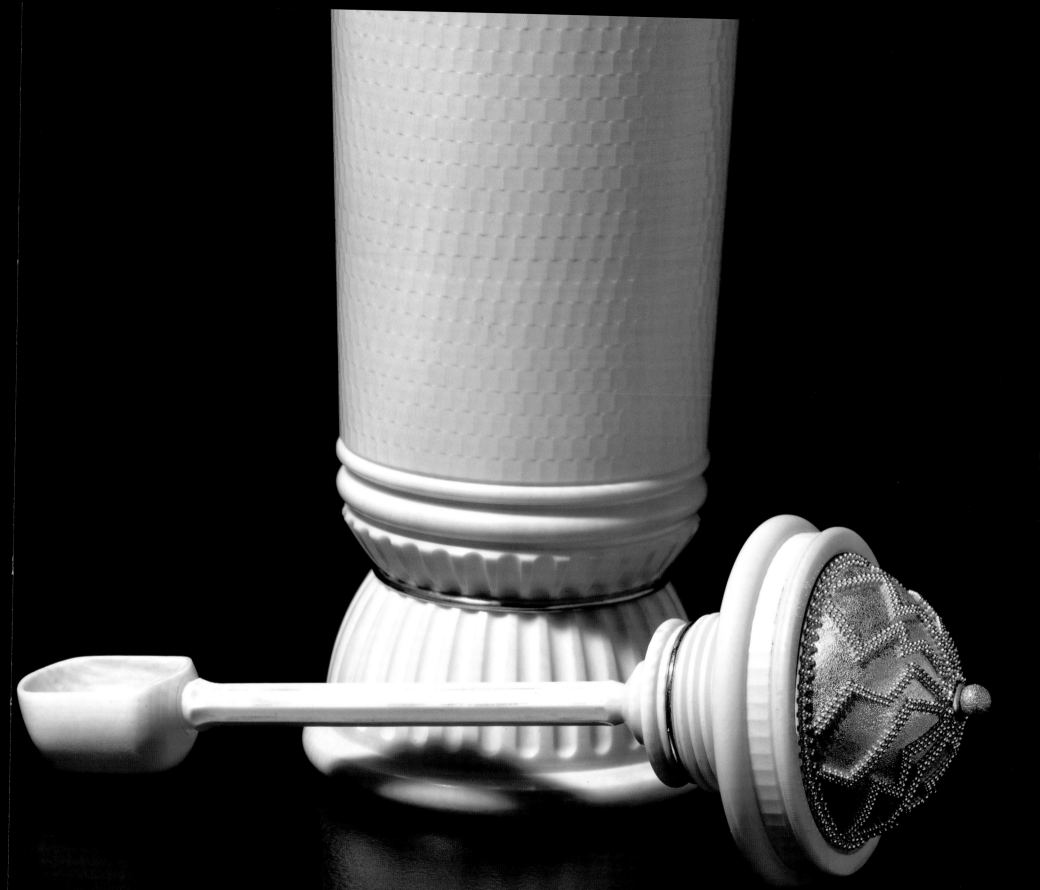

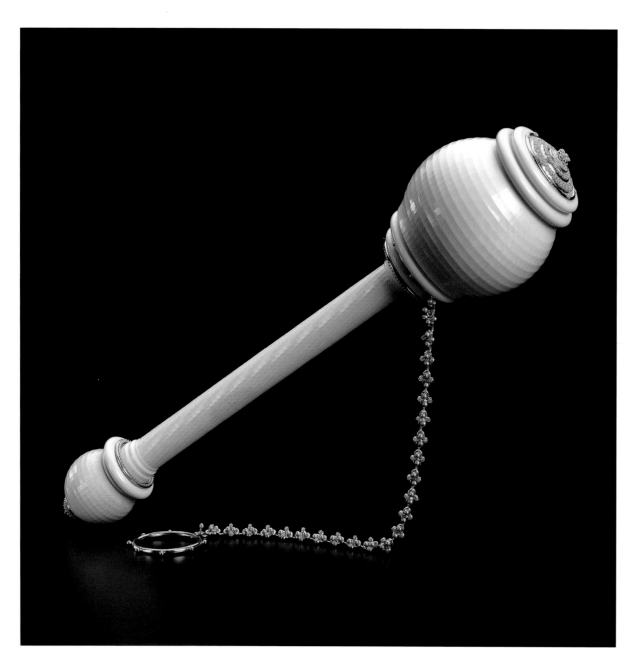

30. *Gold Dust Wand.* 1983–85

Twenty-two-karat gold, five ounces of pure gold dust, mastodon ivory

(ornamentally turned and diamond faceted)

9 x 2 x 2 inches (22.86 x 5.08 x 5.08 cm)

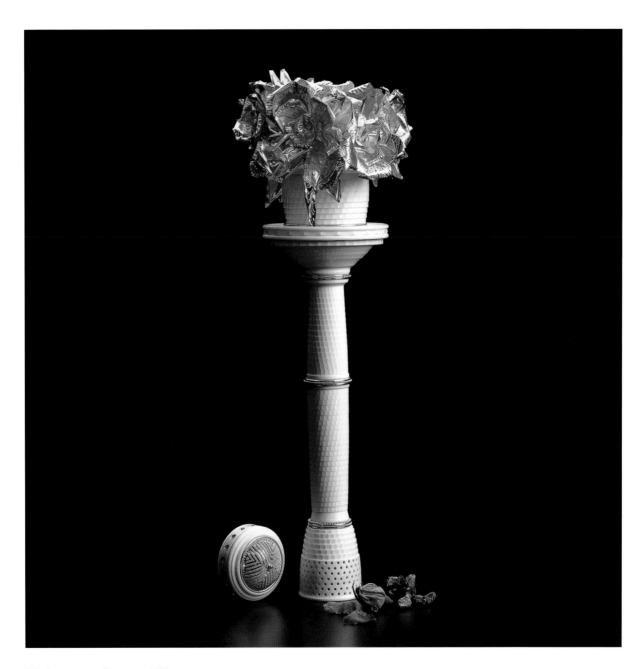

31. *Anniversary Bouquet.* 1983

Pure gold, twenty-two-karat gold, mastodon ivory

(ornamentally turned and diamond faceted)

9 x 3 x 3 inches (22.86 x 7.62 x 7.62 cm)

32. *Table Pomander.* 1984–85

Twenty-two-karat gold, mastodon ivory, horn

4 x 3 inches (10.16 x 7.62 cm)

7 x 5 inches (17.78 x 12.7 cm)

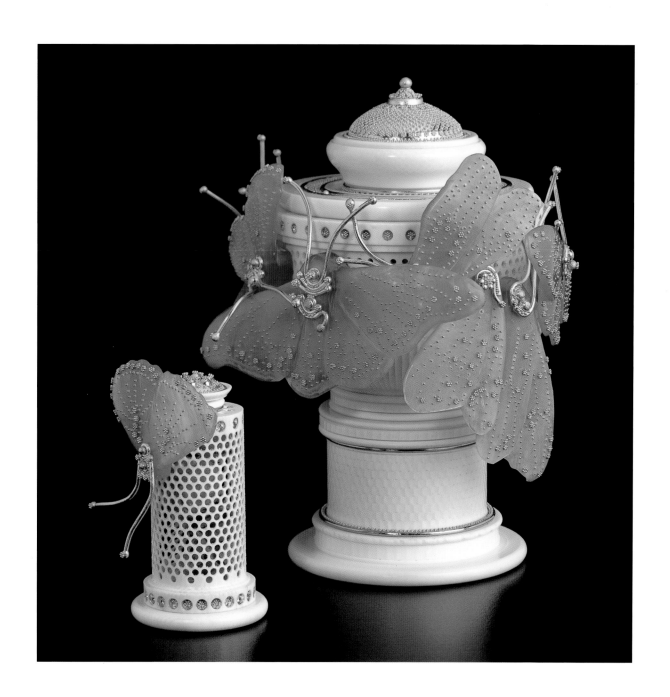

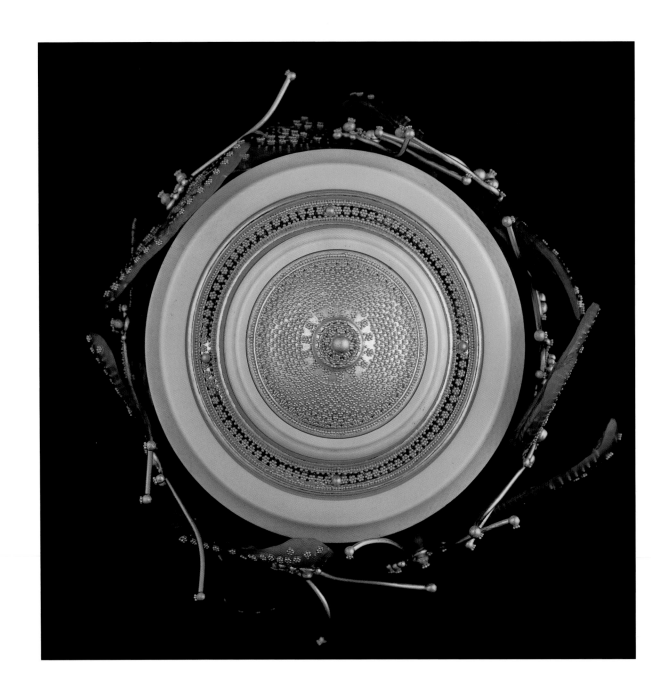

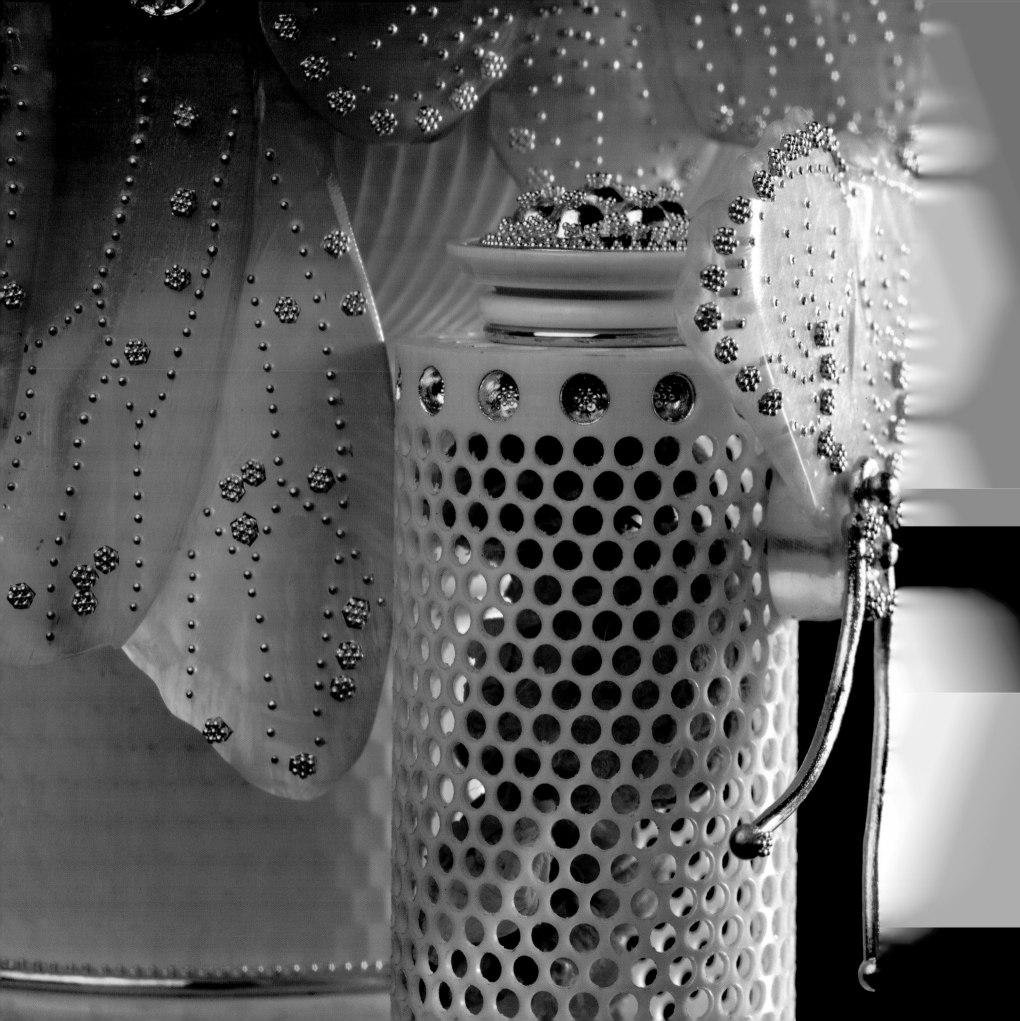

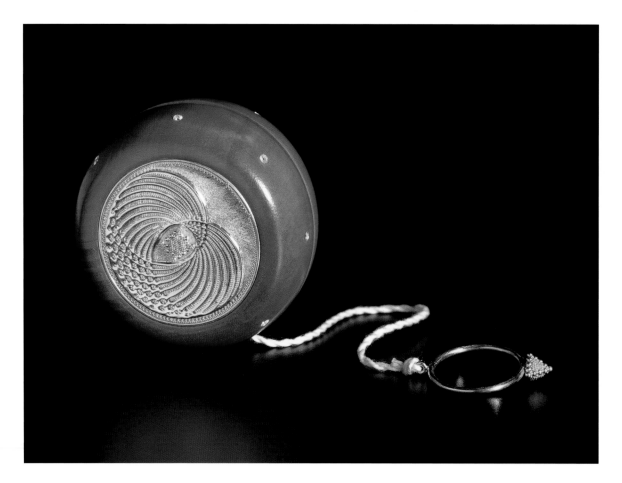

33. *Yo-Yo.* 1986

Twenty-two-karat gold, pink ivory wood, cotton cord

2 inches in diameter (5.08 cm)

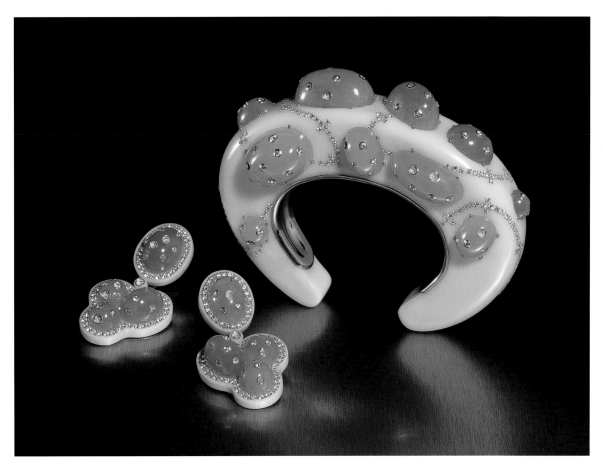

34. *Jelly-Bean Suite.* 1991

Bakelite, pure gold, eighteen-karat gold, Burmese rubies, diamonds

3 x 4 x 1 inches (7.62 x 10.16 x 2.54 cm)

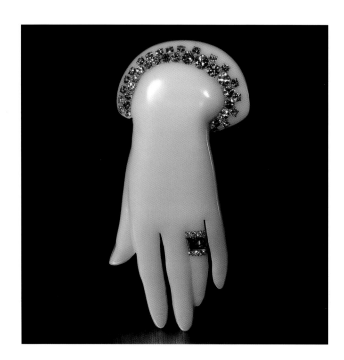

35. *Jeweled Hand* (brooch). 1989

Bakelite, pure gold, eighteen-karat gold, blue diamonds,

orange and white diamonds

2 1/2 x 1 3/4 x 1/2 inches (6.35 x 4.45 x 1.27 cm)

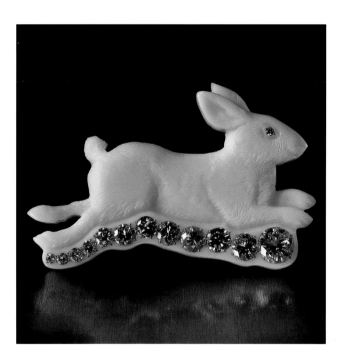

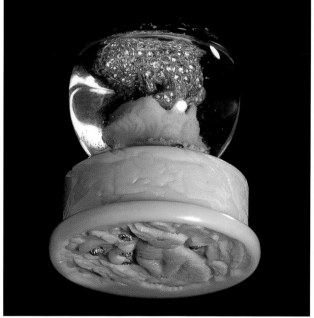

36. *Running Bunny* (brooch). 1990

Bakelite, pure gold, eighteen-karat gold,

pink diamonds, blue diamond

1 ¹/₂ x 2 ¹/₄ x ¹/₂ inches (3.81 x 5.72 x 1.27 cm)

37. *Snow Globe.* 1991

Bakelite, pure gold, twenty-two-karat gold,

eighteen-karat gold, stainless steel, pink (Argyle) diamonds,

Colombian emeralds, mastodon ivory, glass, glycerine, water

2 ¹/₂ x 3 inches (6.35 x 7.62 cm)

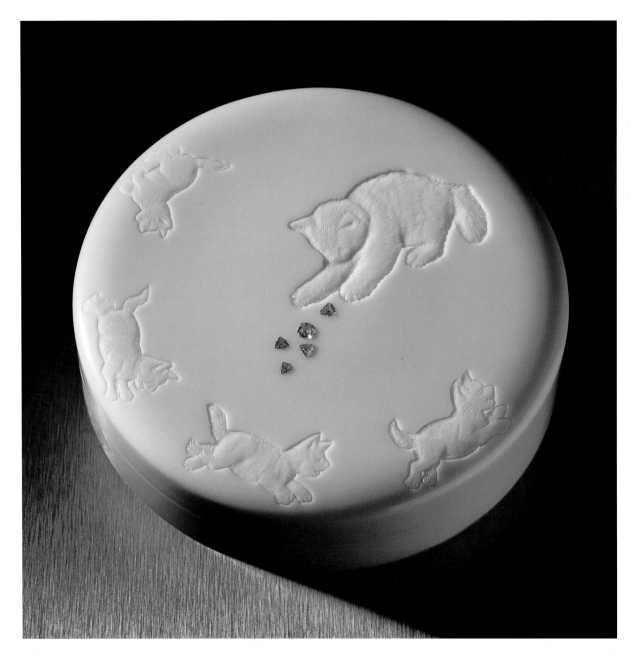

38. *Cat Powder Box.* 1990–93

Bakelite, pure gold, pink (Argyle) diamonds, swan's down puff

6 inches in diameter (15.24 cm)

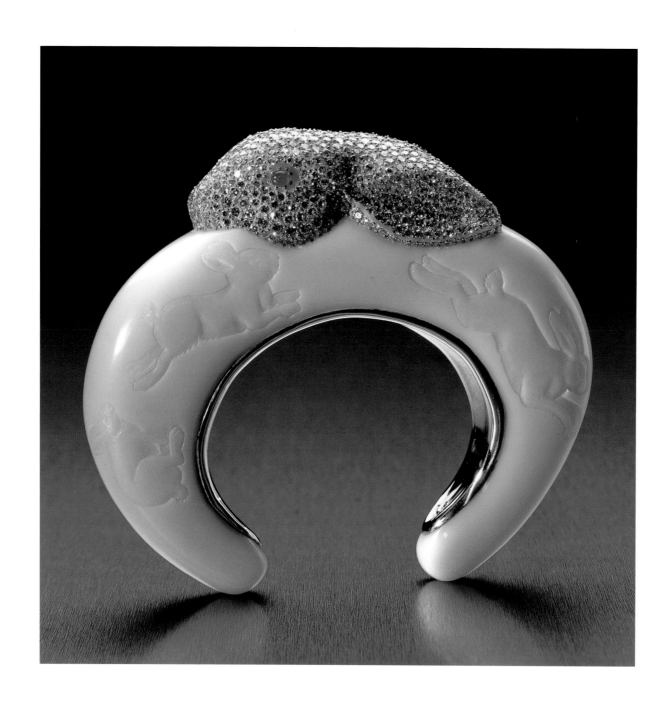

39. *Bunny Bangle.* 1988–92

Bakelite, pure gold, pink (Argyle) diamonds, Burmese rubies

3 x 4 x 1 inches (7.62 x 10.16 x 2.54 cm)

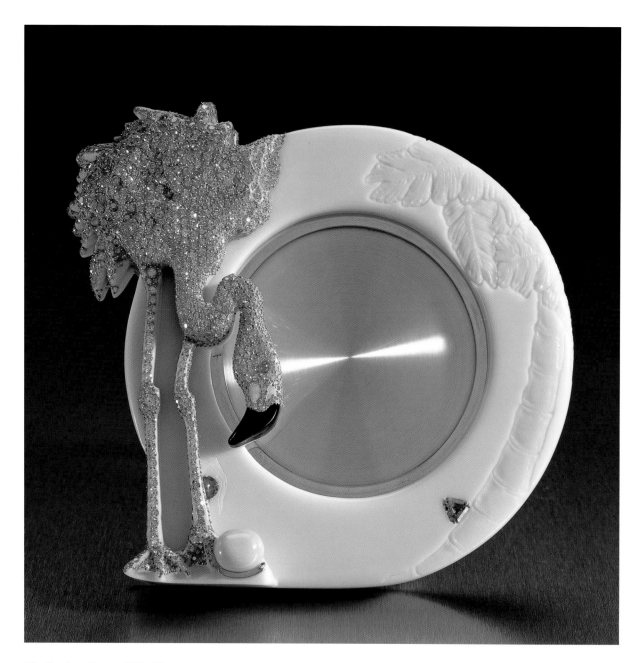

40. *Flamingo Frame.* 1989–92

Bakelite, pure gold, twenty-two-karat gold, eighteen-karat gold,

pink (Argyle) diamonds, Burmese rubies, Colombian emeralds,

Mississippi River conch pearl, glass

6 x 5 x 1 ¹/₂ inches (15.24 x 12.70 x 3.81 cm)

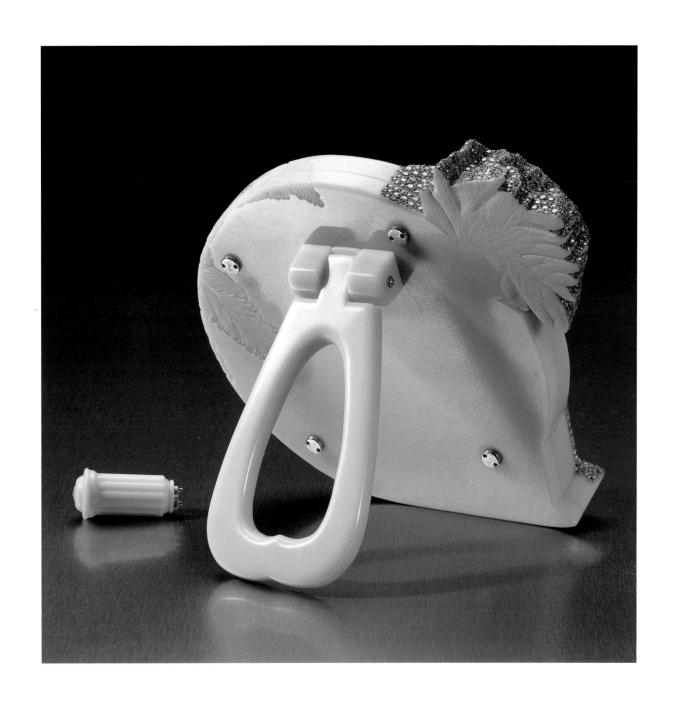

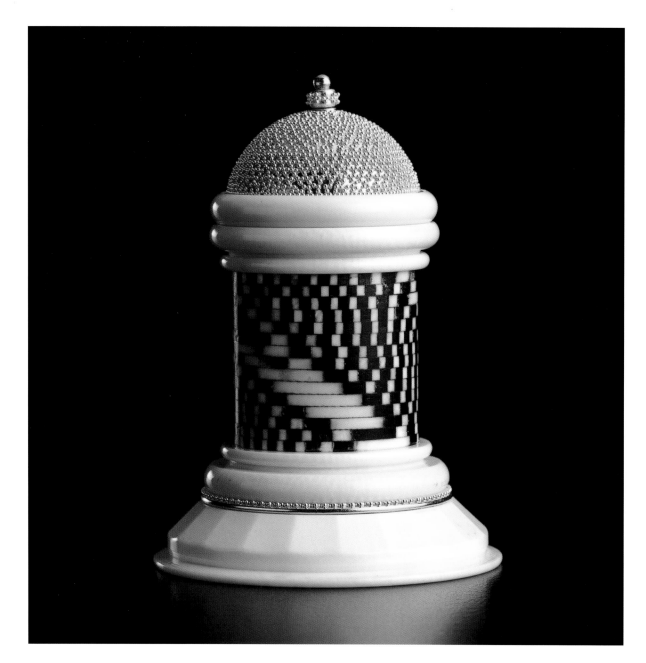

41. *Black and White.* 1975–85

Twenty-two-karat gold, mastodon ivory, African blackwood

2 x 1 $^{1}/_{4}$ x 1 inches (5.08 x 3.18 x 2.54 cm)

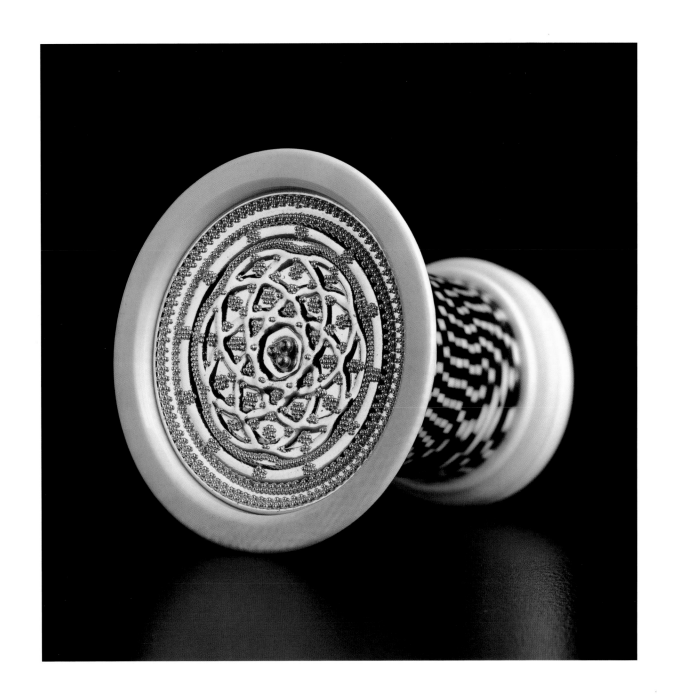

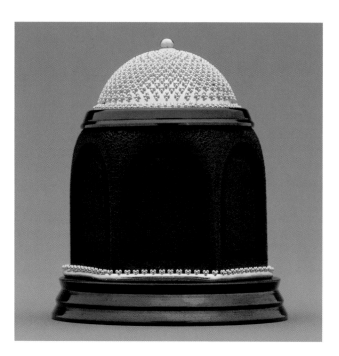

42. *Temple*. 1987–88

Pure gold, twenty-two-karat gold, fire-blued steel

2 x 1 inches (5.08 x 2.54 cm)

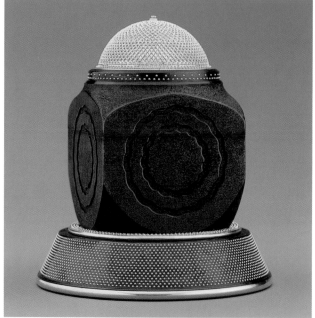

43. *Rose Square*. 1987–90

Pure gold, twenty-two-karat gold, steel

2 ³/₄ x 2 ¹/₄ inches (6.99 x 5.72 cm)

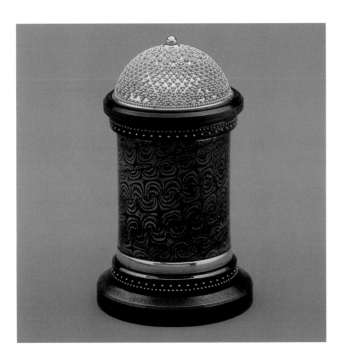

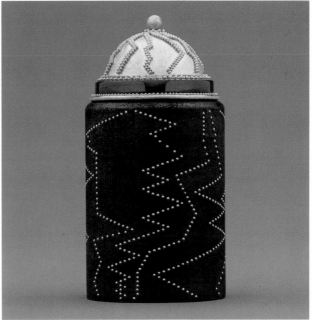

44. *Swirls.* 1987

Twenty-two-karat gold, Damascus steel, fire-blued steel

2 x 1 inches (5.08 x 2.54 cm)

45. *Zig Zag.* 1987–88

Twenty-two-karat gold, steel, fire-blued steel

2 x 1 inches (5.08 x 2.54 cm)

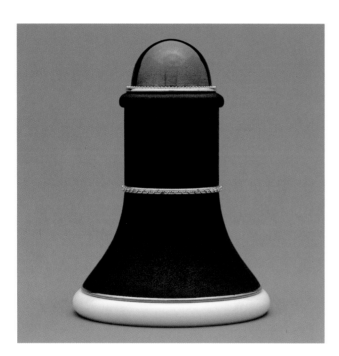 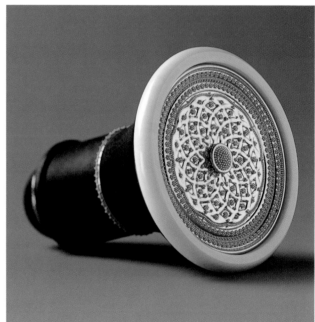

46. *Blue Dome.* 1988

Pure gold, twenty-two-karat gold, steel, mastodon ivory

2 ³/₄ x 2 ¹/₄ inches (6.99 x 5.72 cm)

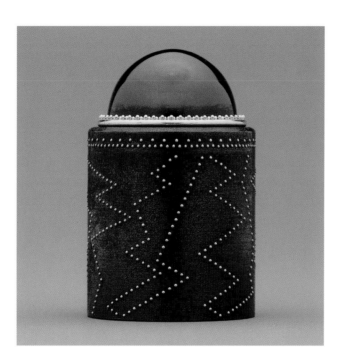

47. *Zig Zag Blue.* 1987–88

Pure gold, twenty-two-karat gold, steel, chromium steel

$^3/_4$ x 1 $^1/_4$ inches (1.91 x 3.18 cm)

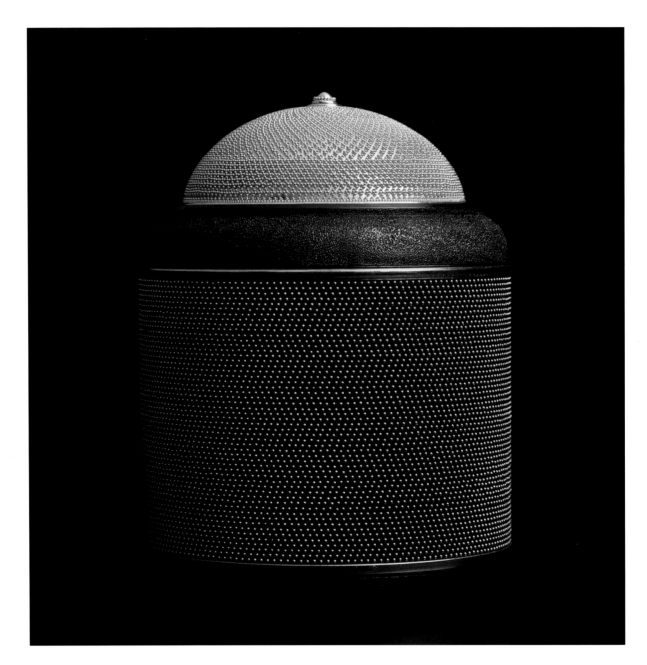

48. *Second Dome.* 1983–89

Pure gold, twenty-two-karat gold, steel

3 x 3 x 3 inches (7.62 x 7.62 x 7.62 cm)

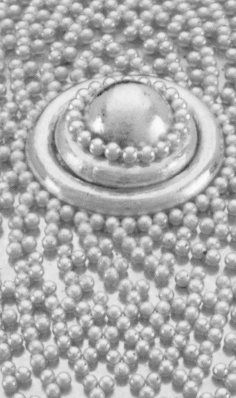

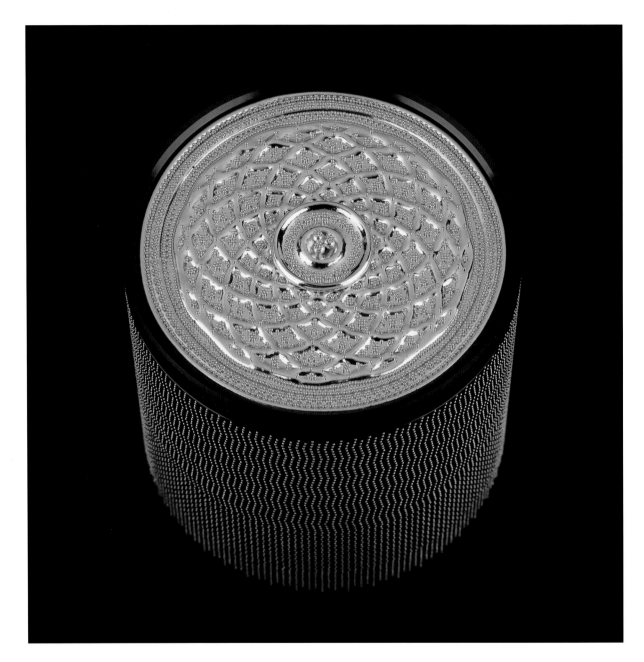

49. *Gauze.* 1988–89

Pure gold, twenty-two-karat gold, steel

3 ¹/₂ x 3 x 3 inches (8.89 x 7.62 x 7.62 cm)

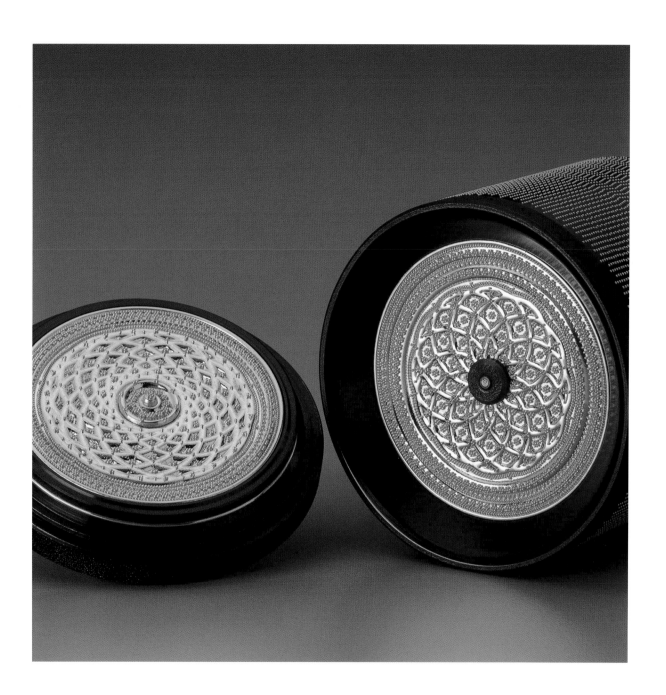

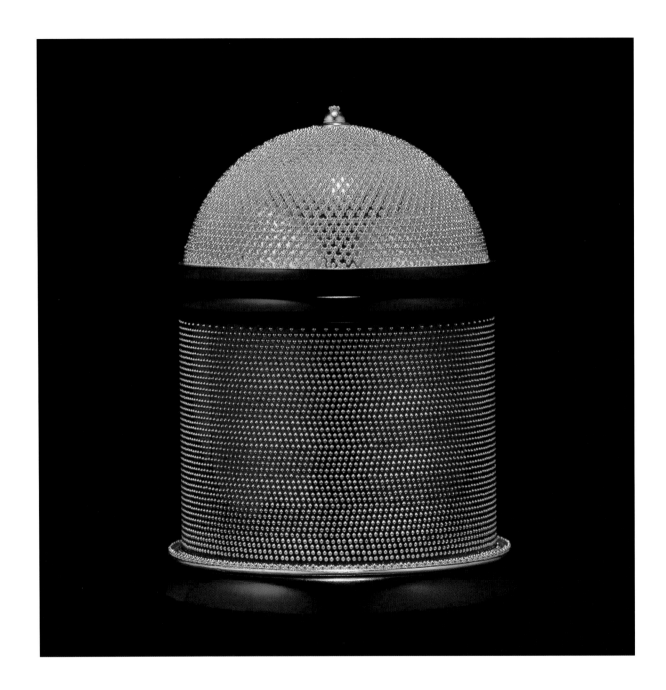

50. *7110*. 1984–89

Pure gold, twenty-two-karat gold, steel

1 ³/₄ x 2 ¹/₄ inches (4.45 x 5.72 cm)

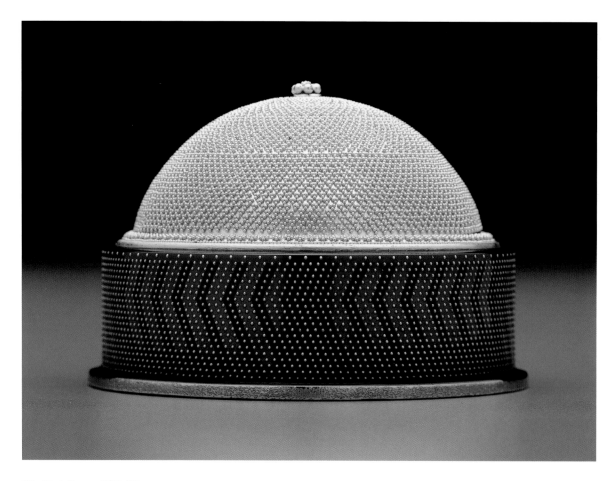

51. *First Dome.* 1982–89

Pure gold, twenty-two-karat gold, steel

2 3/4 x 2 3/8 inches (6.99 x 6.05 cm)

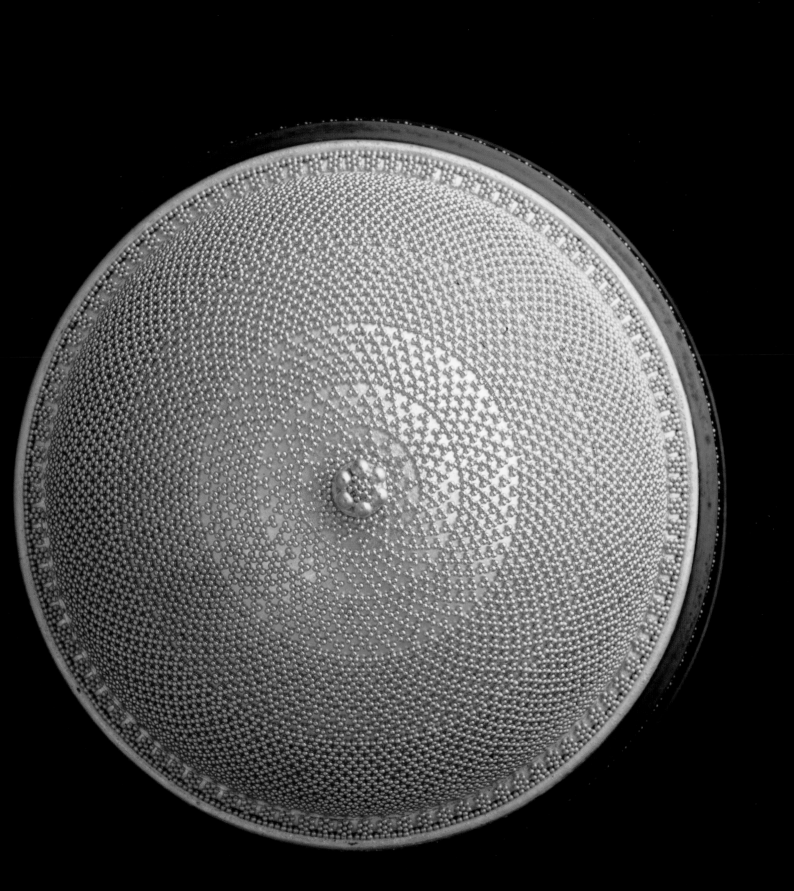

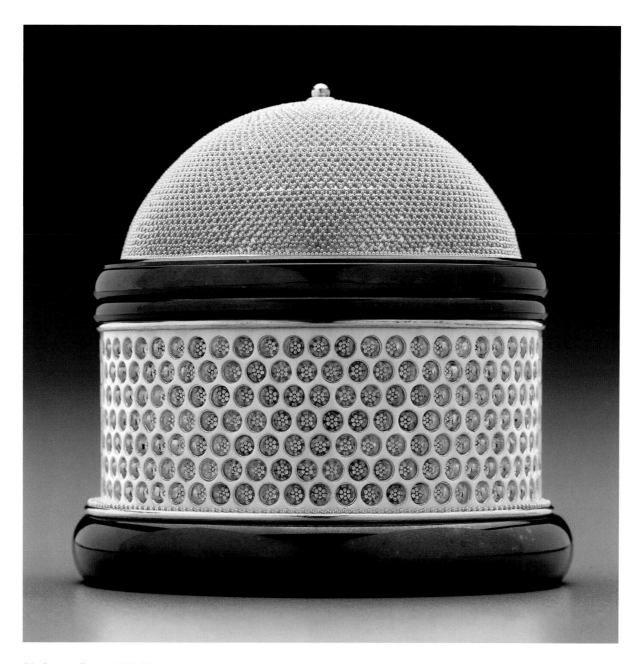

52. *Largest Dome.* 1983–87

Twenty-two-karat gold, mastodon ivory, fire-blued steel

3 ⁷/₈ x 3 ³/₈ inches (9.84 x 8.59 cm)

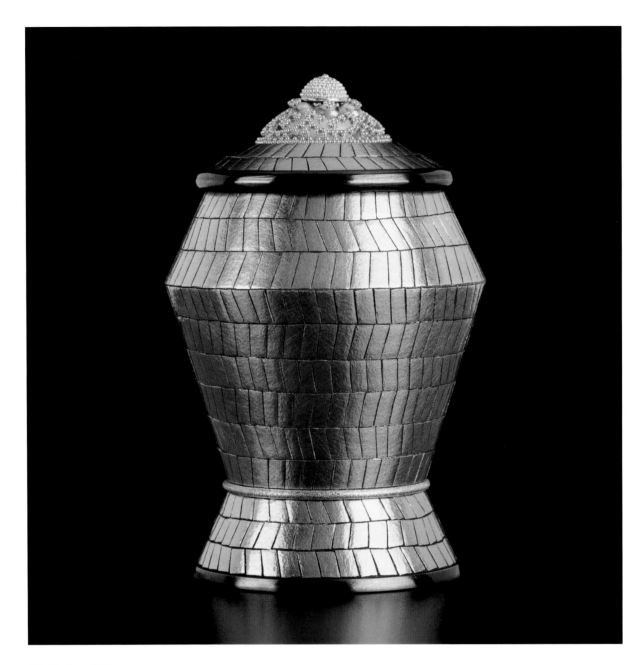

53. *Daphne.* 1989

Pure gold, steel

2 1/2 x 1 1/2 x 1 1/2 inches (6.35 x 3.81 x 3.81 cm)

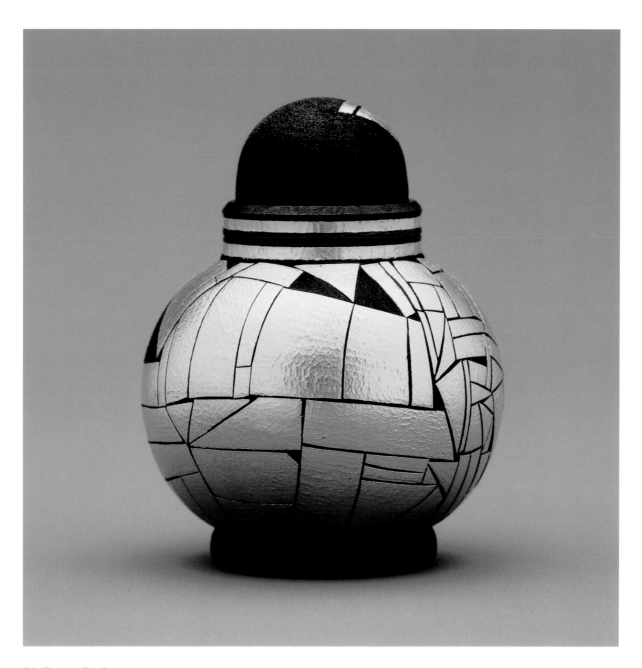

54. *Essence Bottle.* 1988

Pure gold, steel

$1\ ^3/_4$ x $1\ ^3/_8$ inches (4.45 x 3.51 cm)

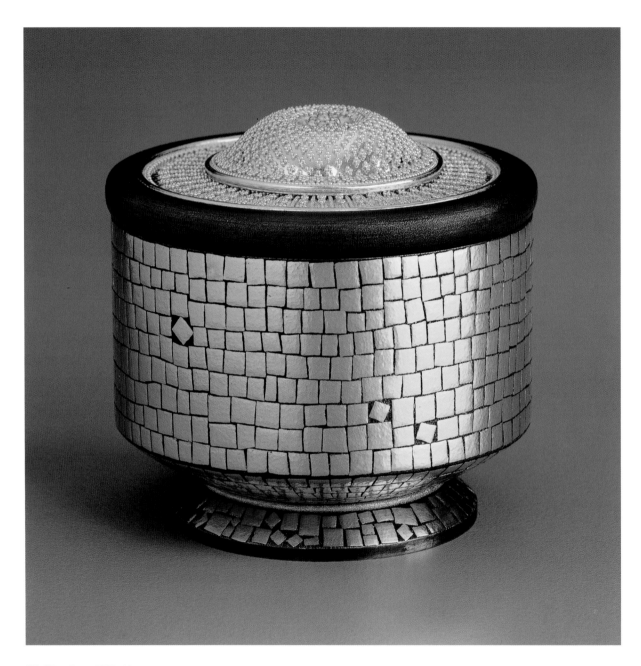

55. *Theodora.* 1988–93

Pure gold, twenty-two-karat gold, steel

2 x 2 ¹/₄ inches (5.08 x 5.72 cm)

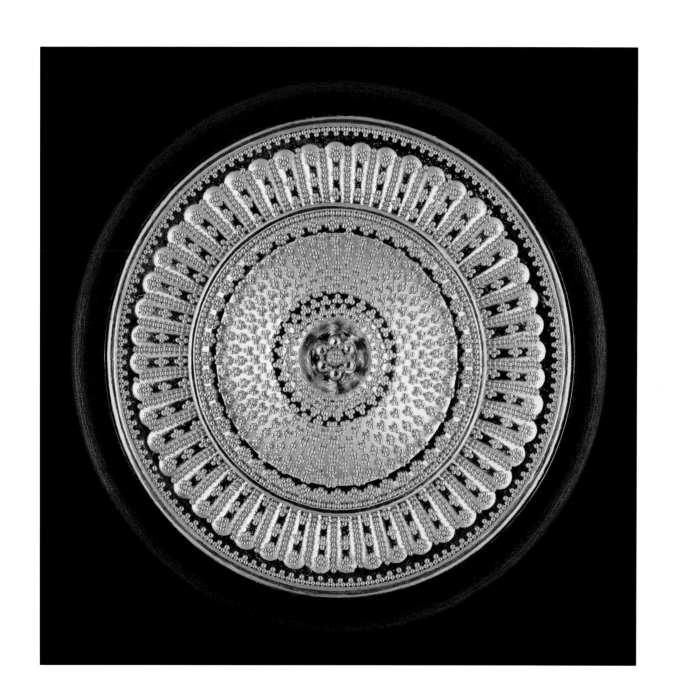

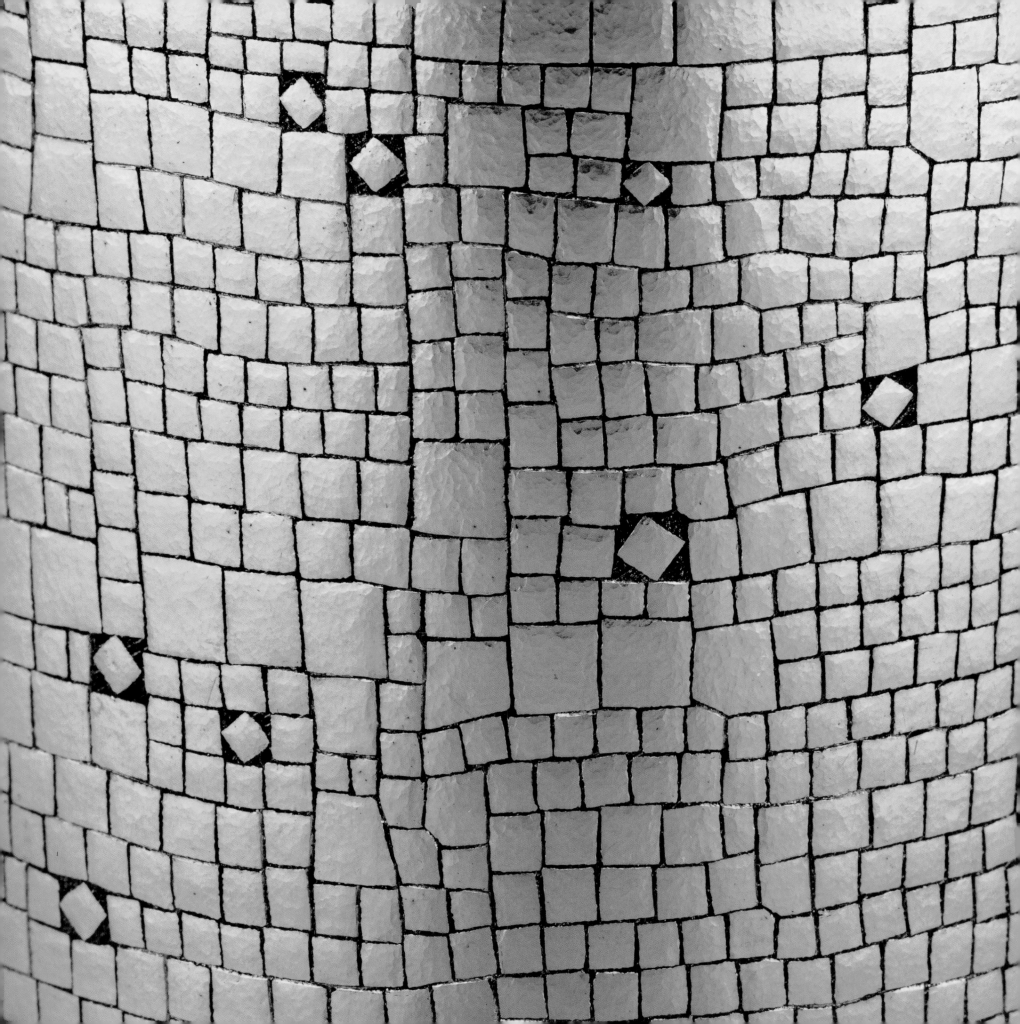

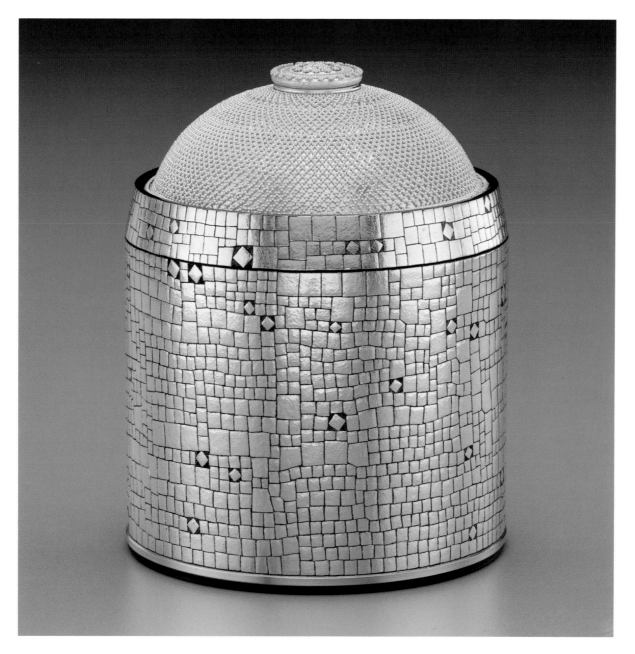

56. *Justinian.* 1989–93

Pure gold, twenty-two-karat gold, steel

3 ¹/₄ x 3 x 3 inches (8.26 x 7.62 x 7.62 cm)

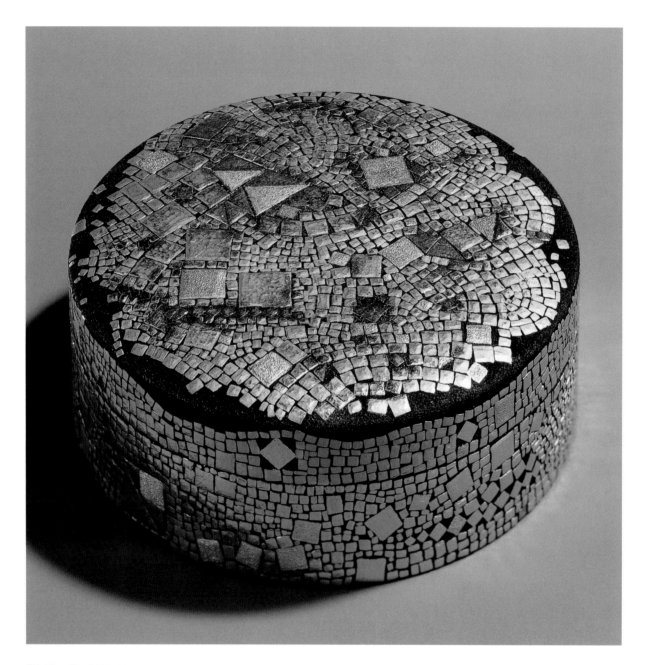

57. *Placidia.* 1988–89

Pure gold, steel

1 x 3 ¹/₂ inches (2.54 x 8.89 cm)

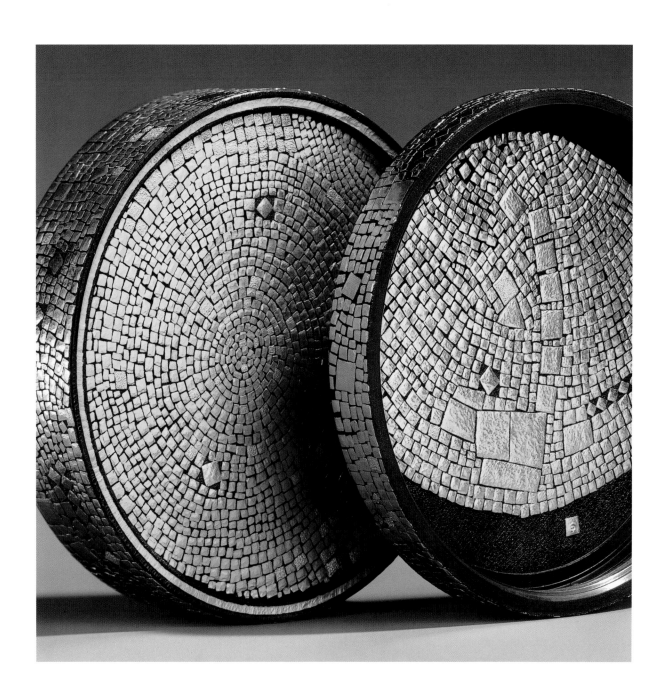

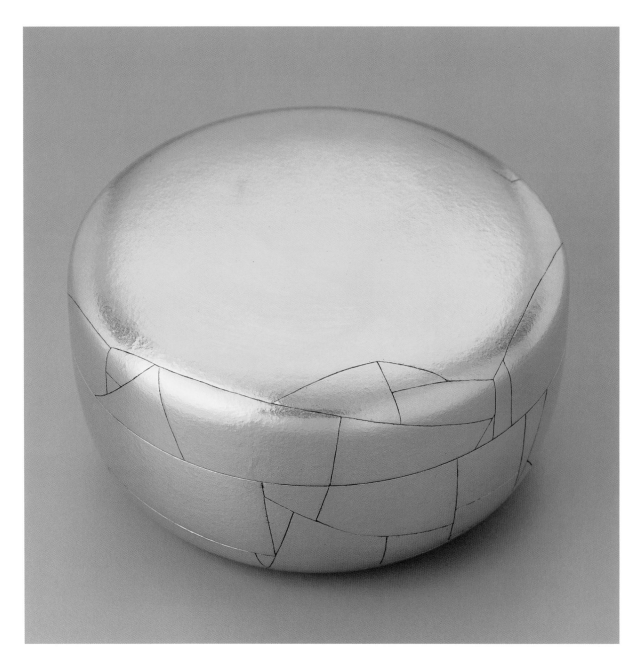

58. *Pillow Box.* 1989–93

Pure gold, steel

4 inches in diameter (10.16 cm)

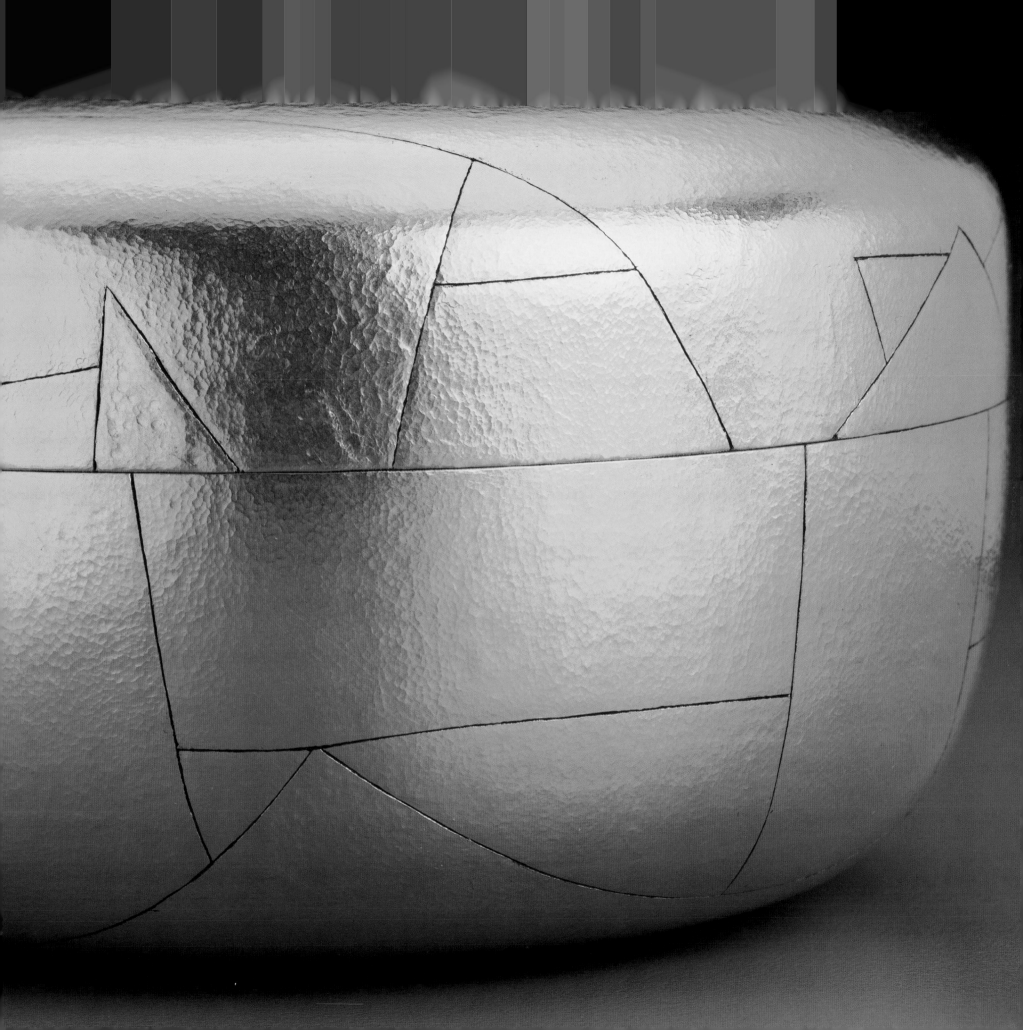

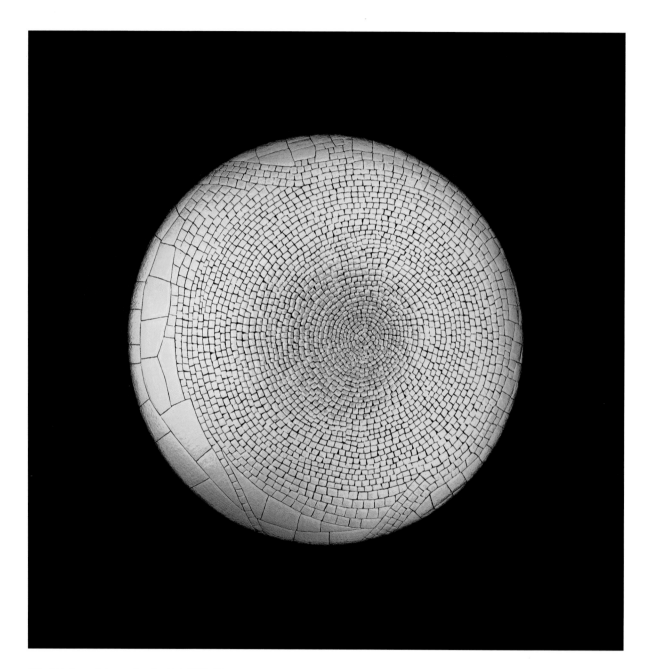

59. *Old Growth* (top and underside). 1991–93

Pure gold, steel

4 inches in diameter (10.16 cm)

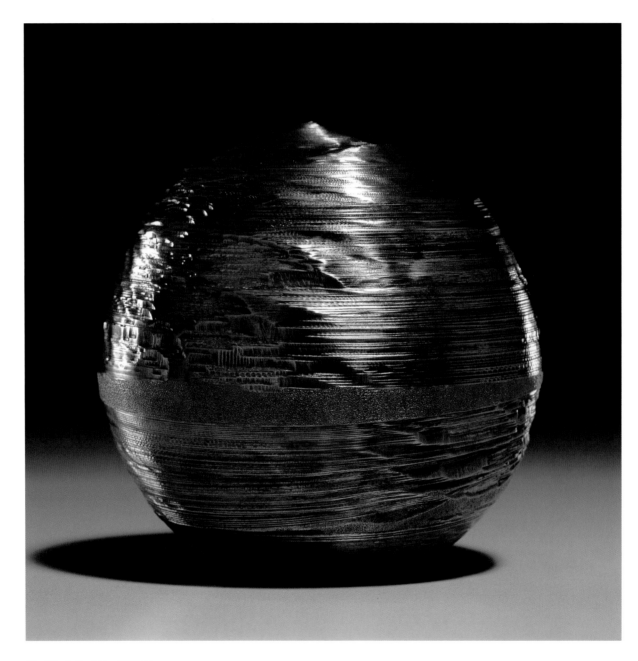

60. *Black Carbide.* 1992–94

Pure gold, steel, carbide

3 x 3 x 3 inches (7.62 x 7.62 x 7.62 cm)

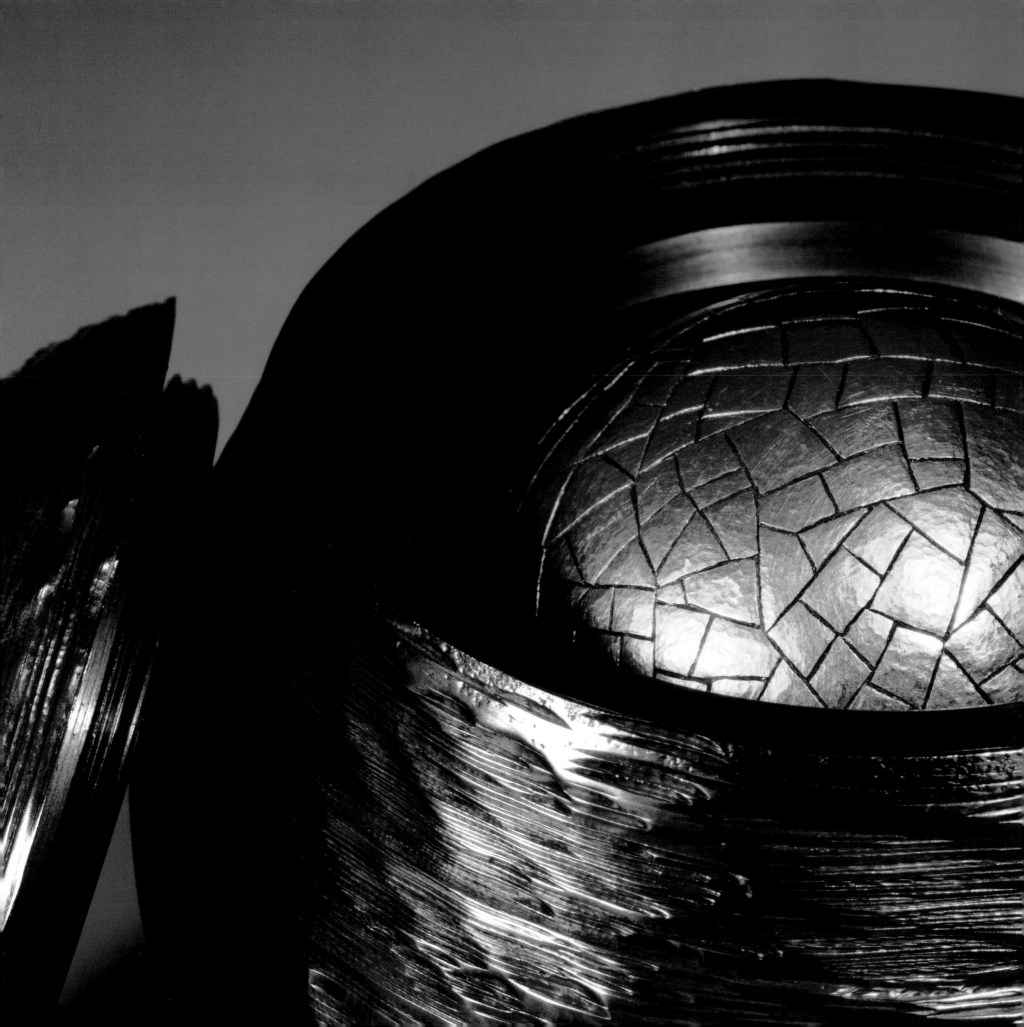

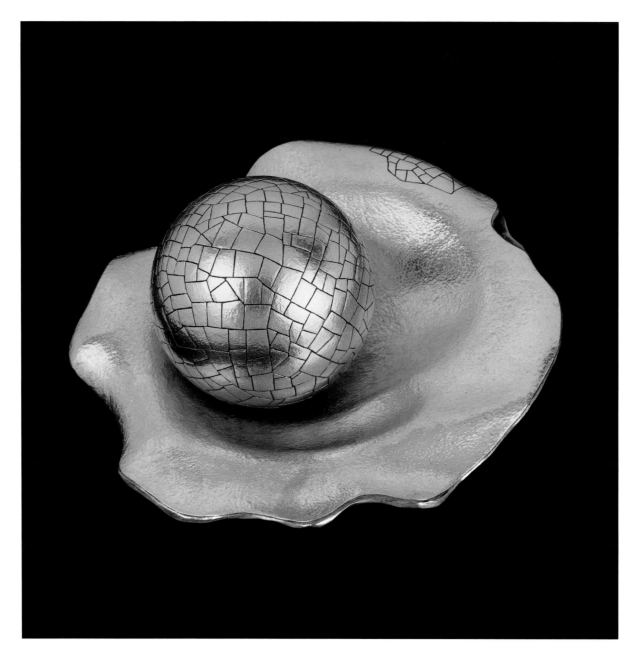

61. _Palm/Sphere._ 1992–95

Pure gold, steel

2 x 3 ¹/₄ inches (5.08 x 8.26 cm)

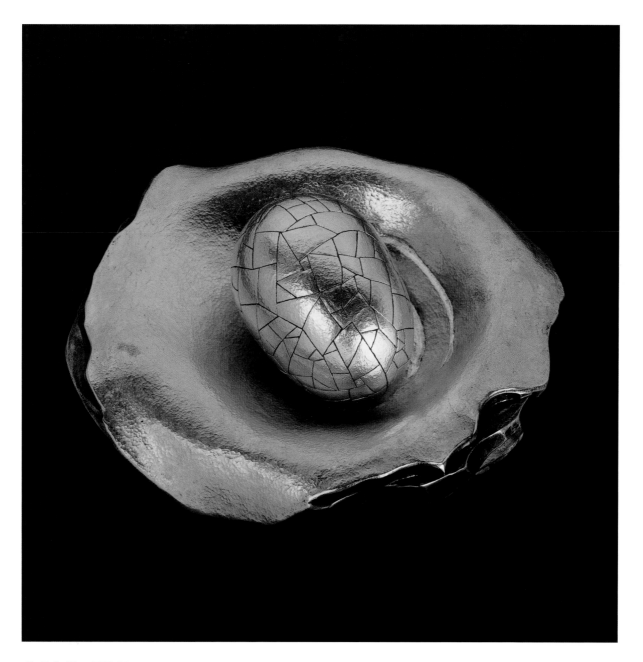

62. *Palm/Egg.* 1992–95

Pure gold, steel

2 x 3 ¹/₄ inches (5.08 x 8.26 cm)

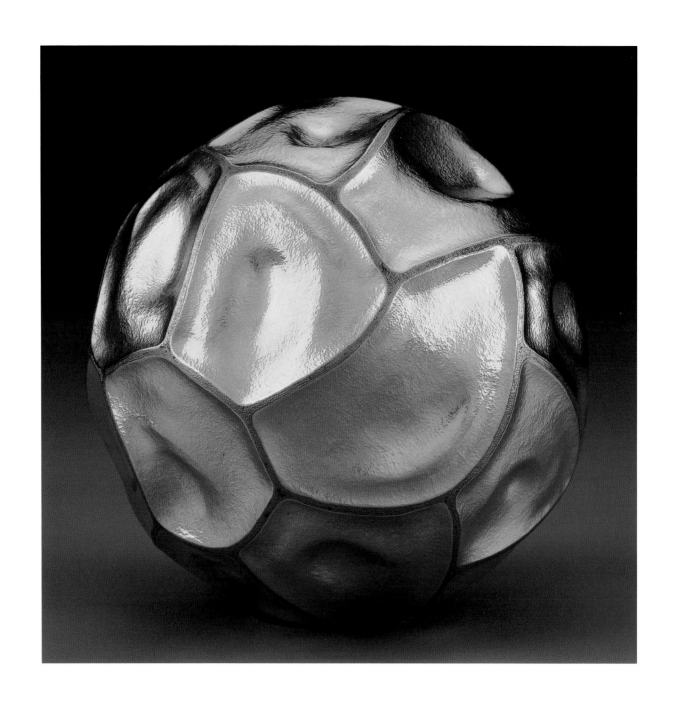

63. *Orb.* 1992–95

Pure gold, steel

4 inches (10.16 cm) diameter

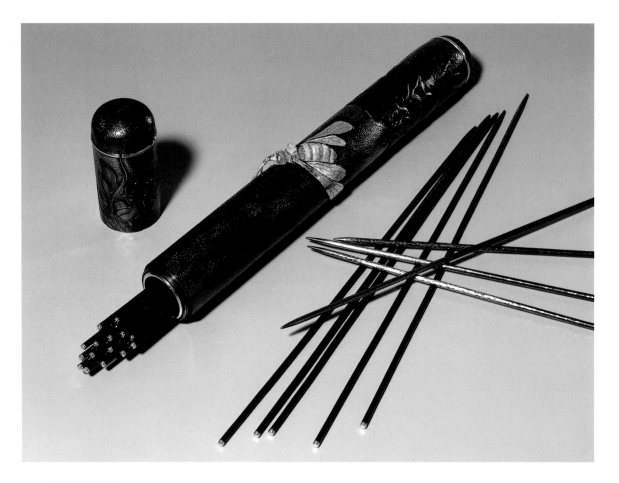

64. *"Pick-Up" Sticks.* 1988–89

Pure gold, twenty-two-karat gold, steel, iron

9 ³/₄ x 1 inches (24.77 x 2.54 cm)

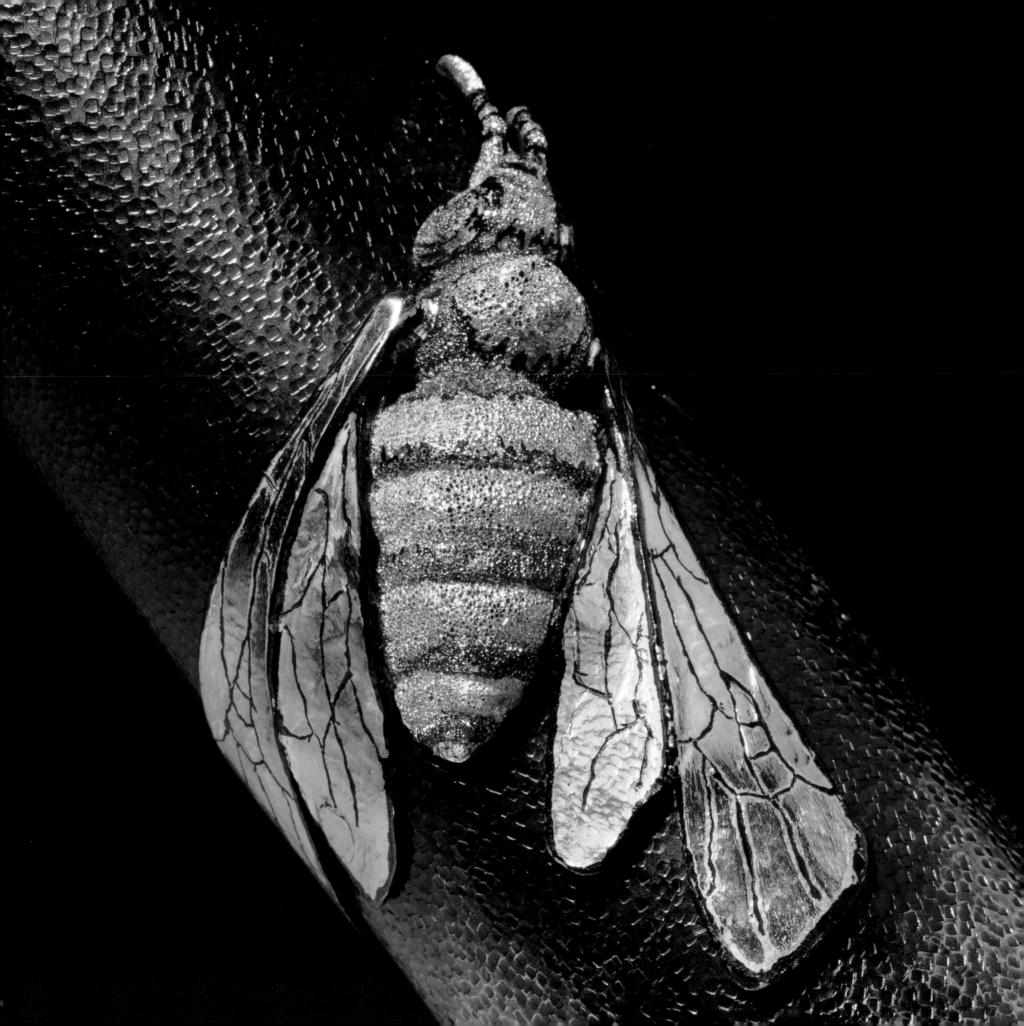

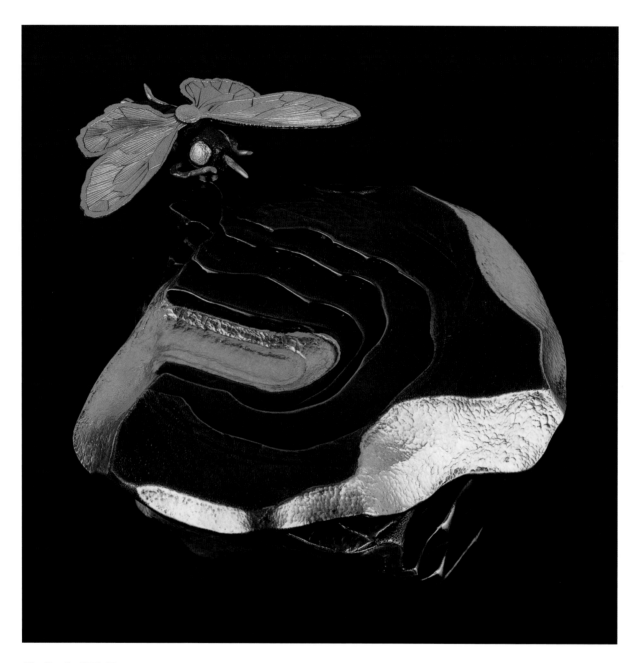

65. *Cicada.* 1991–92

Pure gold, twenty-two-karat gold, steel, rare earth magnets

1 ¹/₂ x 3 x 2 ³/₄ inches (3.81 x 7.62 x 6.99 cm)

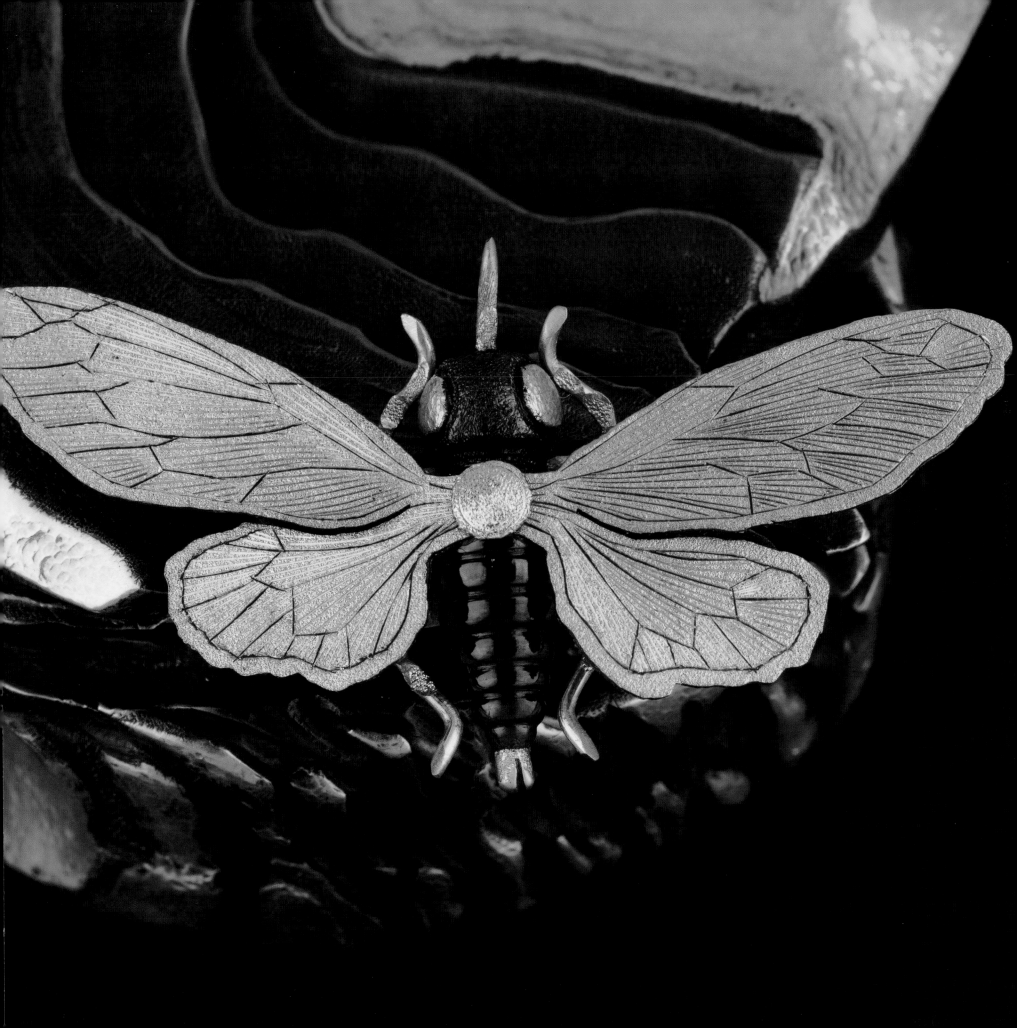

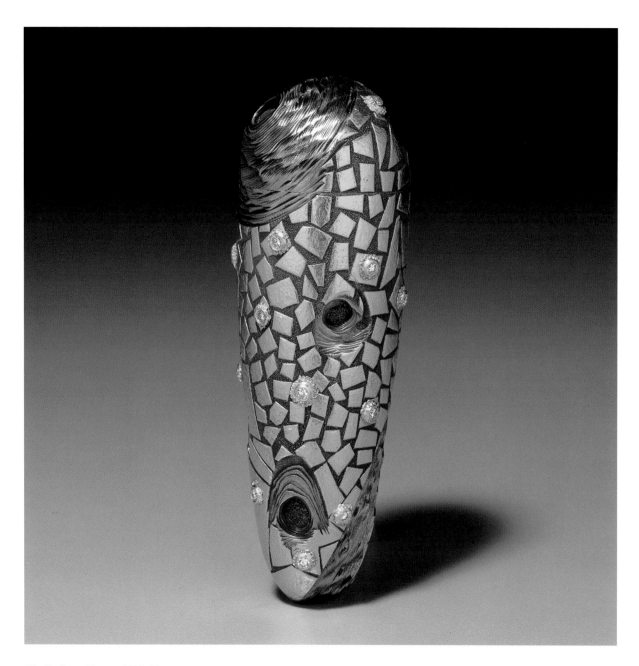

66. *Perfume Flacon.* 1990–92

Pure gold, twenty-two-karat gold, eighteen-karat gold, steel,

rare earth magnets, acrylic, cork

3 x 1 ¹/₄ inches (7.62 x 3.18 cm)

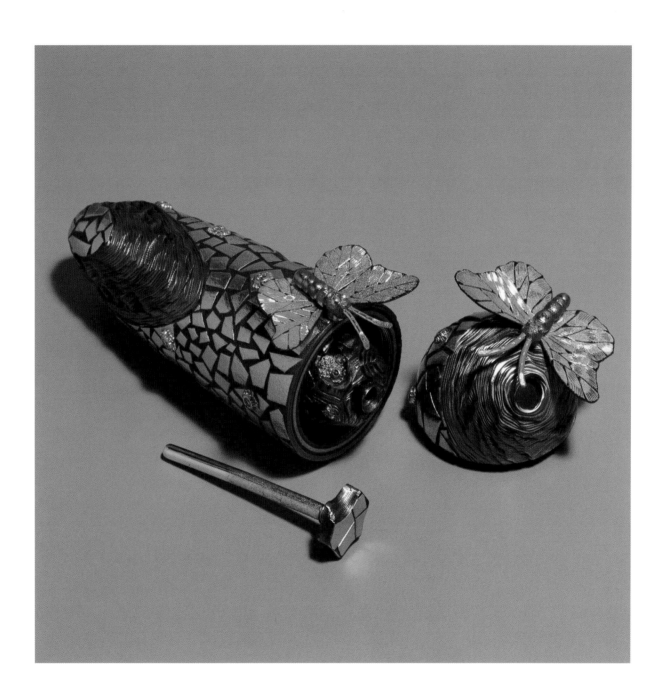

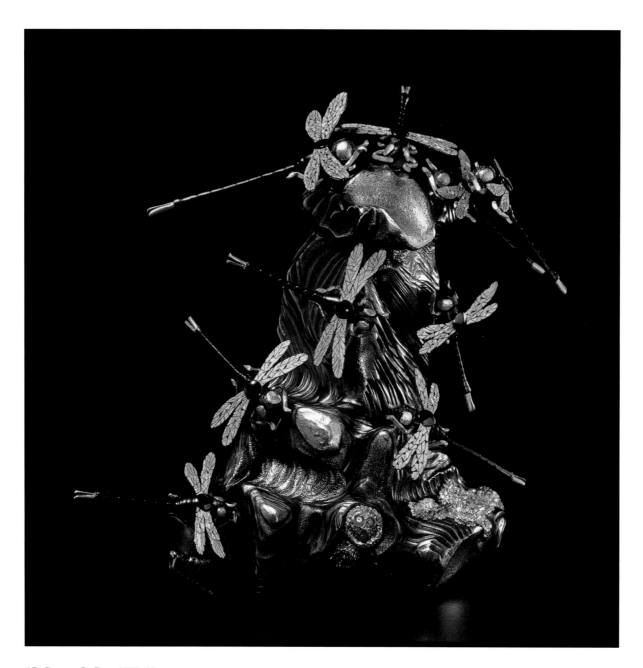

67. *Dragonfly Box.* 1989–92

Pure gold, steel, spring steel, rare earth magnets

5 x 4 x 4 inches (12.7 x 10.16 x 10.16 cm)

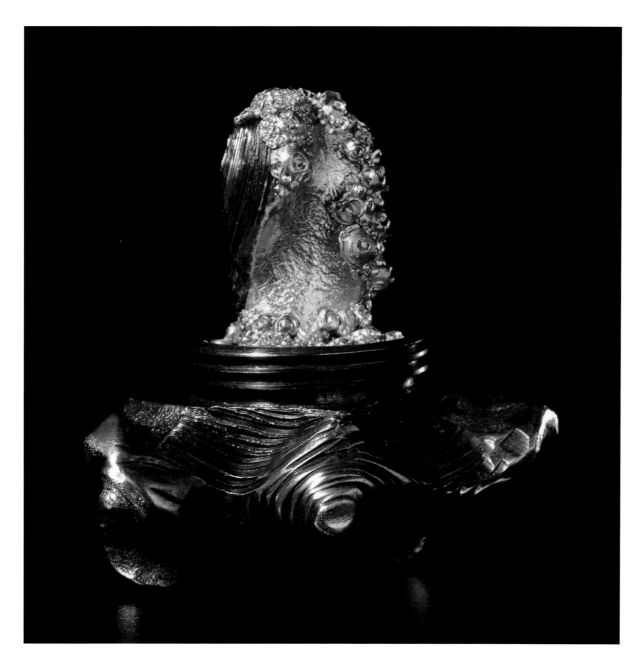

Dragonfly Box (interior)

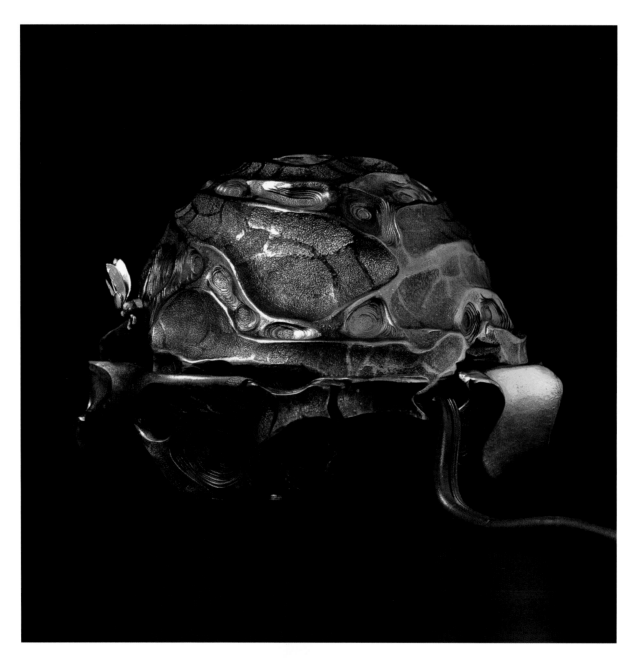

68. *Hive* (night-light). 1988–96

Pure gold, platinum, steel, rare earth magnets, electrical fixture

3 x 4 x 4 inches (7.62 x 10.16 x 10.16 cm)

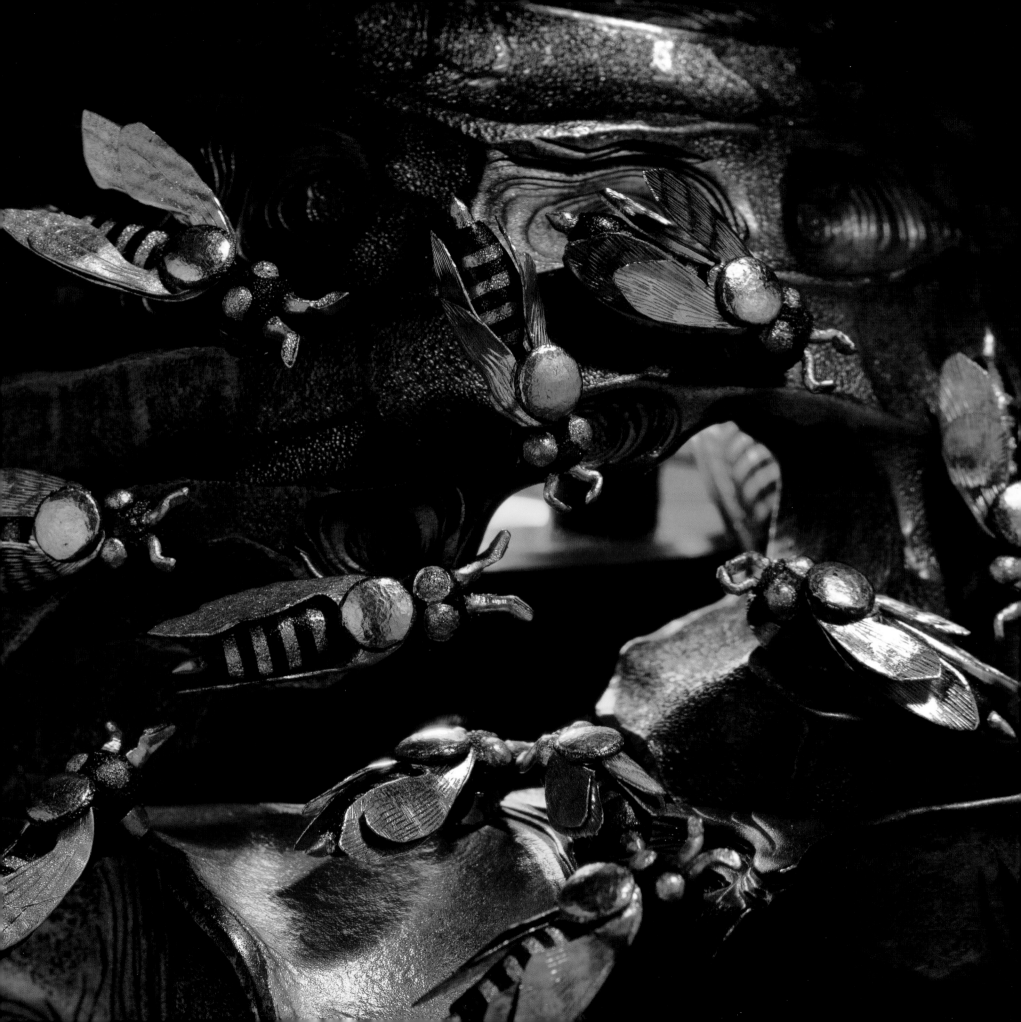

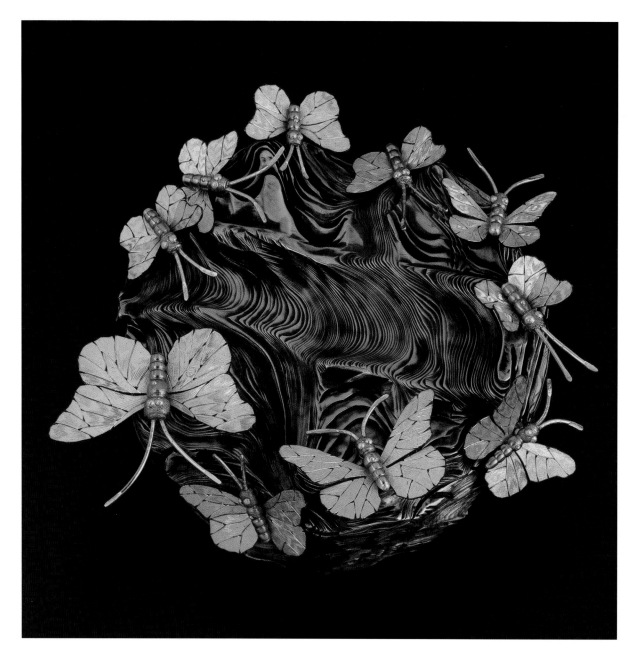

69. *Ten Butterfly Box.* 1991–93

Pure gold, steel, rare earth magnets

3 x 3 ³/₄ x 3 ³/₄ inches (7.62 x 9.53 x 9.53 cm)

Ten Butterfly Box (interior)

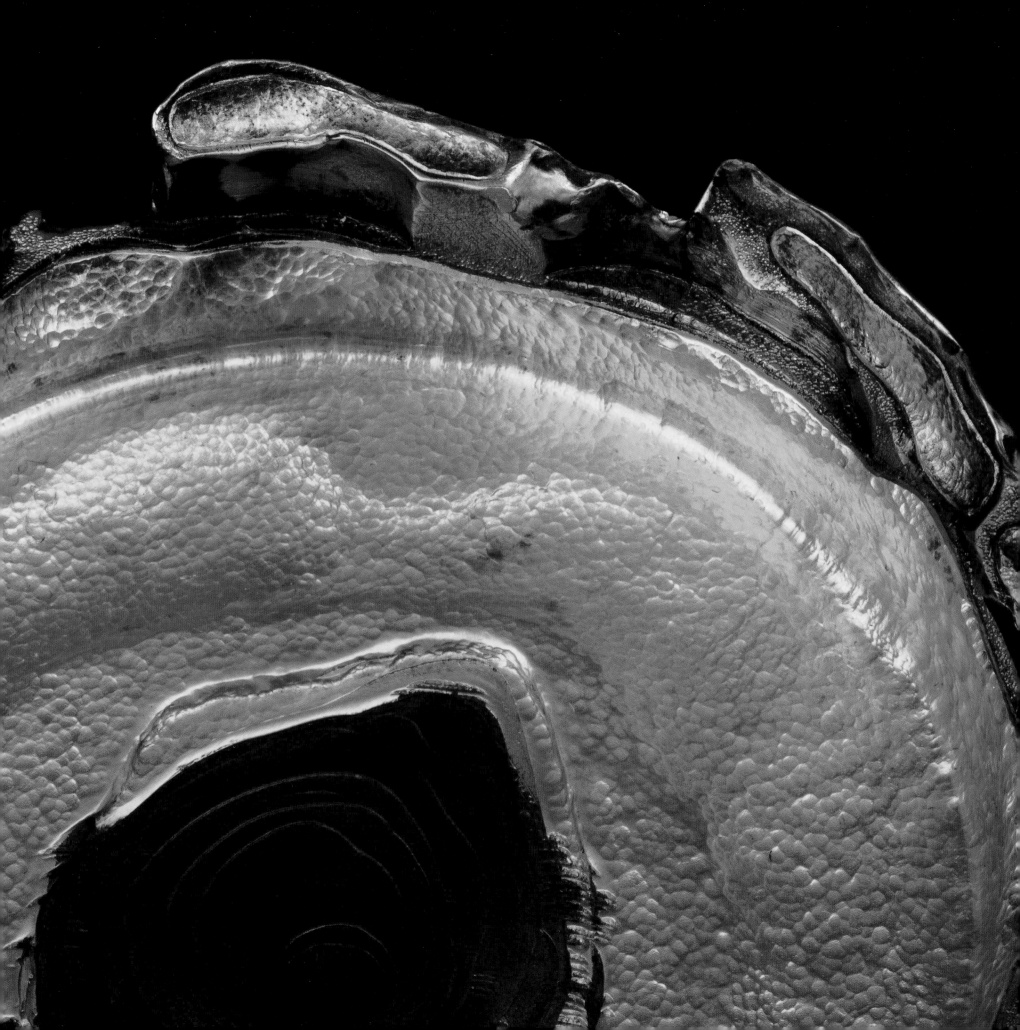

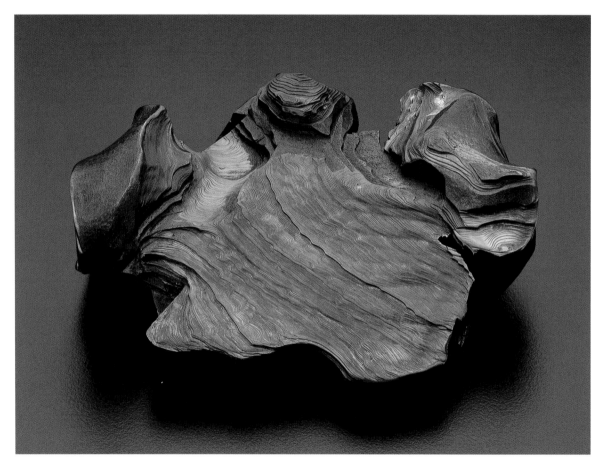

70. *Water Stone.* 1991–95

Pure gold, steel, rare earth magnets

2 x 3 x 4 inches (5.08 x 7.62 x 10.16 cm)

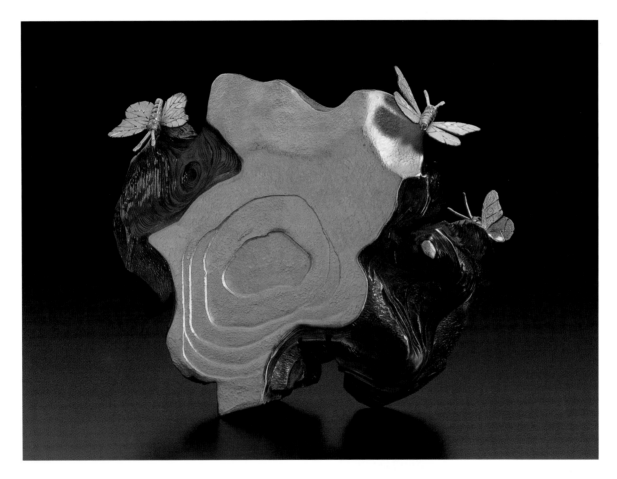

Water Stone (alternate view)

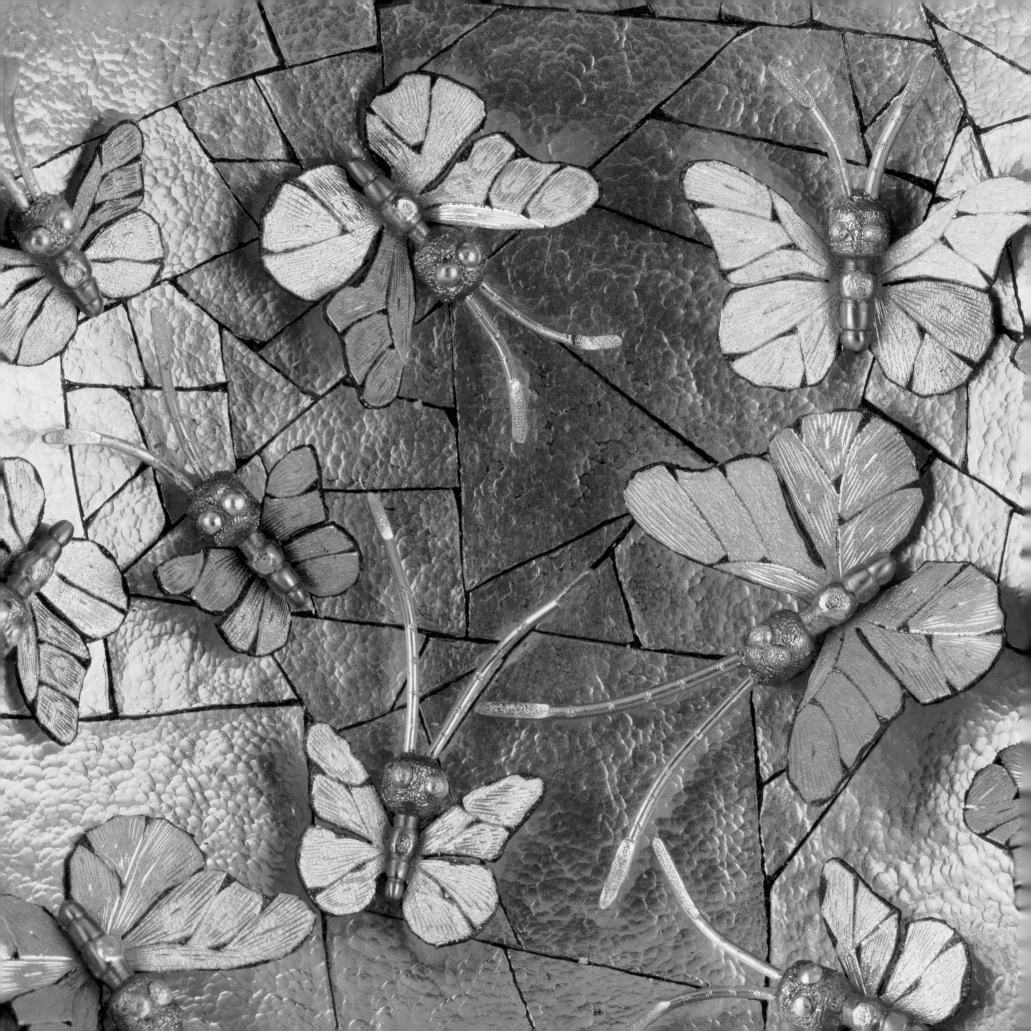

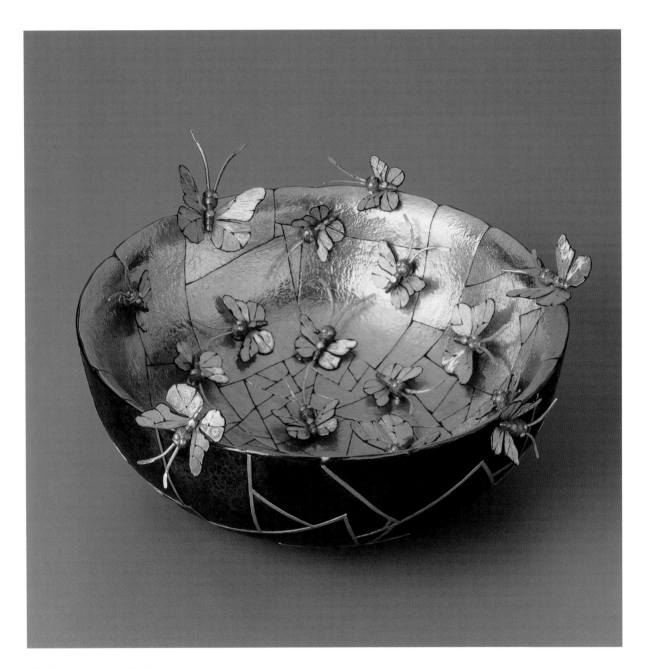

71. *Butterfly Bowl.* 1991–94

Pure gold, steel, rare earth magnets

1 ¹/₄ x 3 ³/₄ inches (3.18 x 9.53 cm)

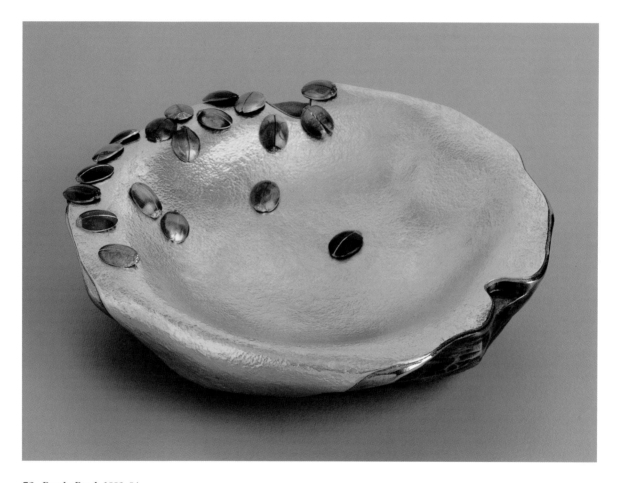

72. *Beetle Bowl.* 1992–94

Pure gold, eighteen-karat gold, steel, stainless steel

1 ¹/₈ x 3 ³/₄ inches (2.86 x 9.53 cm)

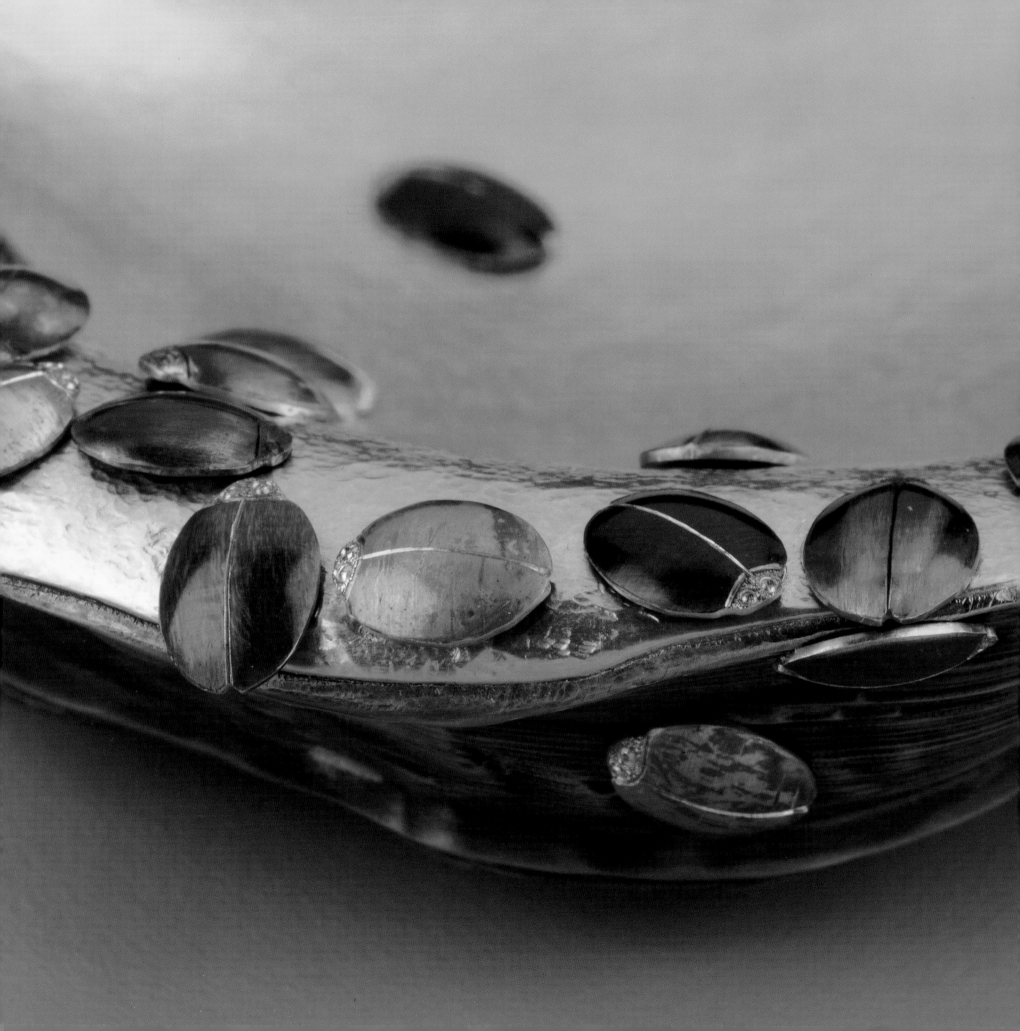

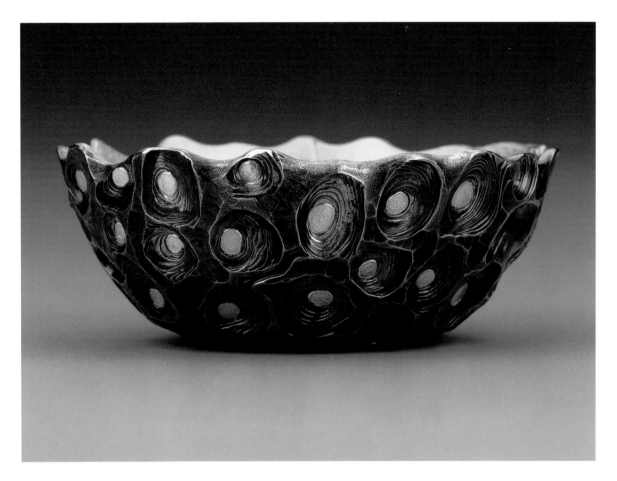

73. *Dragonfly Bowl.* 1991–93

Pure gold, steel, rare earth magnets

1 $^1/_4$ x 3 $^3/_4$ inches (3.18 x 9.53 cm)

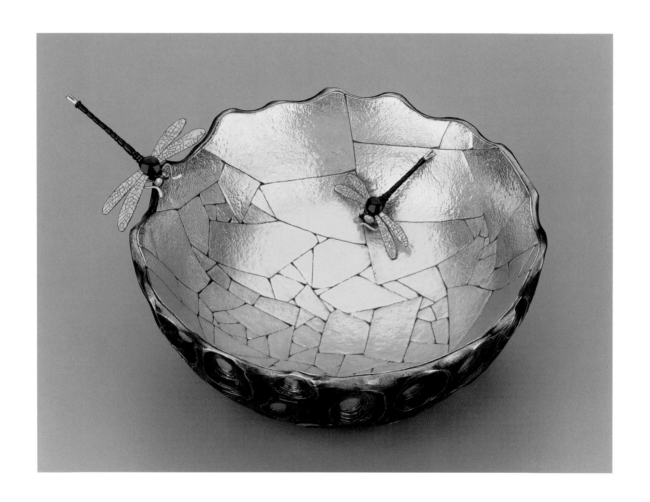

74. *Mountain.* 1990–93

Pure gold, steel, rare earth magnets

3 ³/₄ x 3 ¹/₄ inches (9.53 x 8.26 cm)

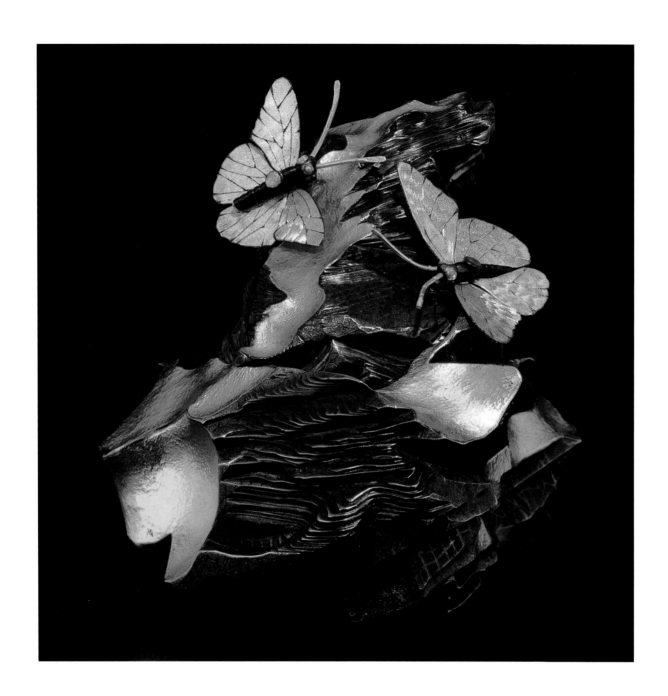

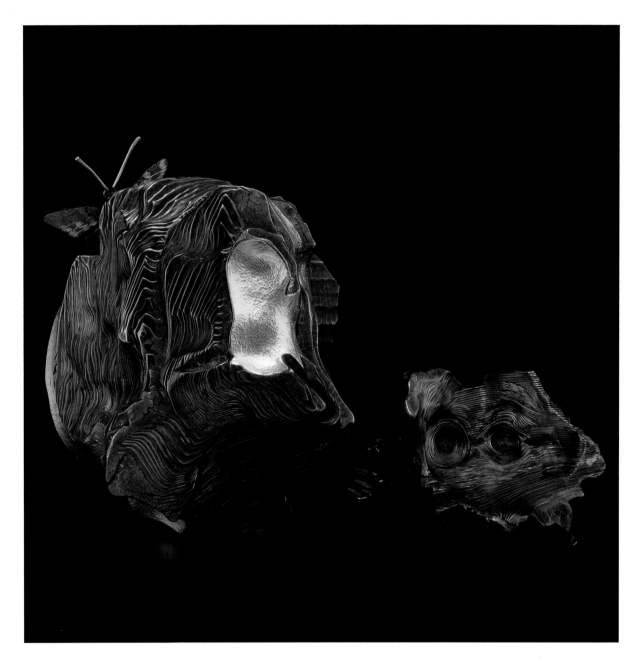

Mountain (alternate view and detail)

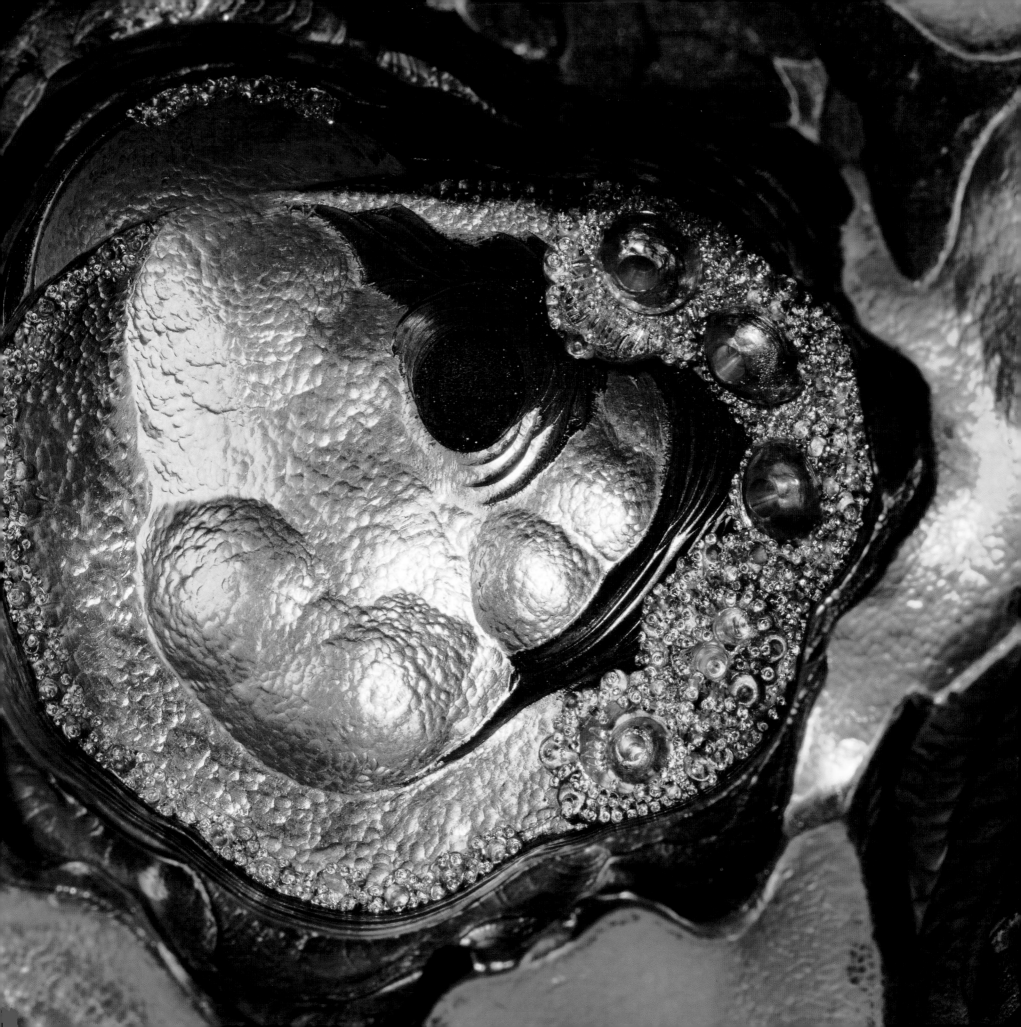

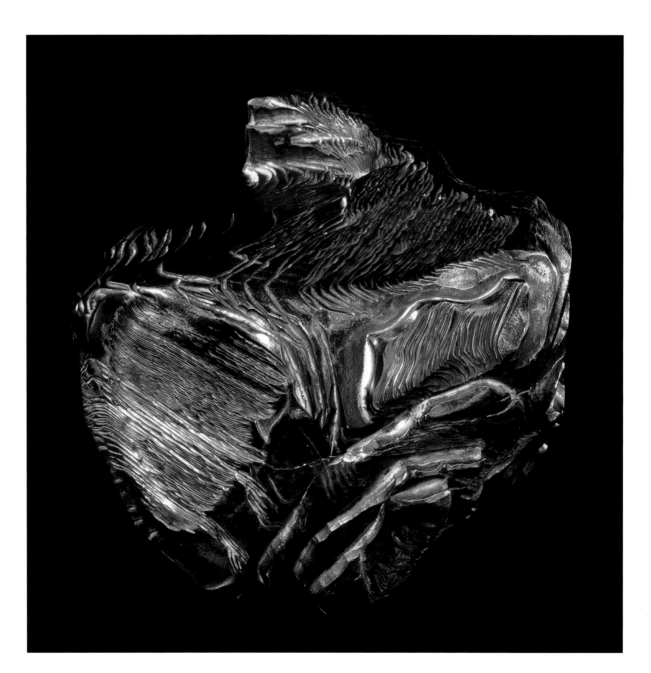

75. *Black Box I.* 1991–96

Pure gold, steel

3 x 4 inches (7.62 x 10.16 cm)

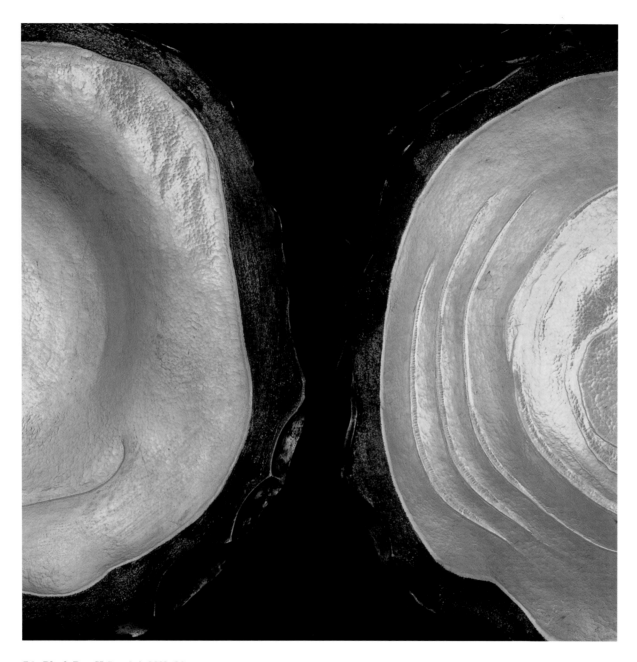

76. *Black Box II* (interior). 1991–96

Pure gold, steel

3 x 4 inches (7.62 x 10.16 cm)

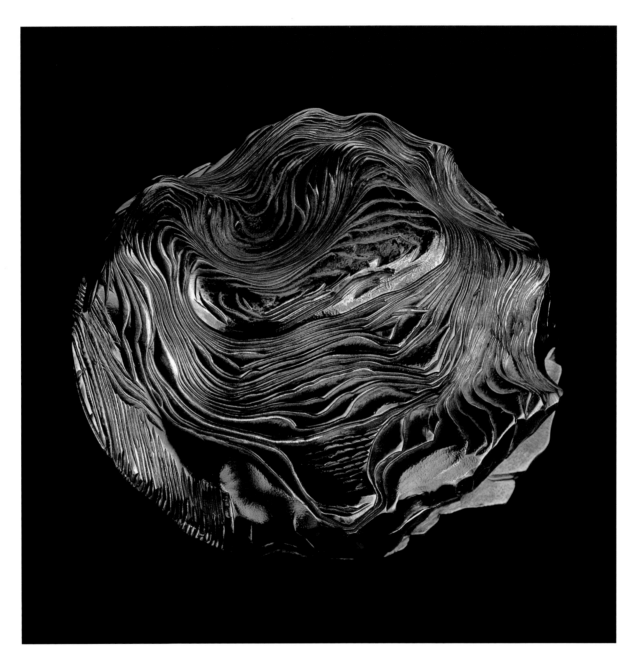

77. *Black Box III.* 1991–96

Pure gold, steel

3 x 4 inches (7.62 x 10.16 cm)

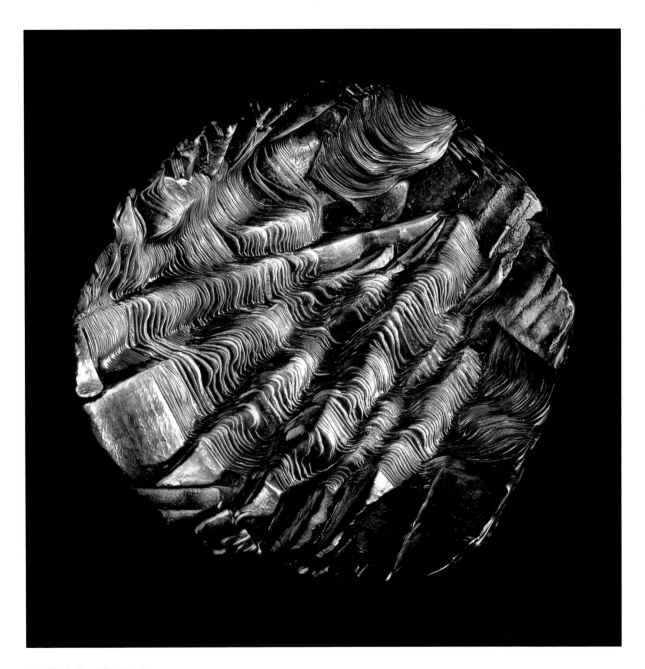

78. *Black Box IV.* 1991–96

Pure gold, steel

3 x 4 inches (7.62 x 10.16 cm)

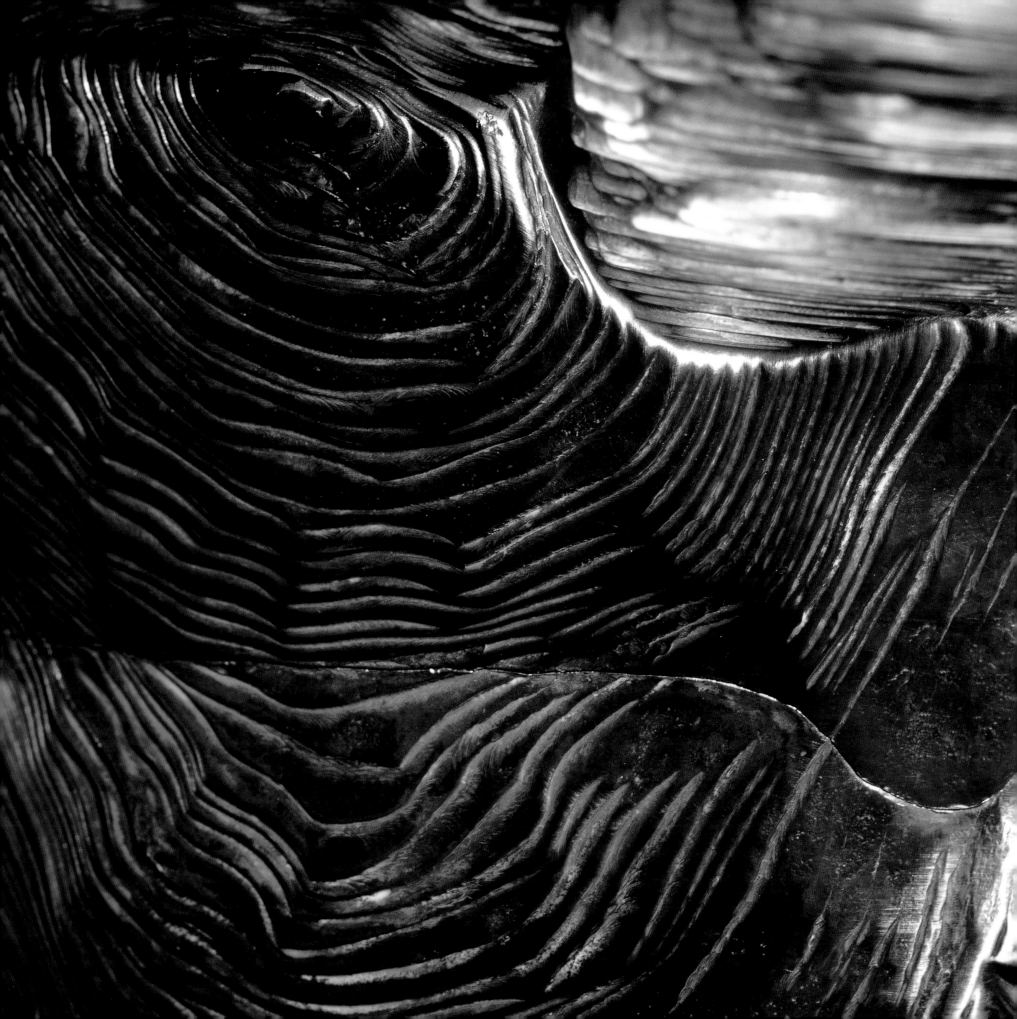

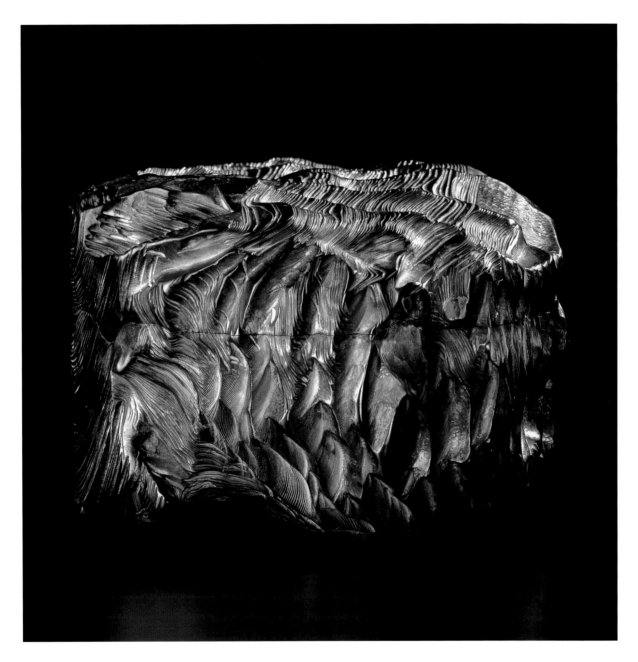

Black Box IV

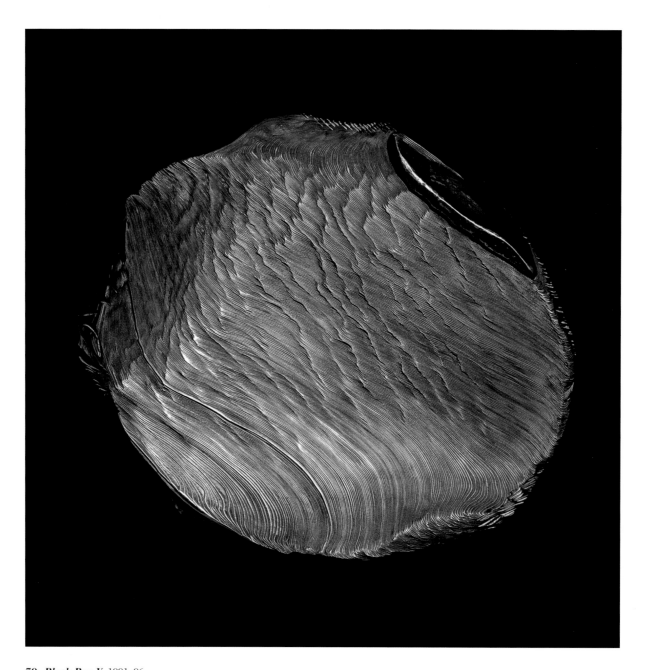

79. *Black Box V.* 1991–96

Pure gold, steel

3 x 4 inches (7.62 x 10.16 cm)

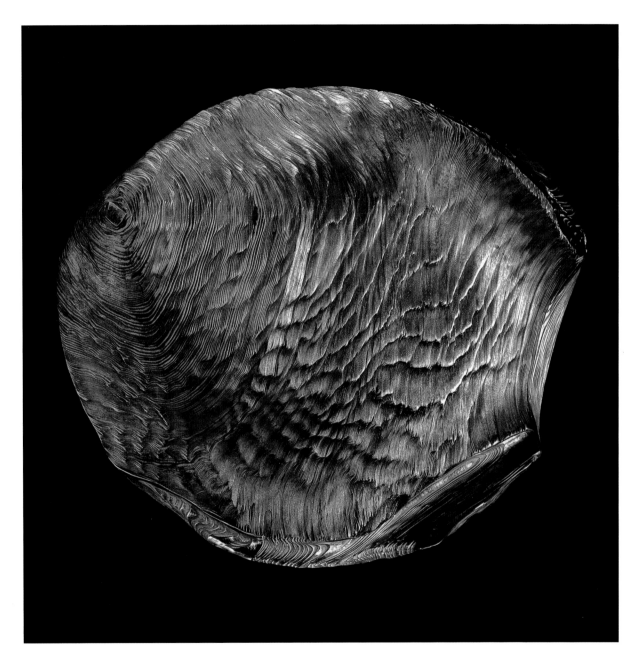

80. *Black Box VI* (top). 1991–96

Pure gold, steel

3 x 4 inches (7.62 x 10.16 cm)

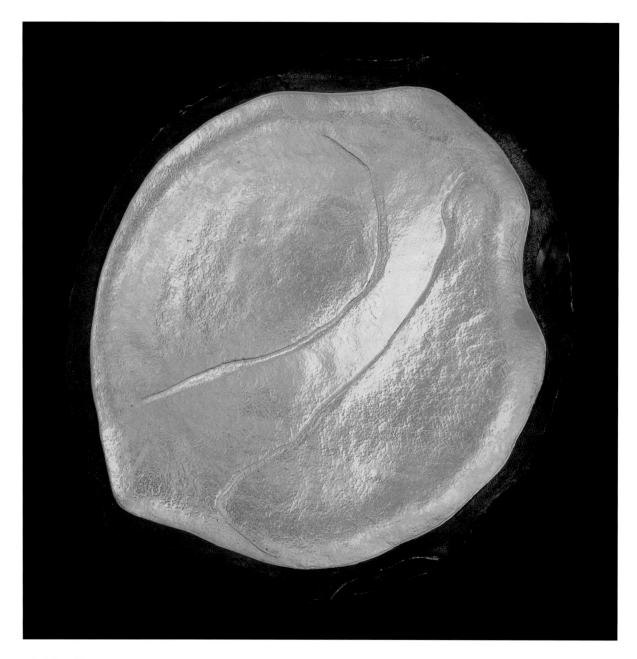

Black Box VI (interiors)

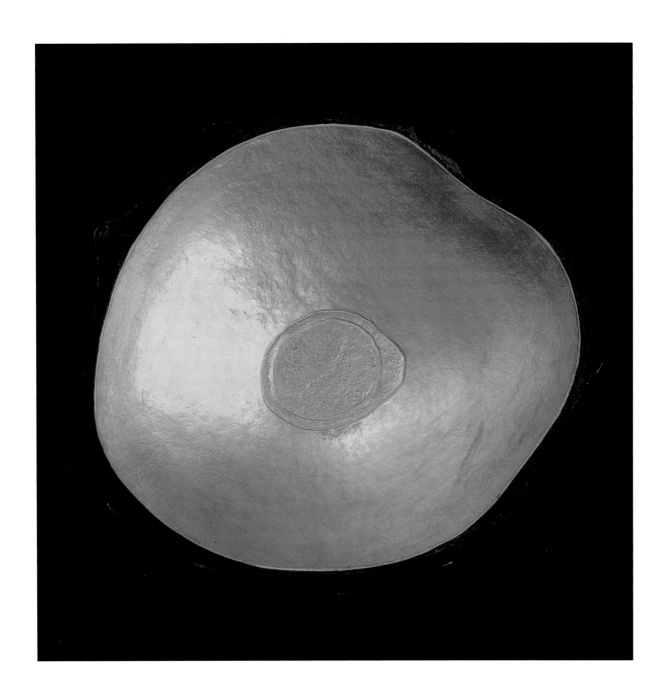

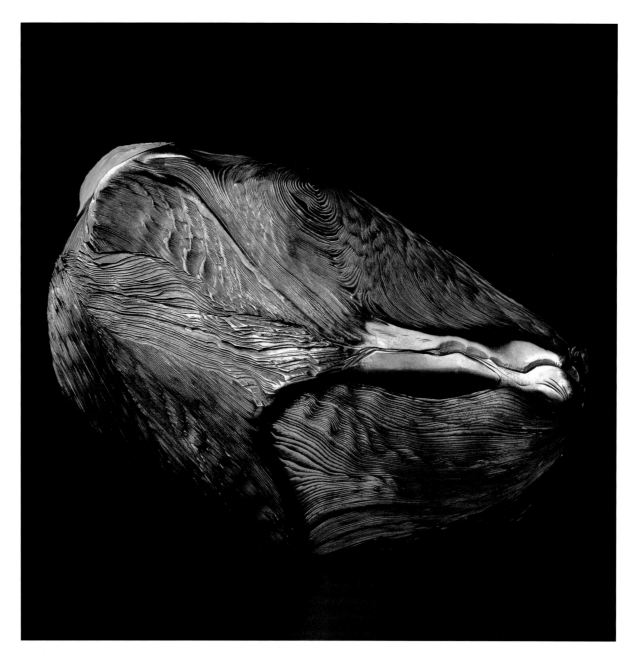

81. *Black Box VII.* 1991–96

Pure gold, steel

3 x 4 inches (7.62 x 10.16 cm)

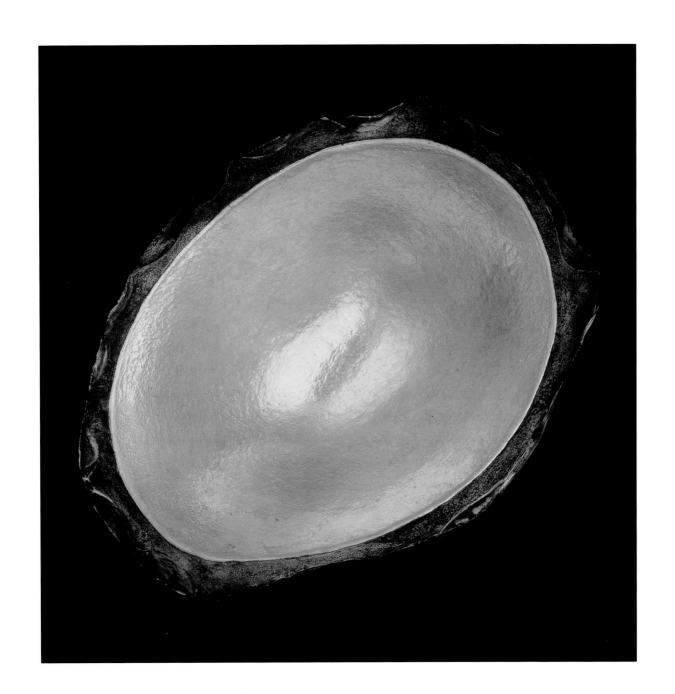

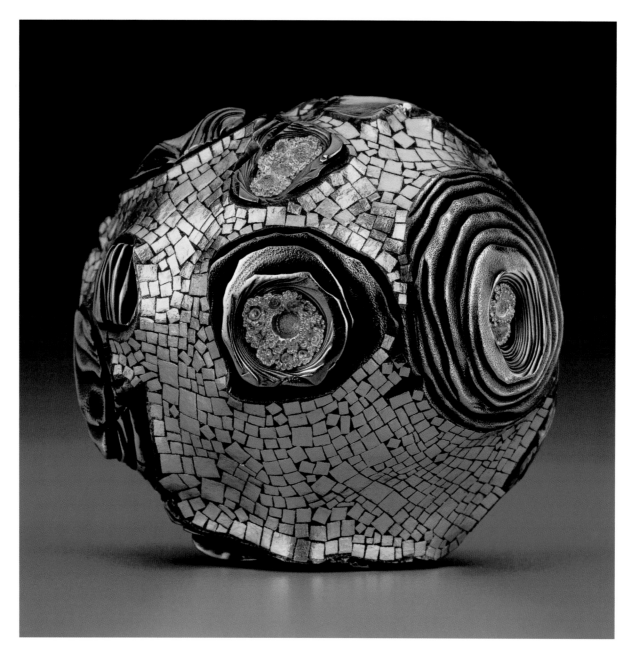

82. *Sharp Edge.* 1995–96

Pure gold, steel

2 ⁷⁄₈ x 4 x 4 inches (7.32 x 10.16 x 10.16 cm)

Sharp Edge (interior)

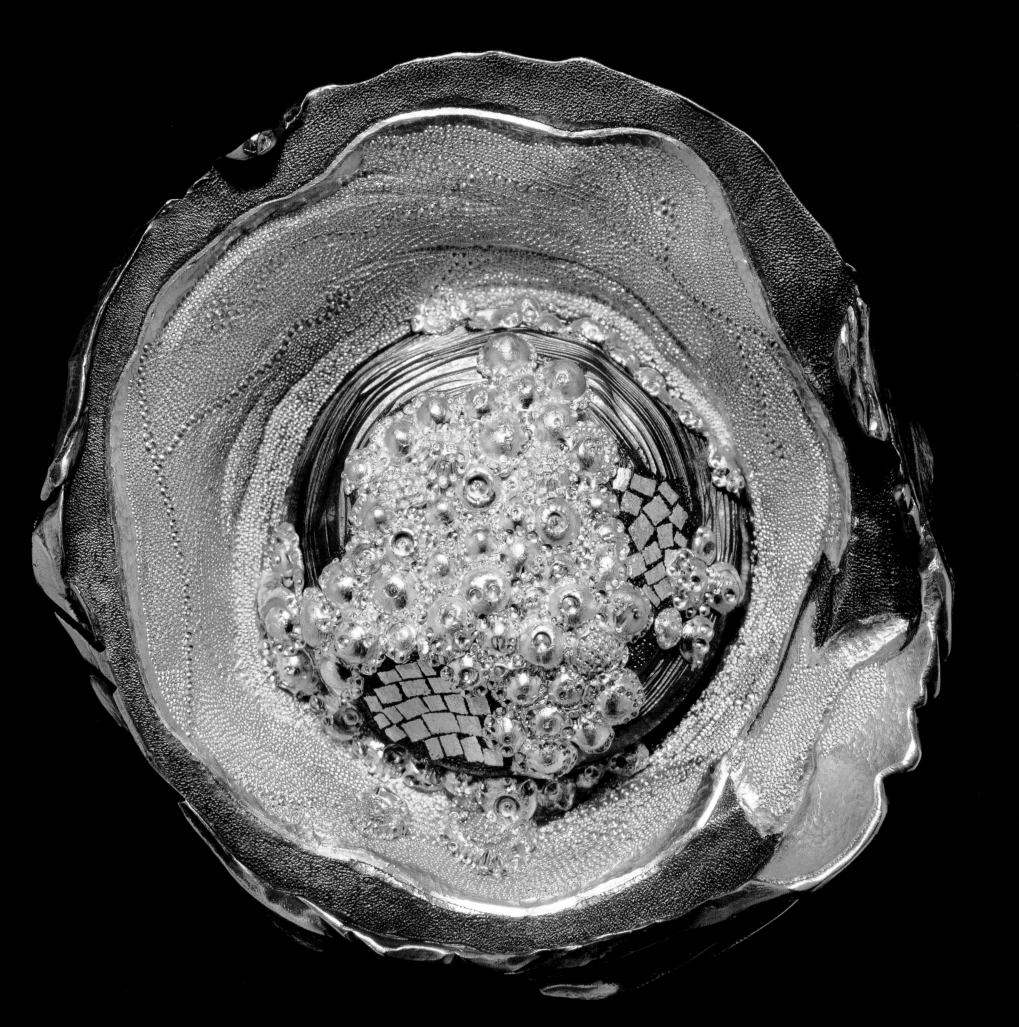

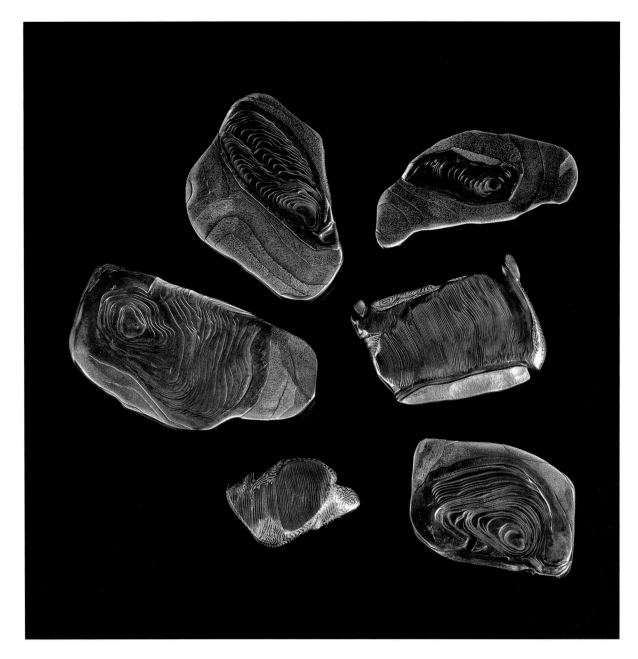

83. *Stones.* 1995–96

Pure gold, steel

Largest 3 x 1 $^3/_4$ x $^1/_4$ inches (7.62 x 4.45 x .64 cm)

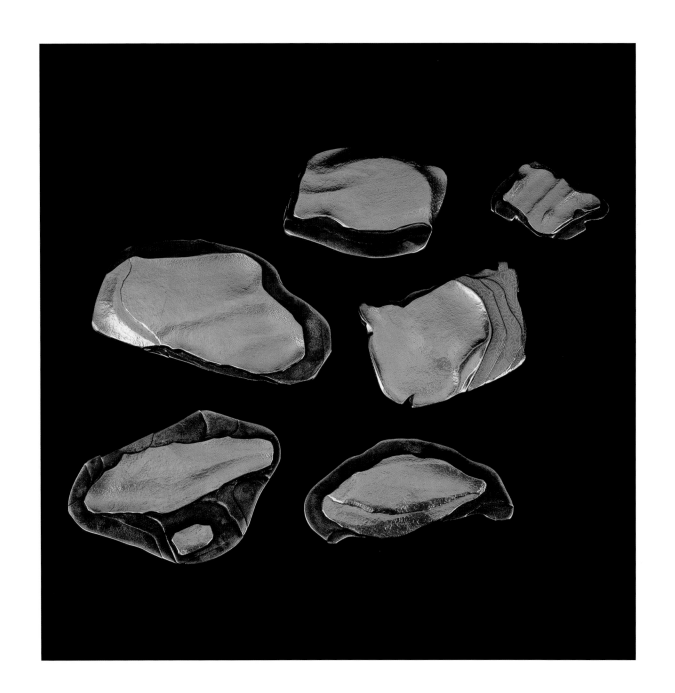

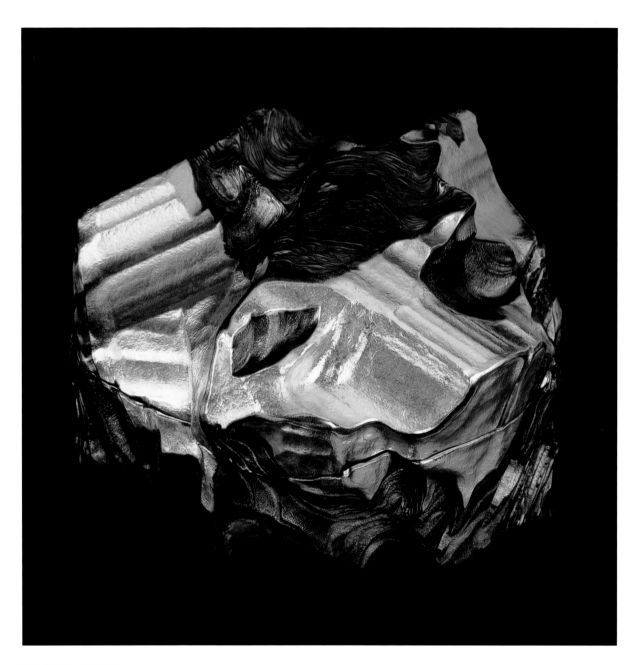

84. *Rivulet.* 1994–96

Pure gold, steel

3 x 4 x 4 inches (7.62 x 10.16 x 10.16 cm)

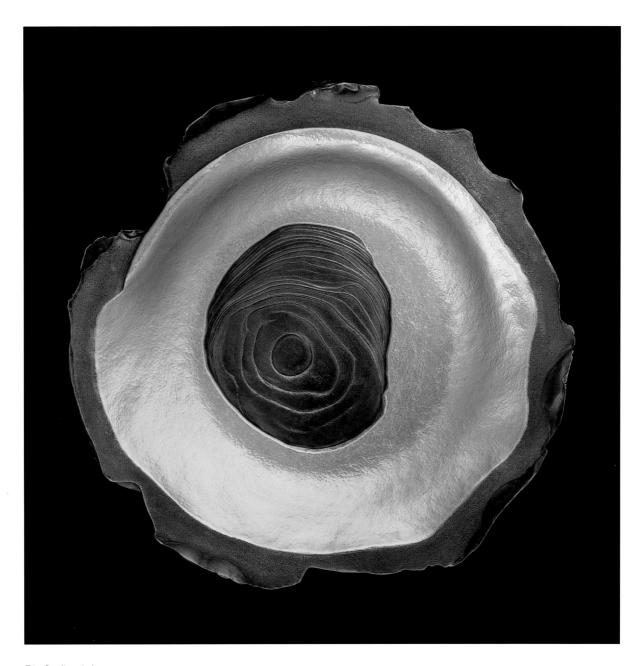

Rivulet (interior)

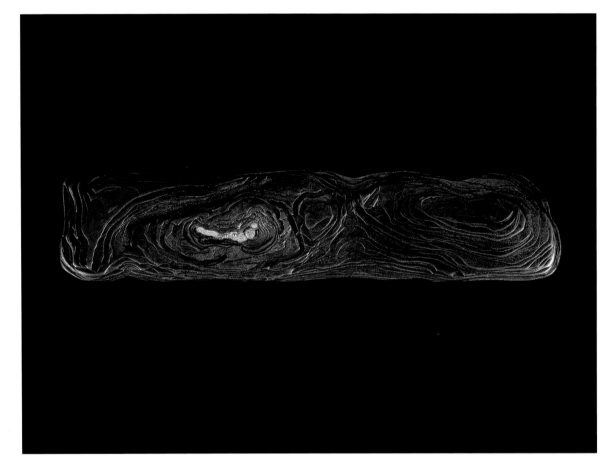

85. *Cobra Piece.* 1992

Pure gold, steel

$^1/_4$ x 5 $^3/_4$ x 1 $^1/_4$ inches (.64 x 14.61 x 3.18 cm)

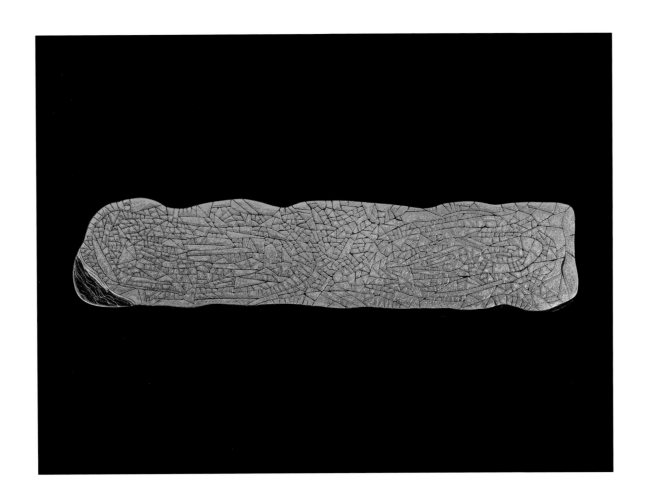

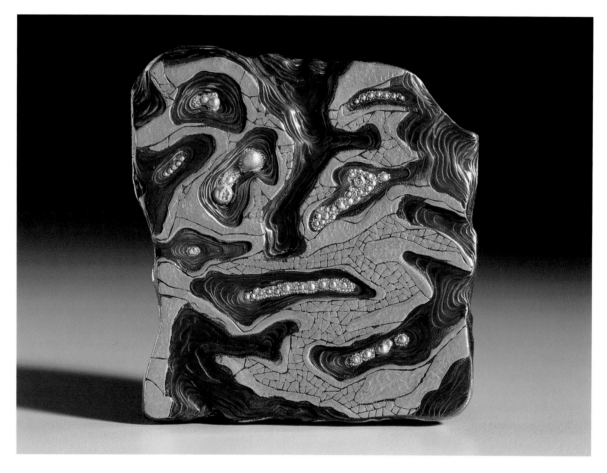

86. _Maze._ 1992

Pure gold, steel

2 ³/₄ x 2 ⁷/₈ x ³/₄ inches (6.99 x 7.32 x 1.91 cm)

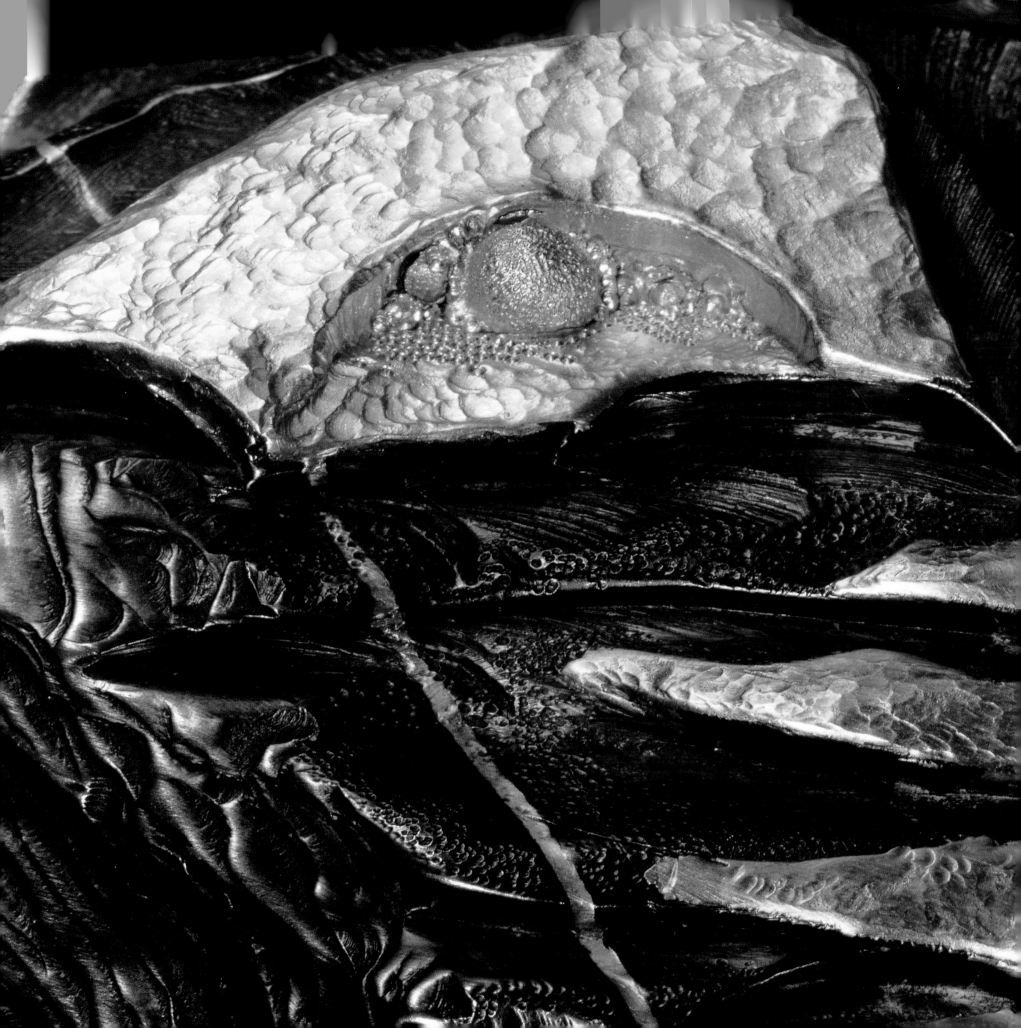

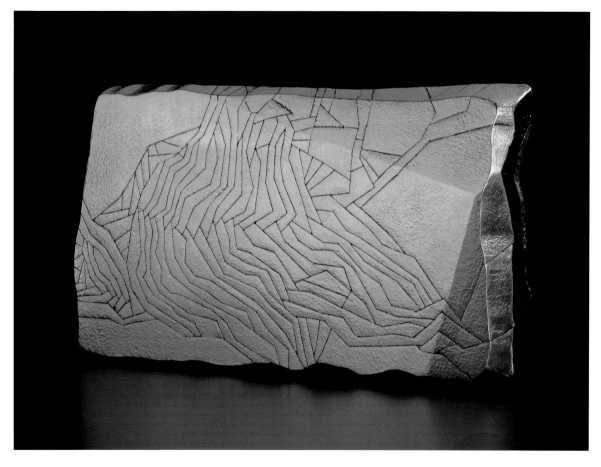

87. Slab. 1991–93

Pure gold, steel

2 $^1/_4$ x 4 x $^3/_4$ inches (5.72 x 10.16 x 1.91 cm)

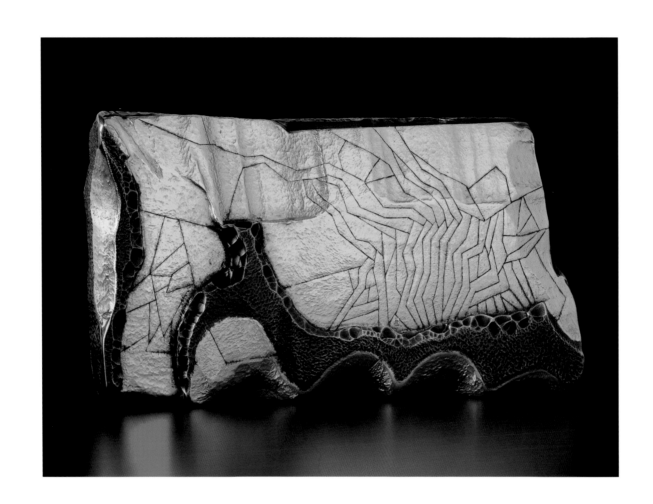

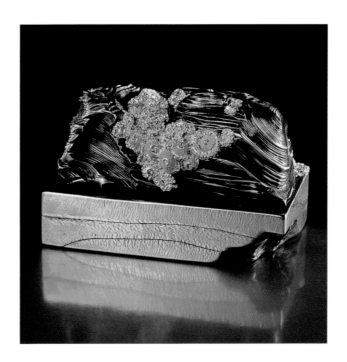

88. *Range.* 1991–94

Pure gold, steel

1 ¹/₂ x 2 ¹/₂ x 1 ¹/₄ inches (3.81 x 6.35 x 3.18 cm)

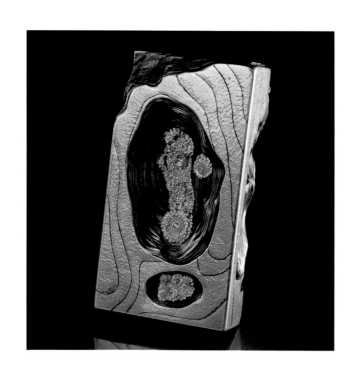

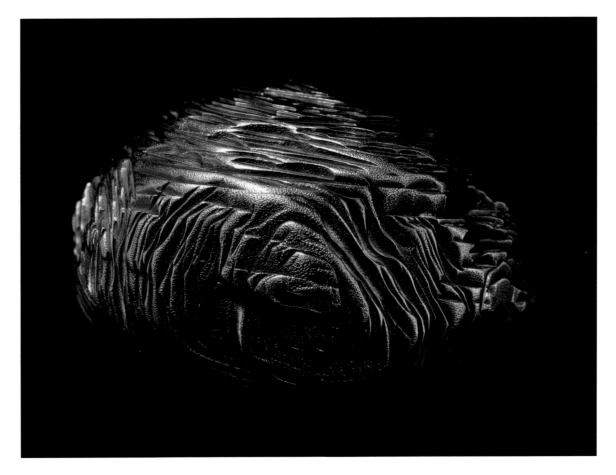

89. Fingerprint. 1993–94

Pure gold, steel

2 x 3 x 3 inches (5.08 x 7.62 x 7.62 cm)

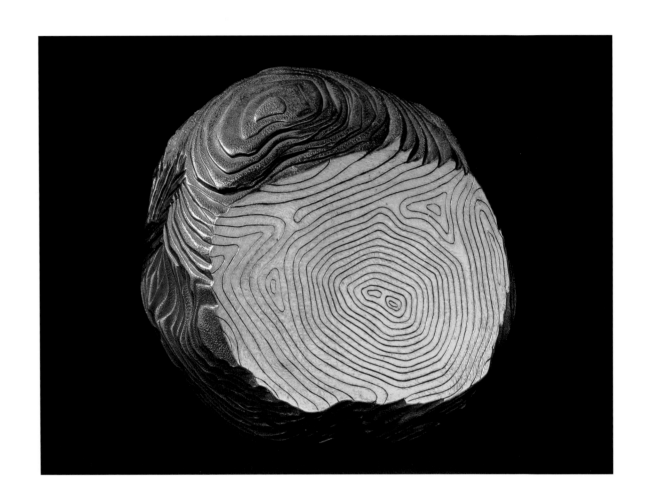

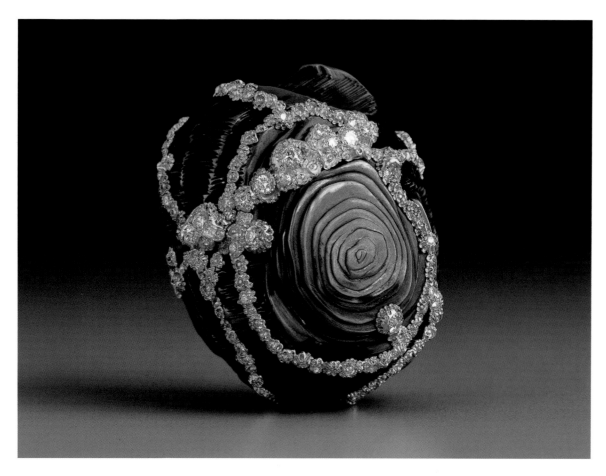

90. *Diamond Egg.* 1991–93

Pure gold, diamonds, steel

2 x 1 ¹/₂ x 1 ¹/₂ inches (5.08 x 3.81 x 3.81 cm)

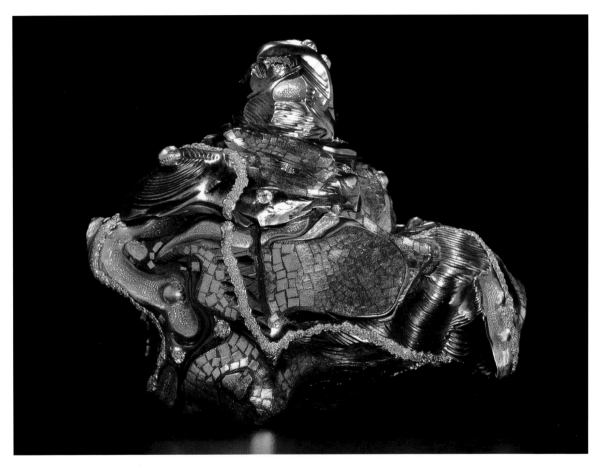

91. *Polestar* 1991–93

Pure gold, diamonds, steel

2 3/4 x 3 1/2 x 2 inches (6.99 x 8.90 x 5.08 cm)

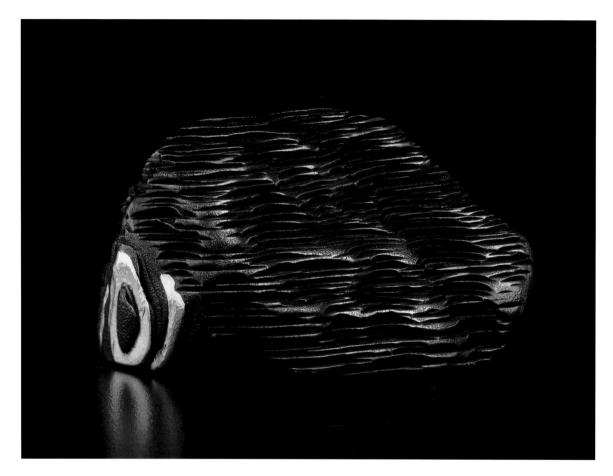

92. _Table Boulder._ 1990–93

Pure gold, steel

_1 $^1/_2$ x 2 $^3/_4$ inches (3.81 x 6.99 cm)_

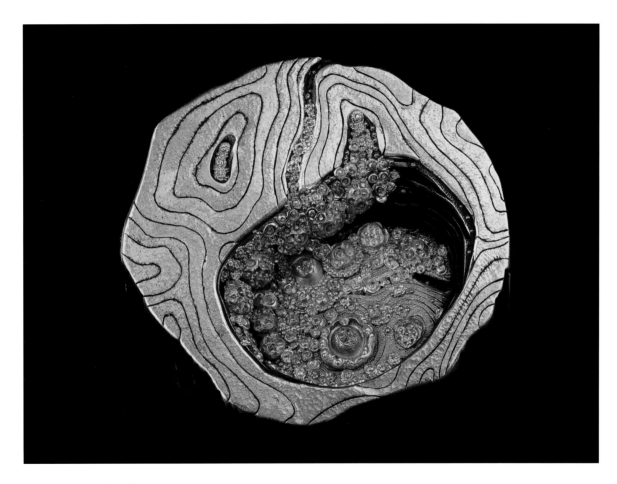

Table Boulder (underside)

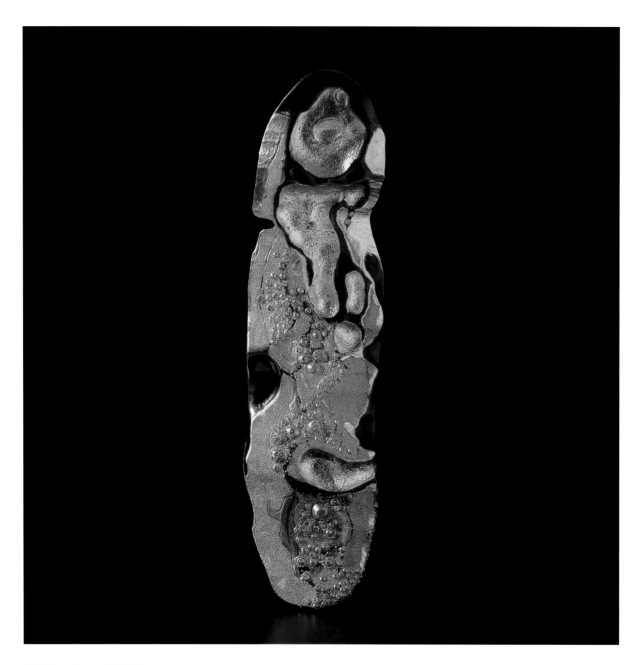

93. *Hand Piece.* 1987–95

Pure gold, steel

6 1/4 x 1 3/4 x 1/2 inches (15.88 x 4.45 x 1.27 cm)

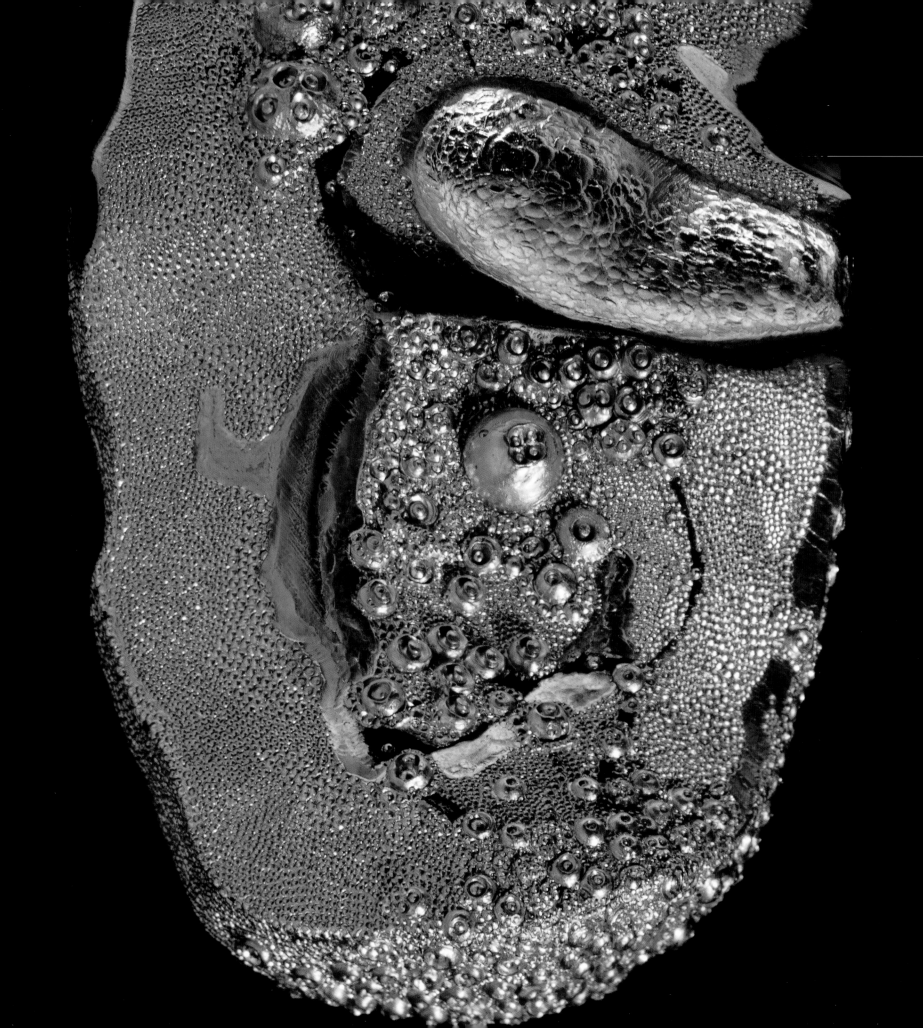

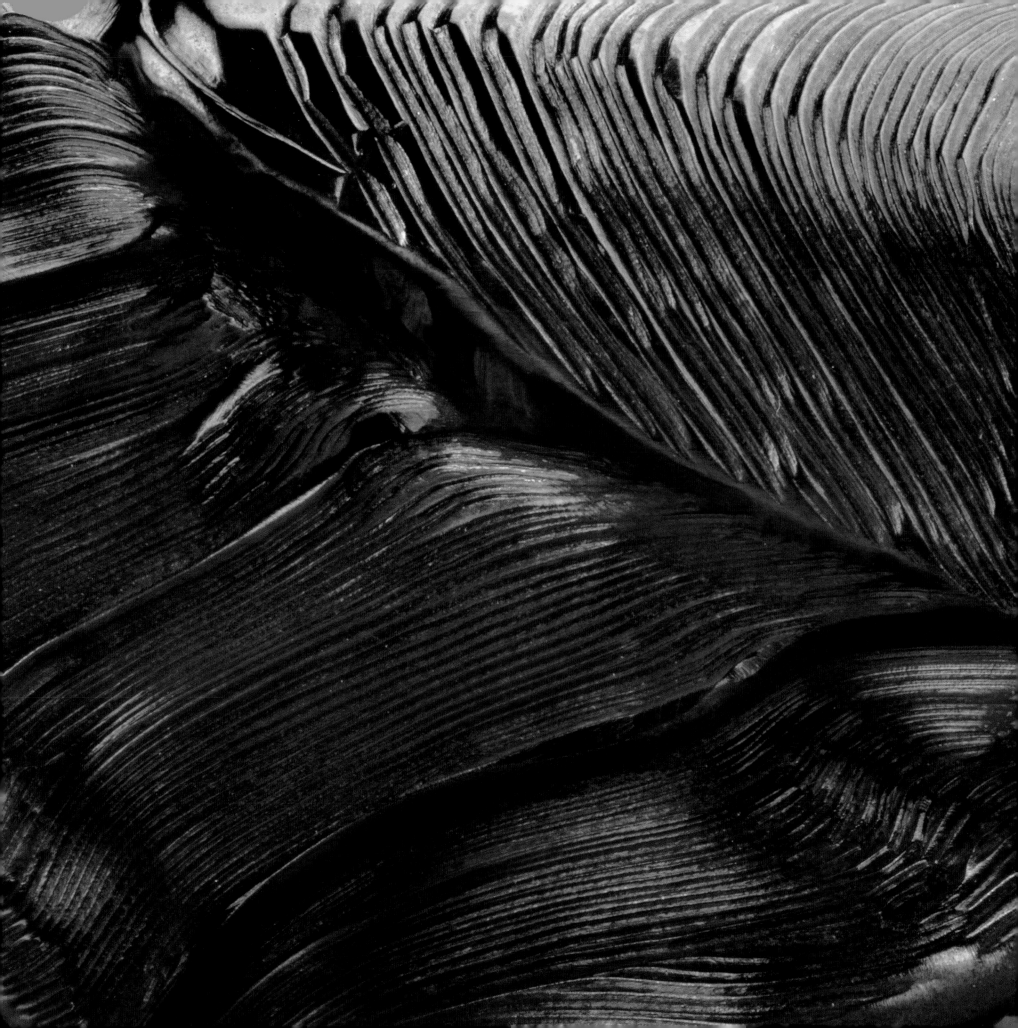

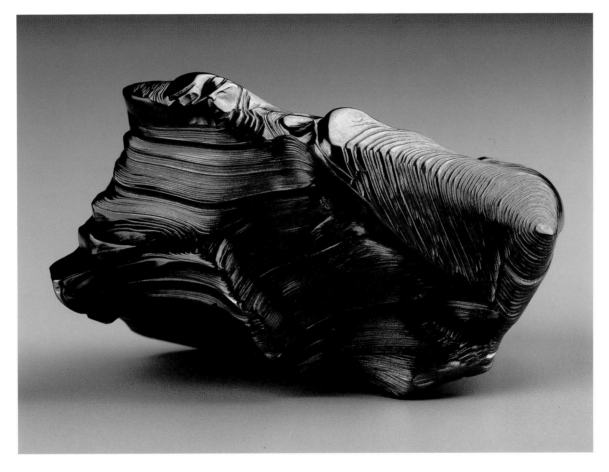

94. *Pointing.* 1993

Pure gold, steel

2 x 3 x 2 inches (5.08 x 7.62 x 5.08 cm)

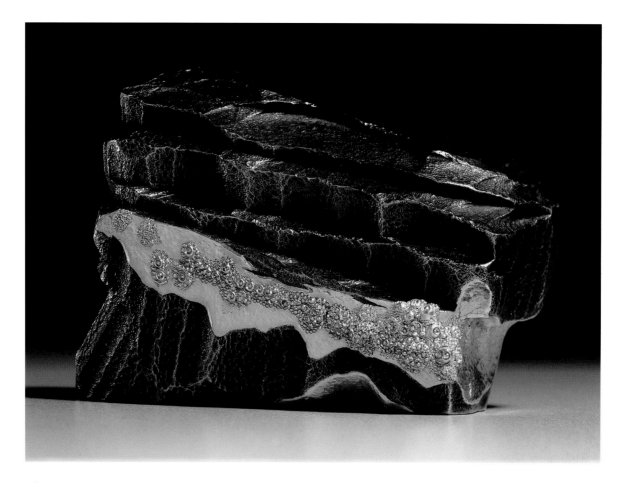

95. *Leaning Boulder.* 1987–92

Pure gold, steel

2 ³/₈ x 3 ¹/₄ x 1 ¹/₄ inches (6.05 x 8.26 x 3.18 cm)

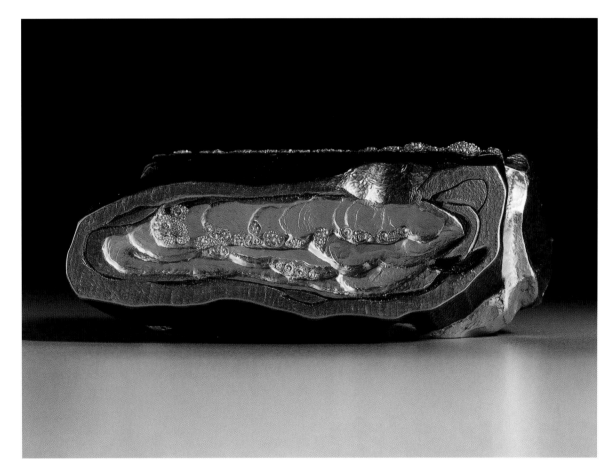

Leaning Boulder (underside)

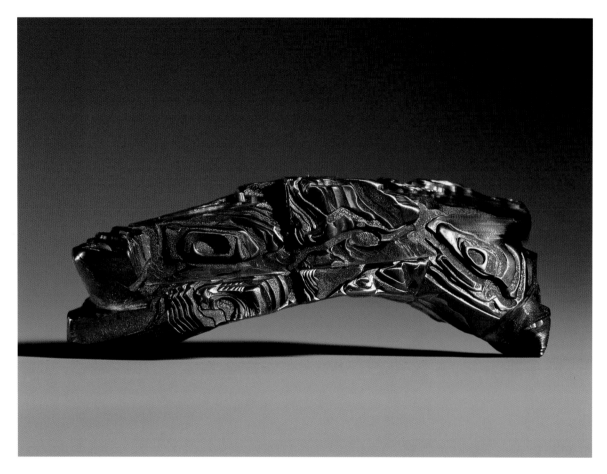

96. *Colored Arch.* 1996

Pure gold, fire-blued steel

1 ¹/₄ x 4 x 1 ¹/₄ inches (3.18 x 10.16 x 3.18 cm)

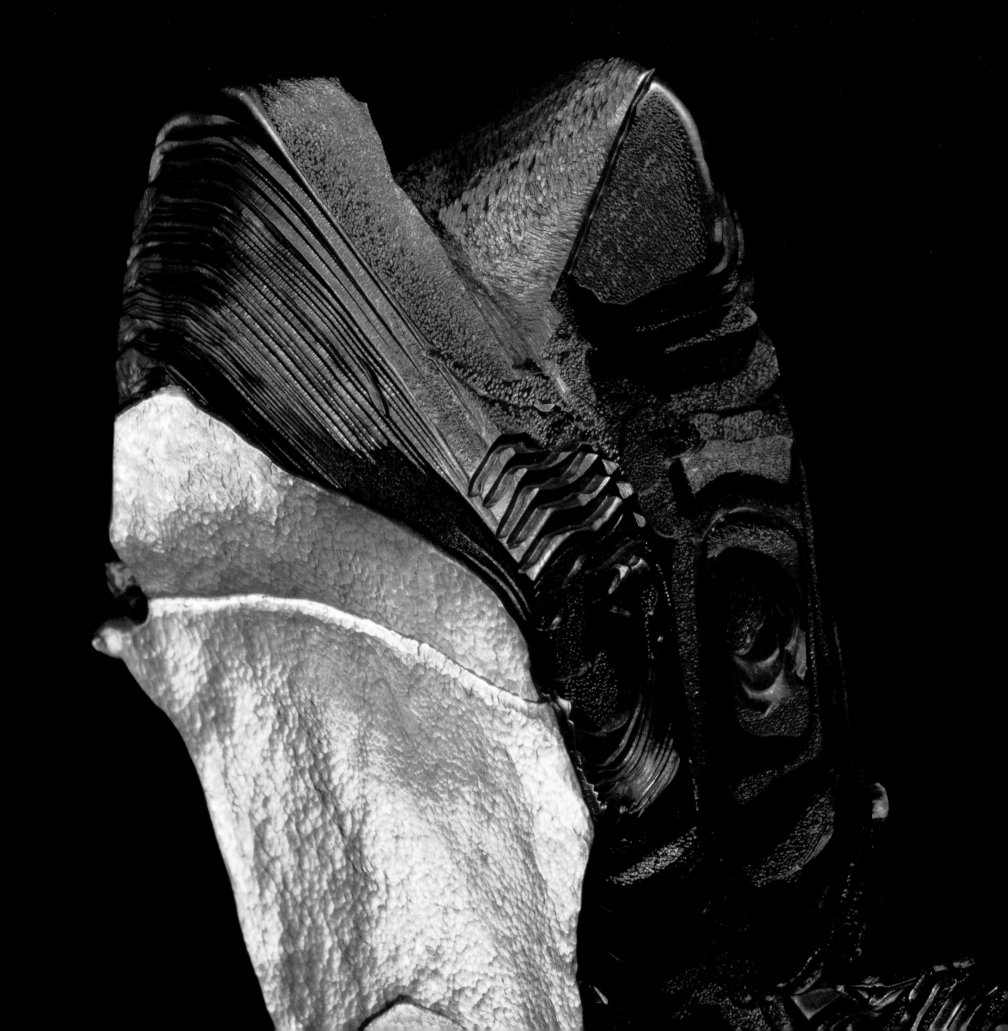

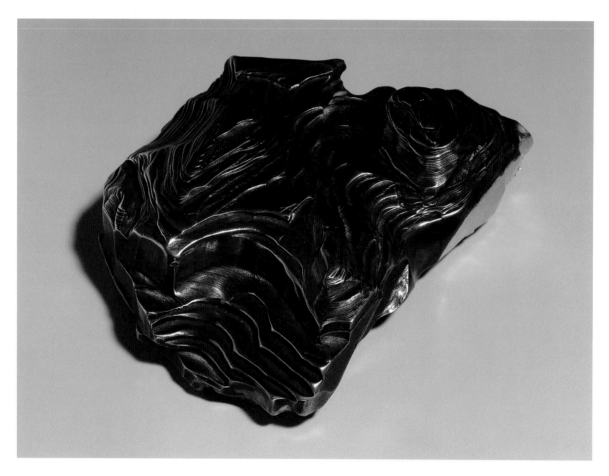

97. *Companion I.* 1990–93

Pure gold, steel

³⁄₄ x 3 ¹⁄₂ x 3 ¹⁄₂ inches (1.91 x 8.89 x 8.89 cm)

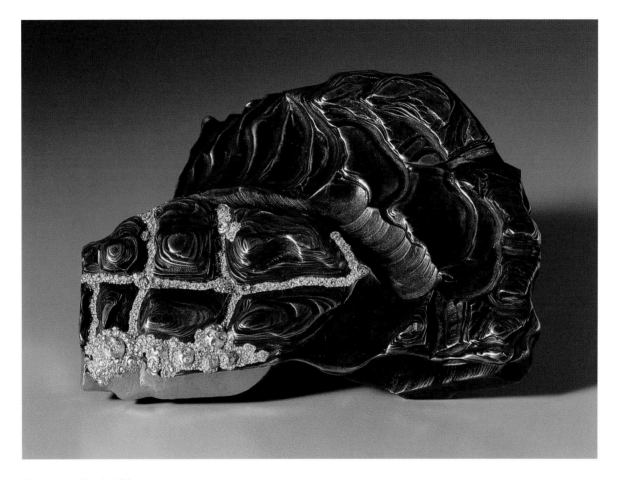

Companion I (underside)

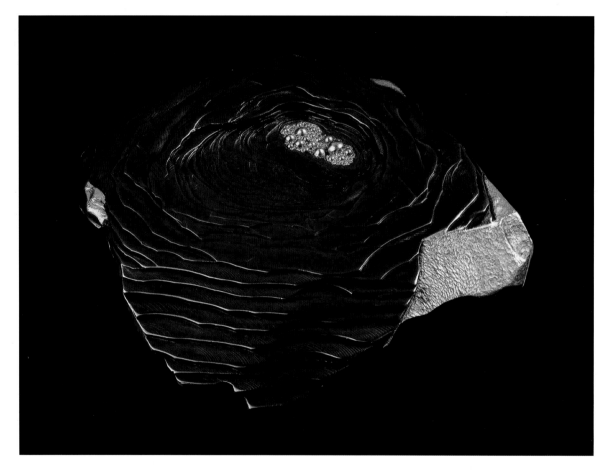

98. *Companion II.* 1990–93

Pure gold, steel

³/₄ x 3 ⁵/₈ x 3 ¹/₂ inches (1.91 x 9.22 x 8.89 cm)

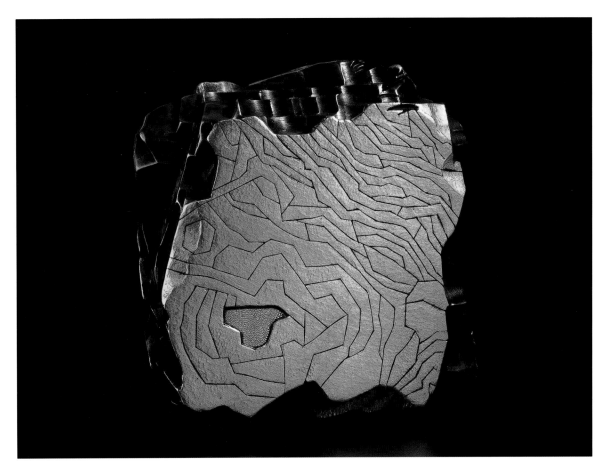

Companion II (underside)

99. *Scholar's Table Piece.* 1994

Pure gold, steel

2 x 3 $^1/_4$ x 3 inches (5.08 x 8.26 x 7.62 cm)

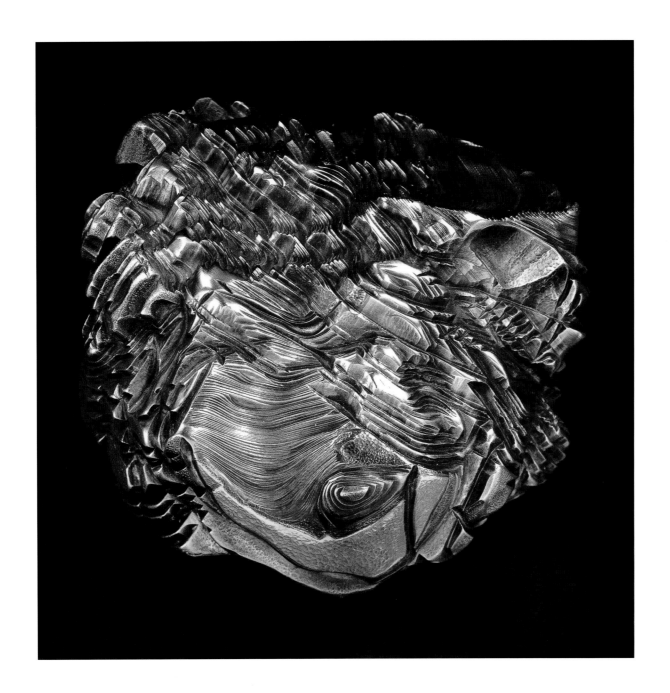

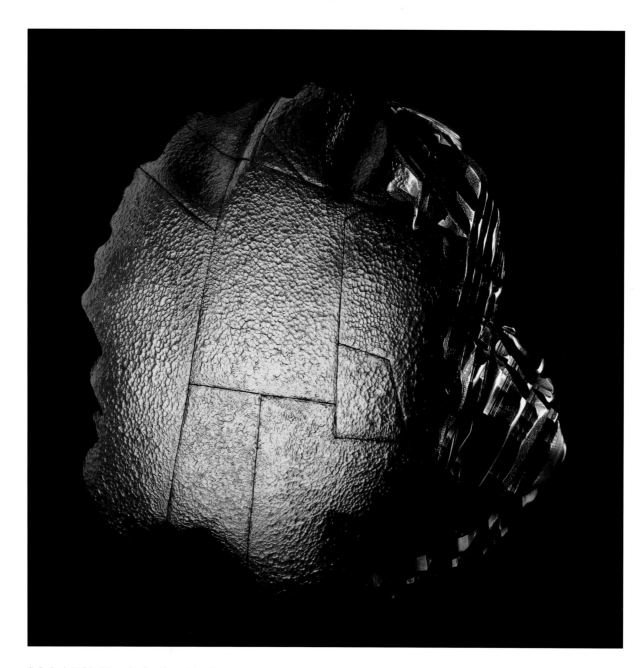

Scholar's Table Piece (underside and detail)

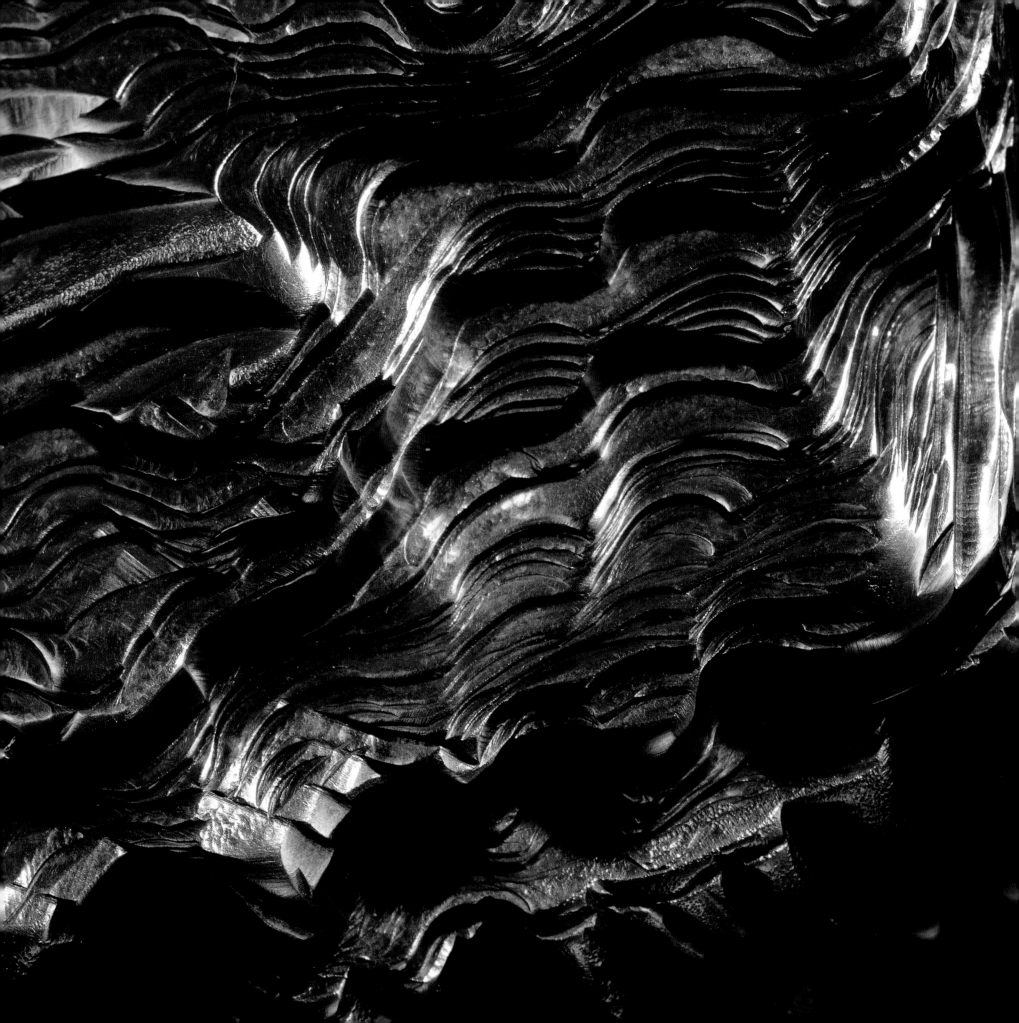

100. *Wave.* 1993–96

Pure gold, steel

2 x 3 $^1/_8$ x 2 $^1/_2$ inches (5.08 x 7.94 x 6.35 cm)

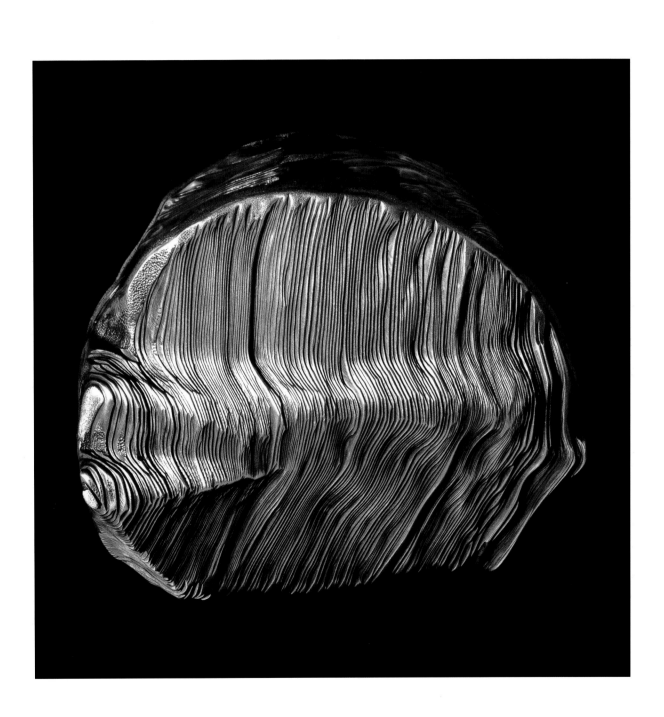

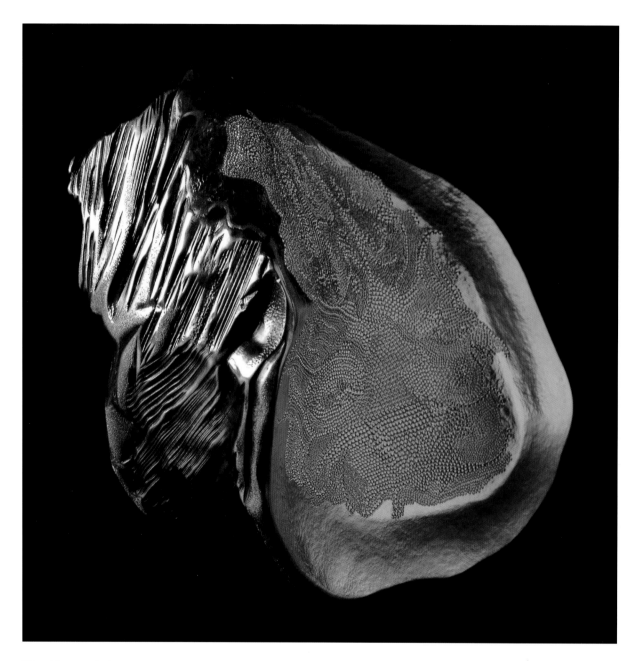

Wave (alternate view)

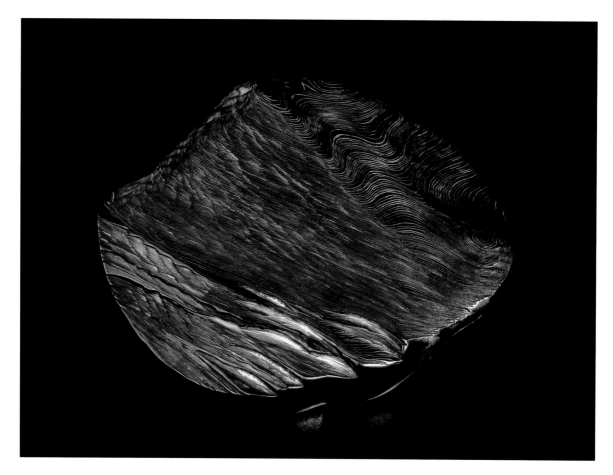

101. *Palm Piece.* 1995

Pure gold, steel

1 $^1/_4$ x 3 $^3/_4$ x 3 $^3/_4$ inches (3.18 x 9.53 x 9.53 cm)

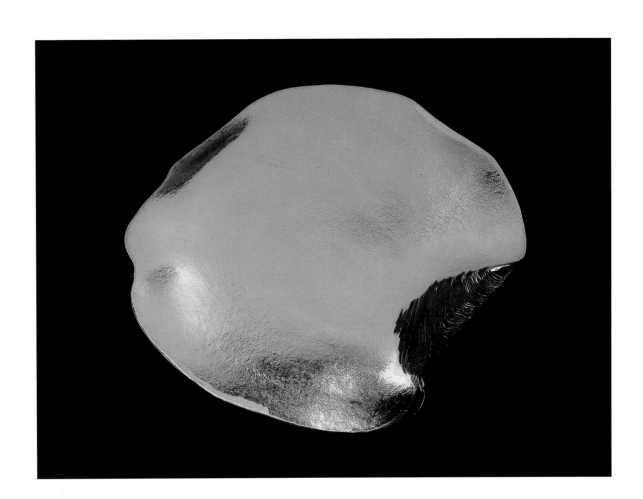

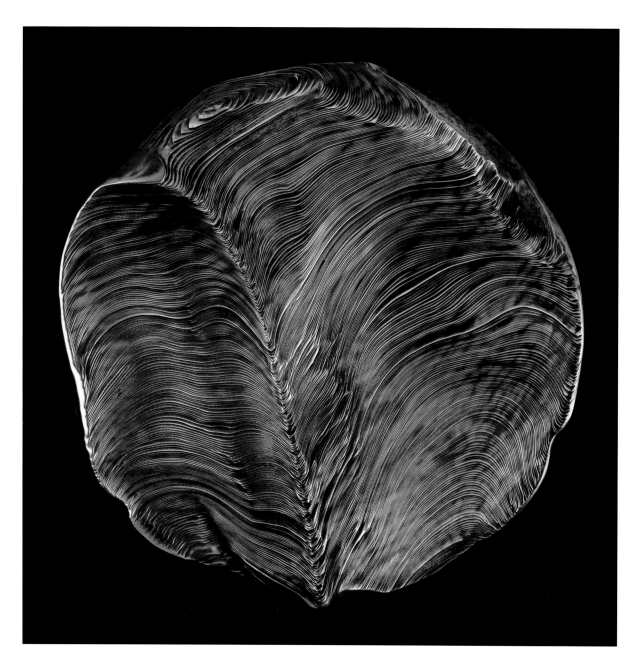

102. *Mirror I.* 1993–96

Pure gold, steel

5 x 5 x $^1/_2$ inches (12.70 x 12.70 x 1.27 cm)

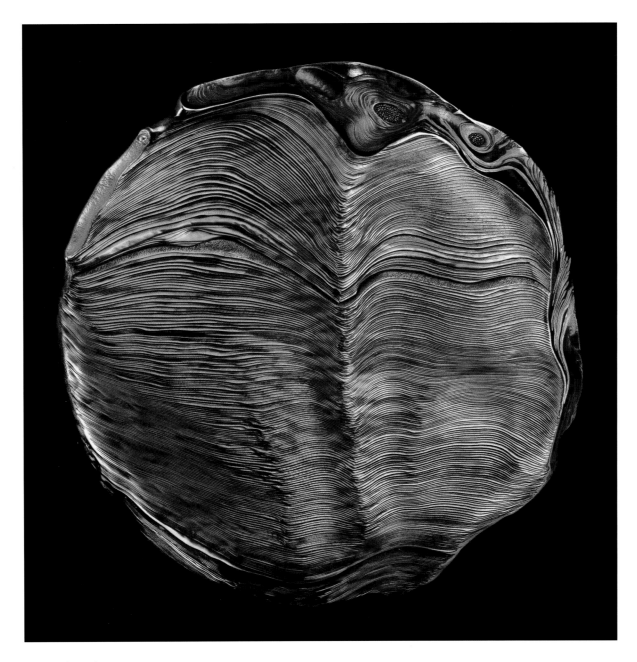

Mirror I (reverse)

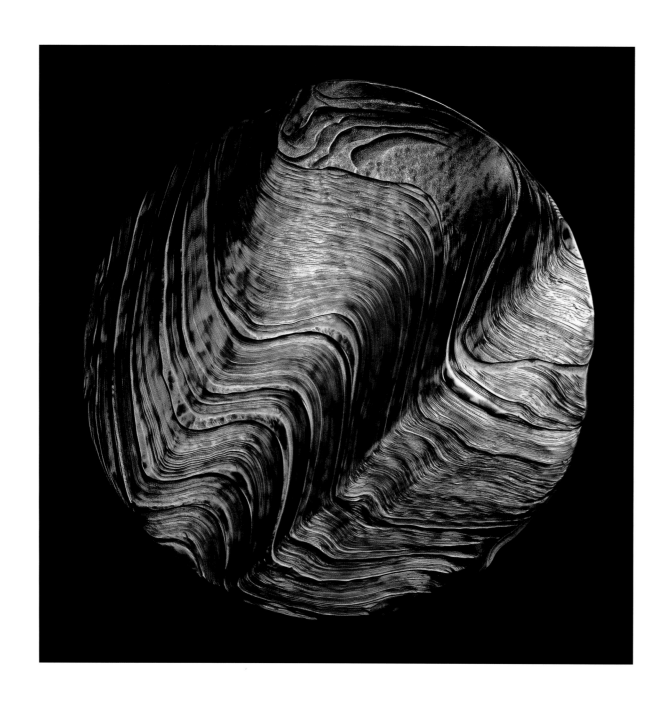

103. *Mirror II.* 1993–96

Pure gold, steel

5 x 5 x ¹/₂ inches (12.70 x 12.70 x 1.27 cm)

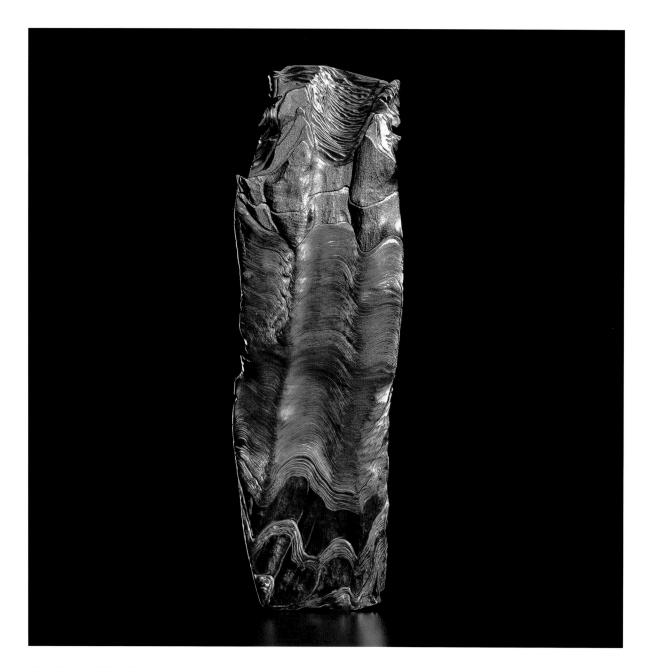

104. *Canto I.* 1994–97

Pure gold, steel

11 x 4 x $^1/_2$ inches (27.94 x 10.16 x 1.27 cm)

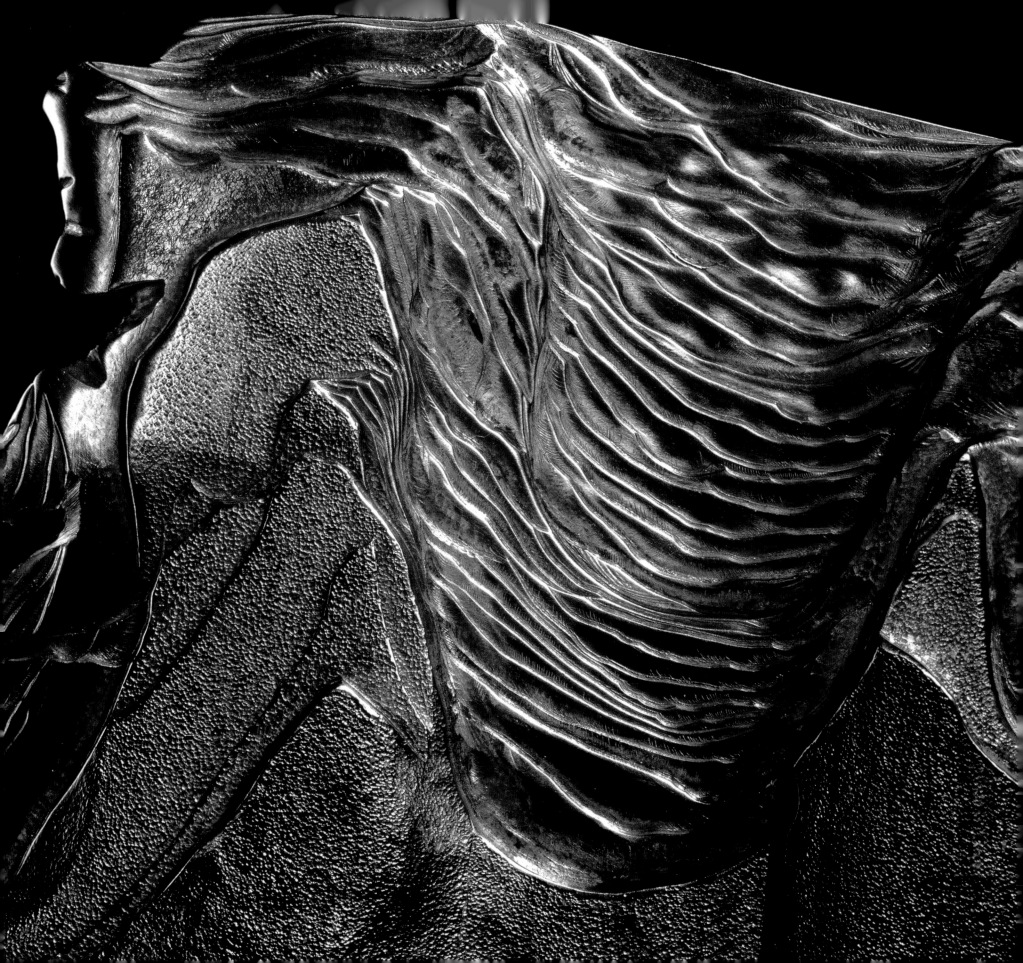

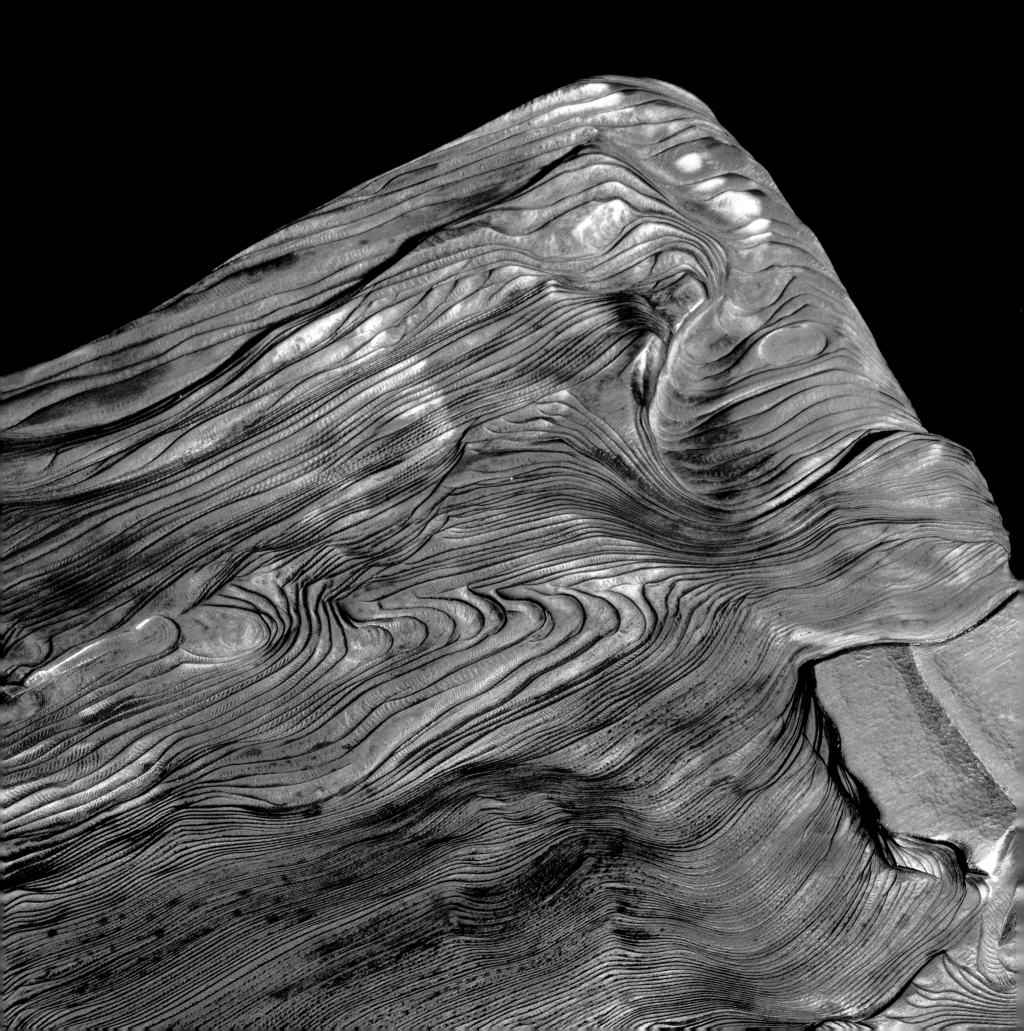

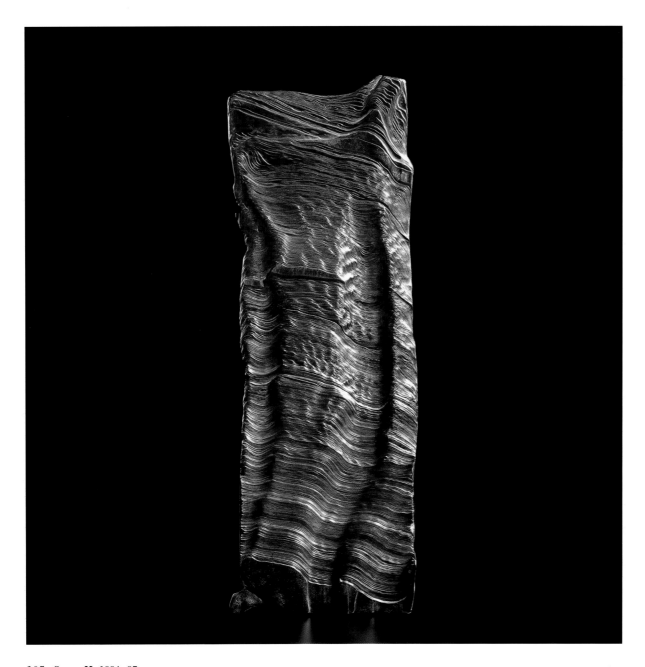

105. *Canto II.* 1994–97

Pure gold, steel

11 x 4 x $^1/_2$ inches (27.94 x 10.16 x 1.27 cm)

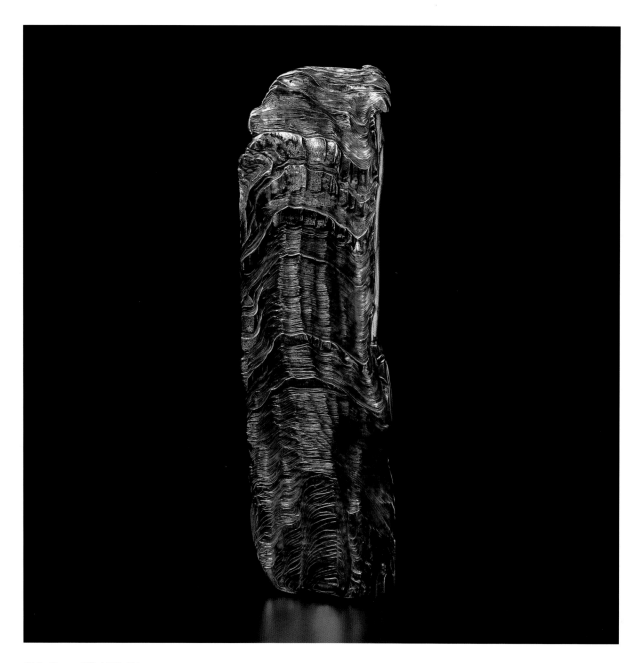

106. *Canto III.* 1994–97

Pure gold, steel

11 x 4 x $\frac{1}{2}$ inches (27.94 x 10.16 x 1.27 cm)

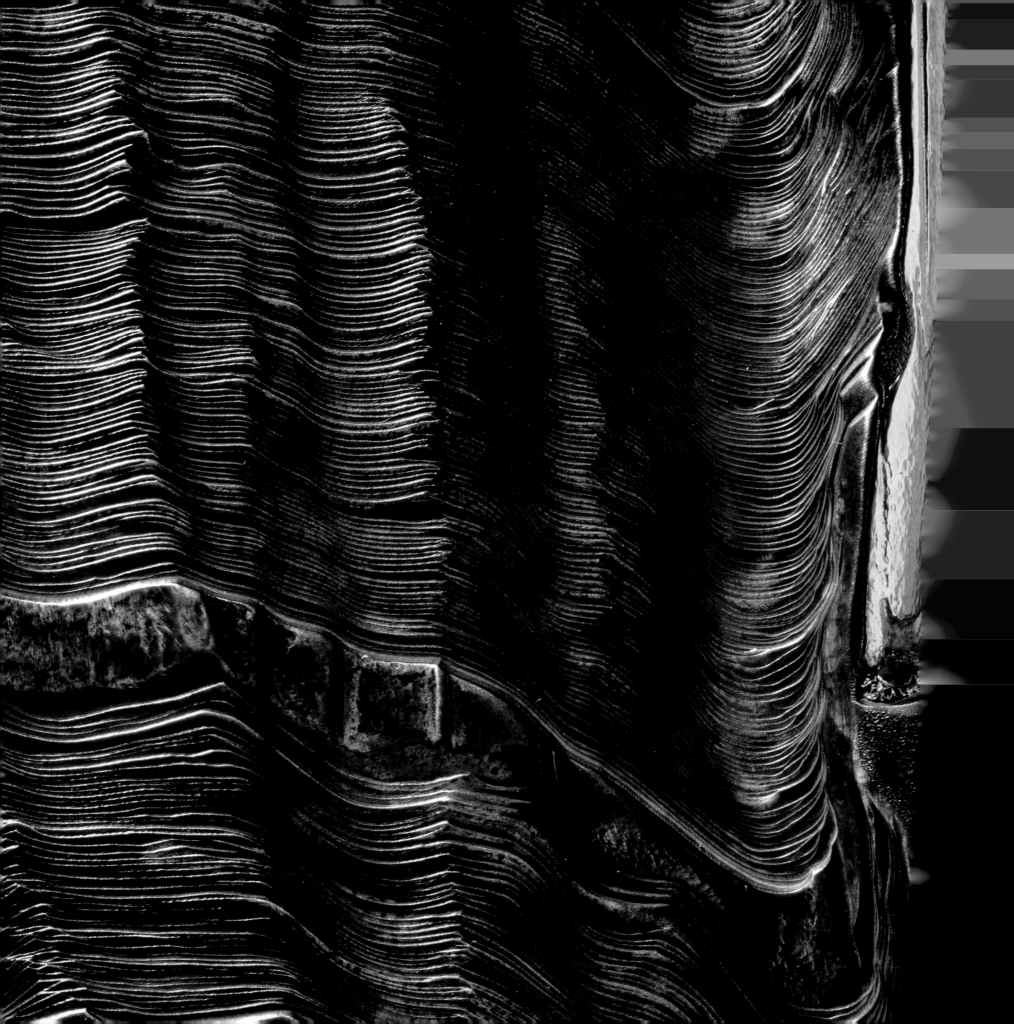

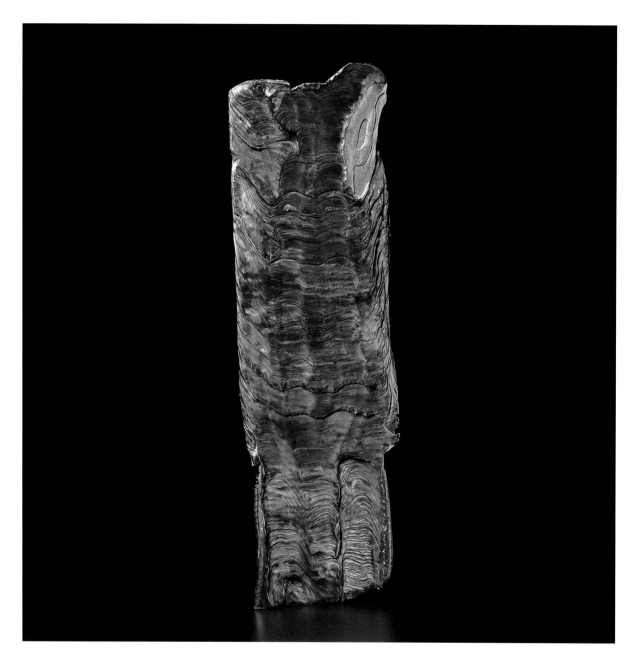

107. *Canto IV.* 1994–97

Pure gold, steel

11 x 4 x $^1/_2$ inches (27.94 x 10.16 x 1.27 cm)

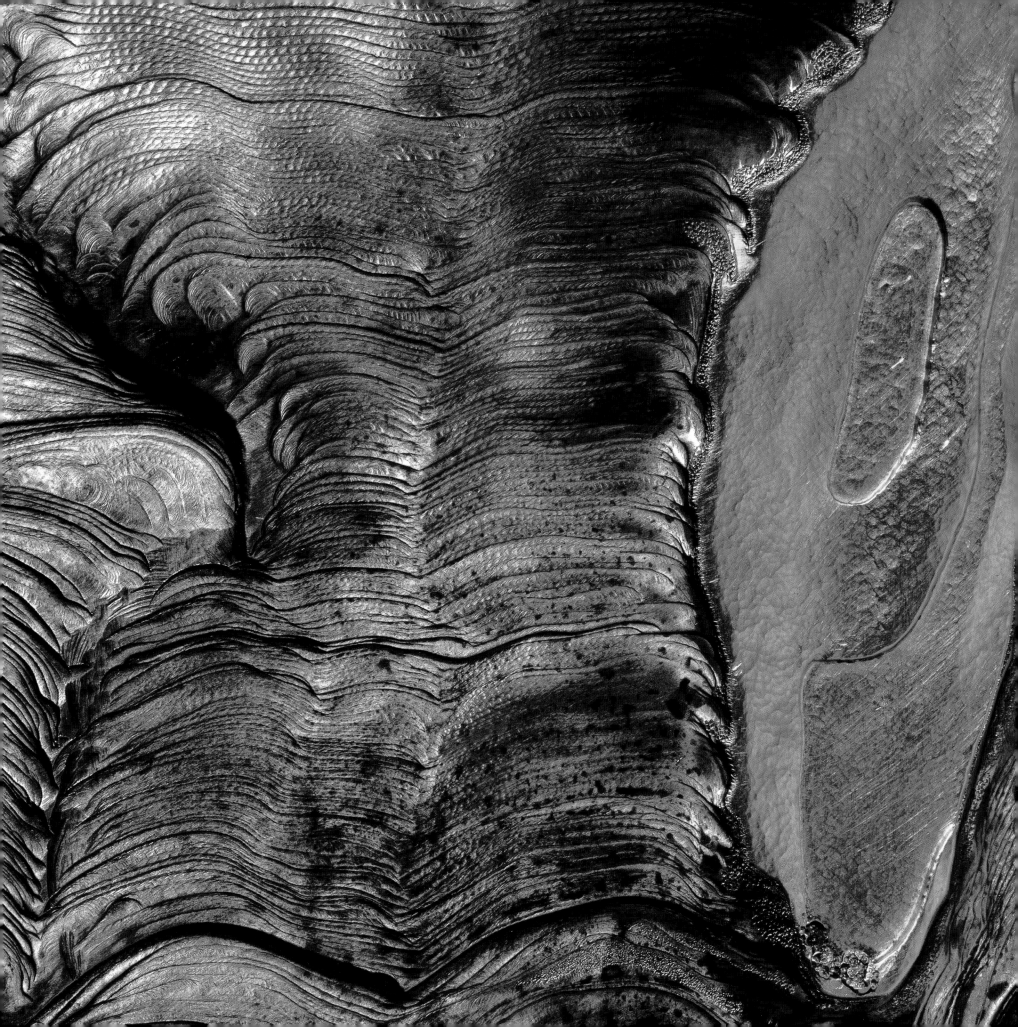

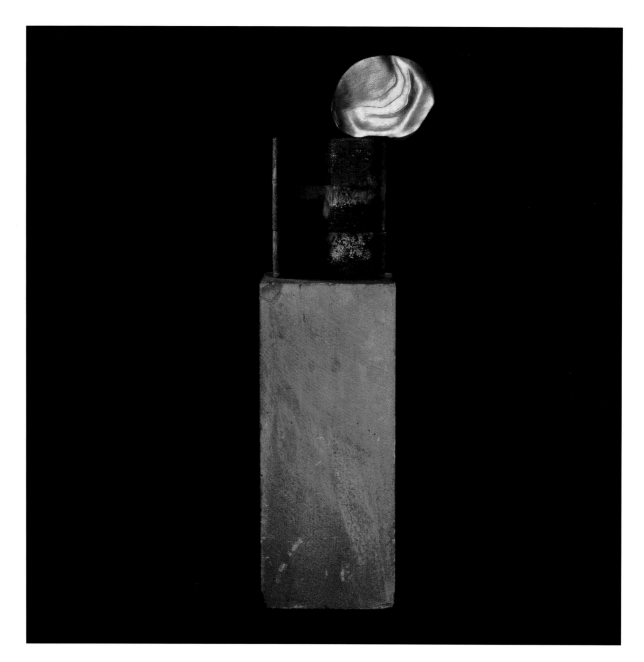

108. *First Piece.* 1997

Pure gold, steel, iron, limestone

24 x 8 x 6 inches (60.96 x 20.32 x 15.24 cm)

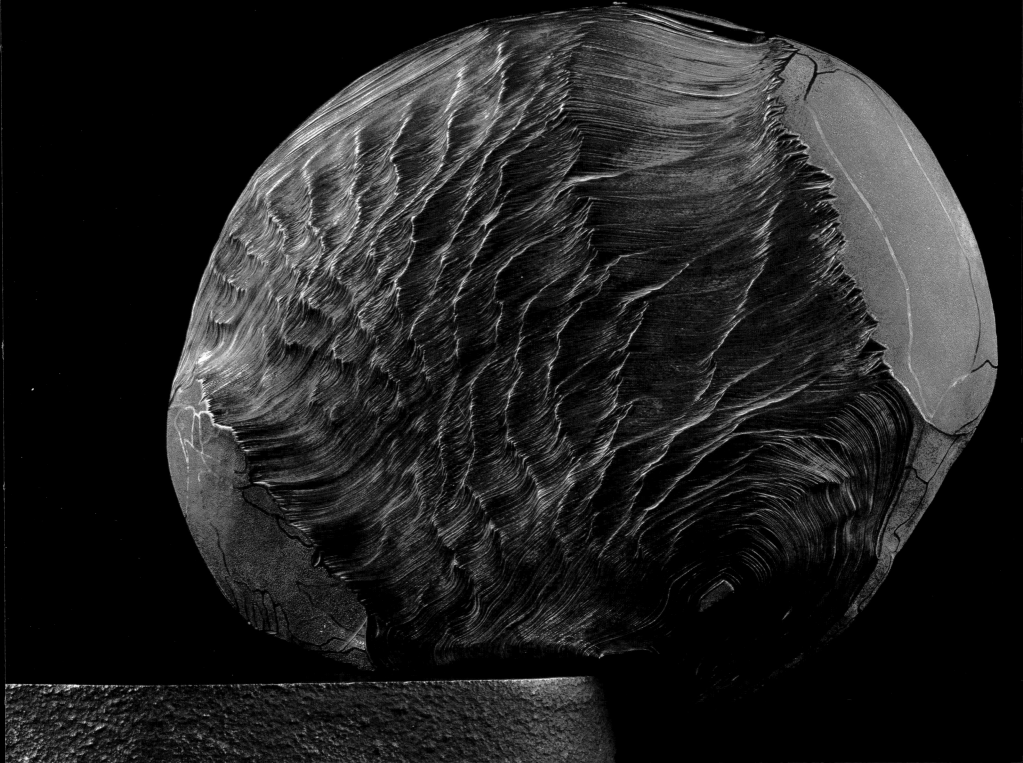

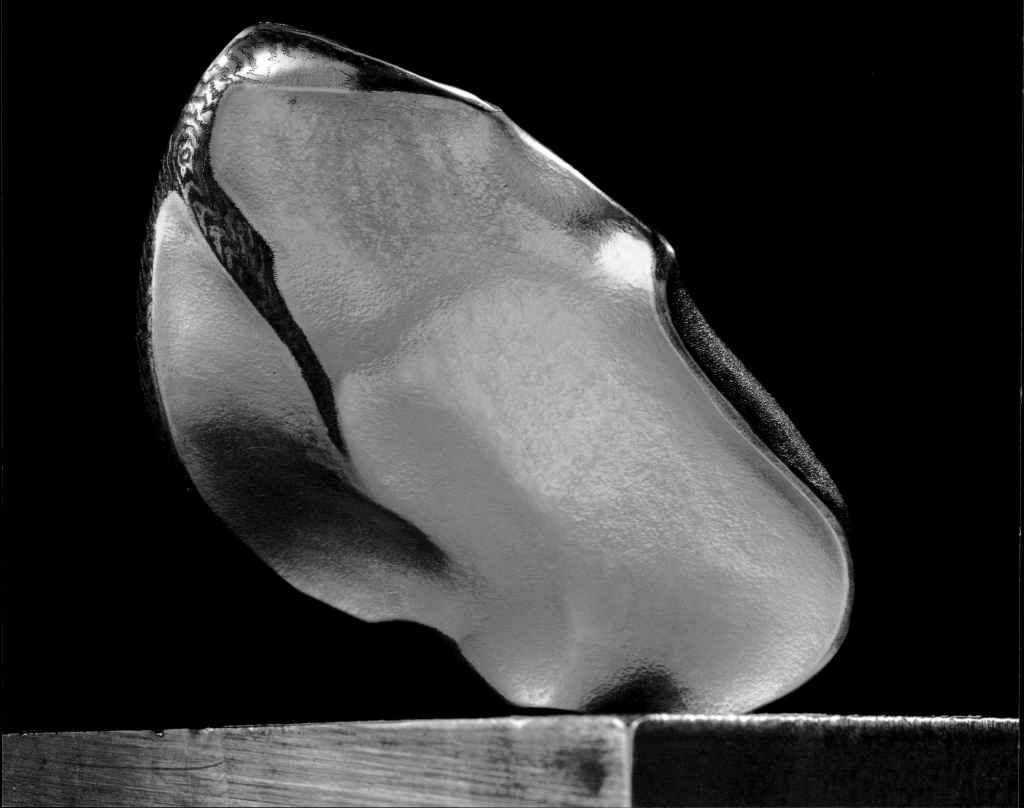

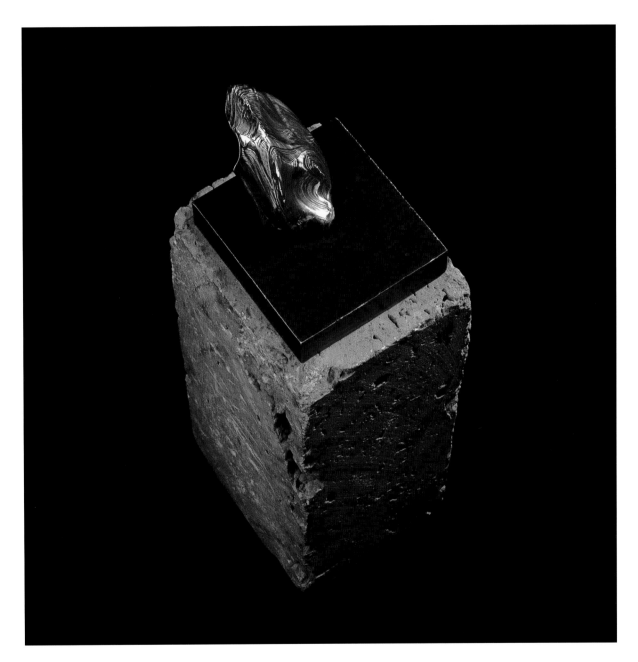

109. *Leaf.* 1997

Pure gold, steel, travertine marble

16 x 6 x 5 inches (40.64 x 15.24 x 12.70 cm)

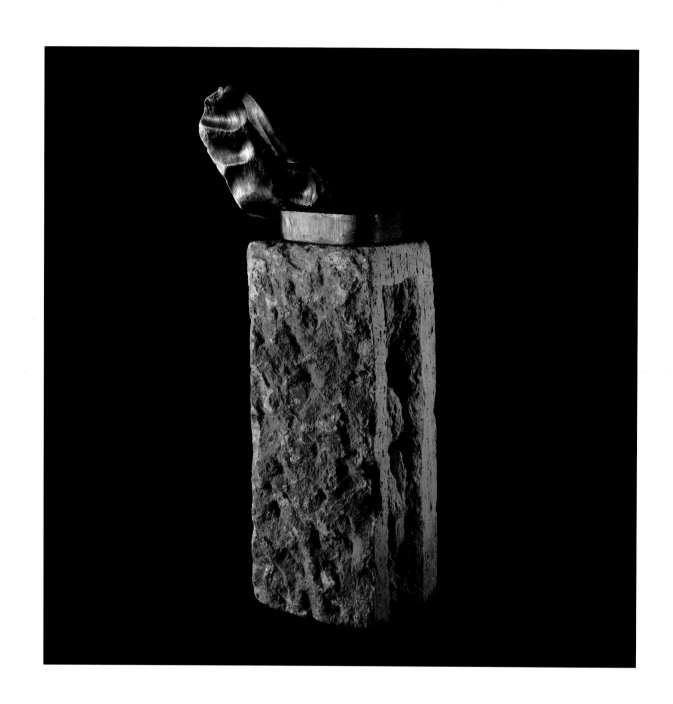

110. *Marker.* 1996–97

Pure gold, steel, travertine marble

22 x 6 x 6 inches (55.88 x 15.24 x 15.24 cm)

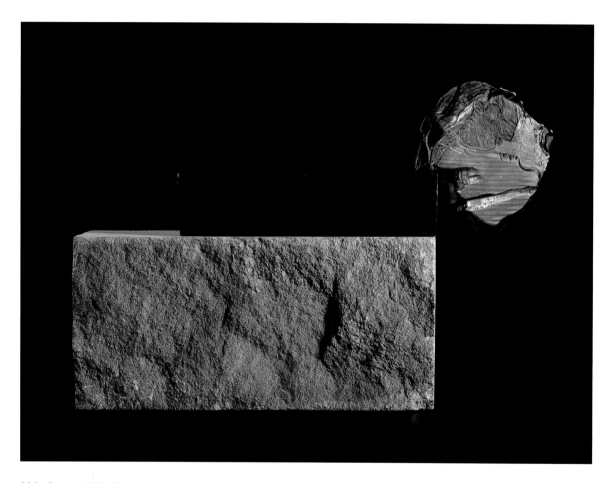

111. *Corner.* 1996–97

Pure gold, steel, limestone

9 ¹/₂ x 11 ¹/₂ x 8 inches (24.13 x 29.21 x 20.32 cm)

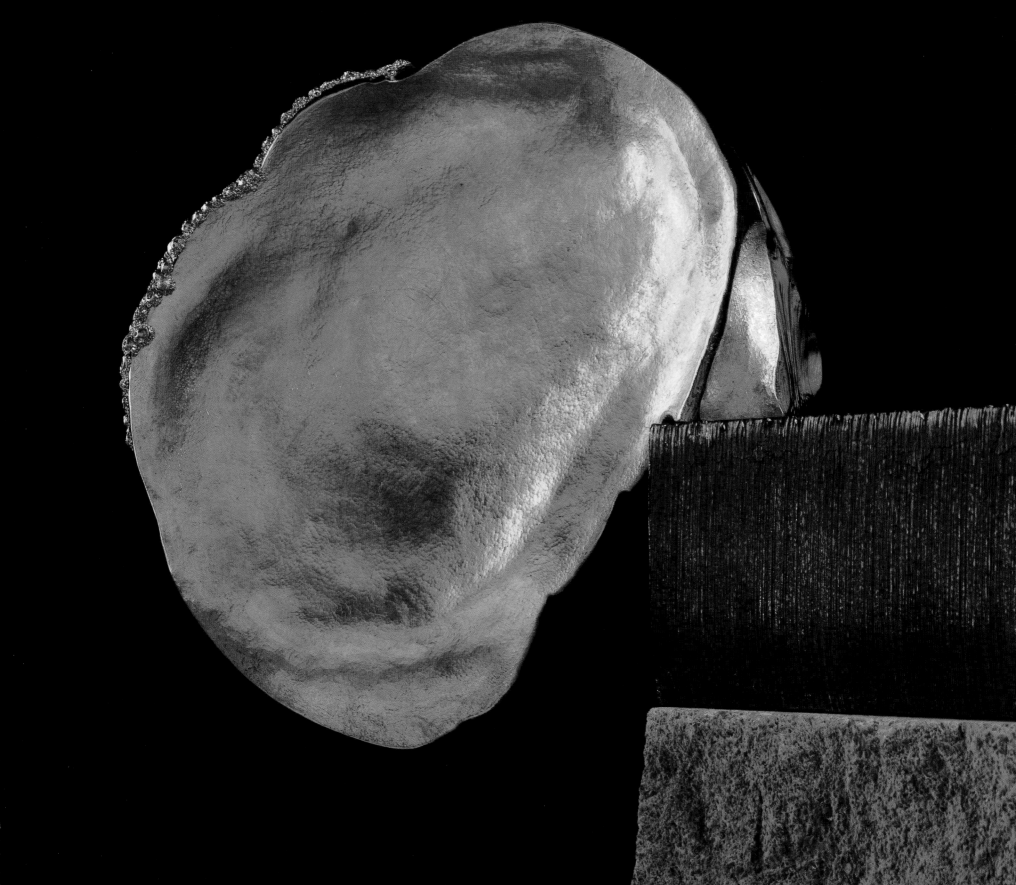

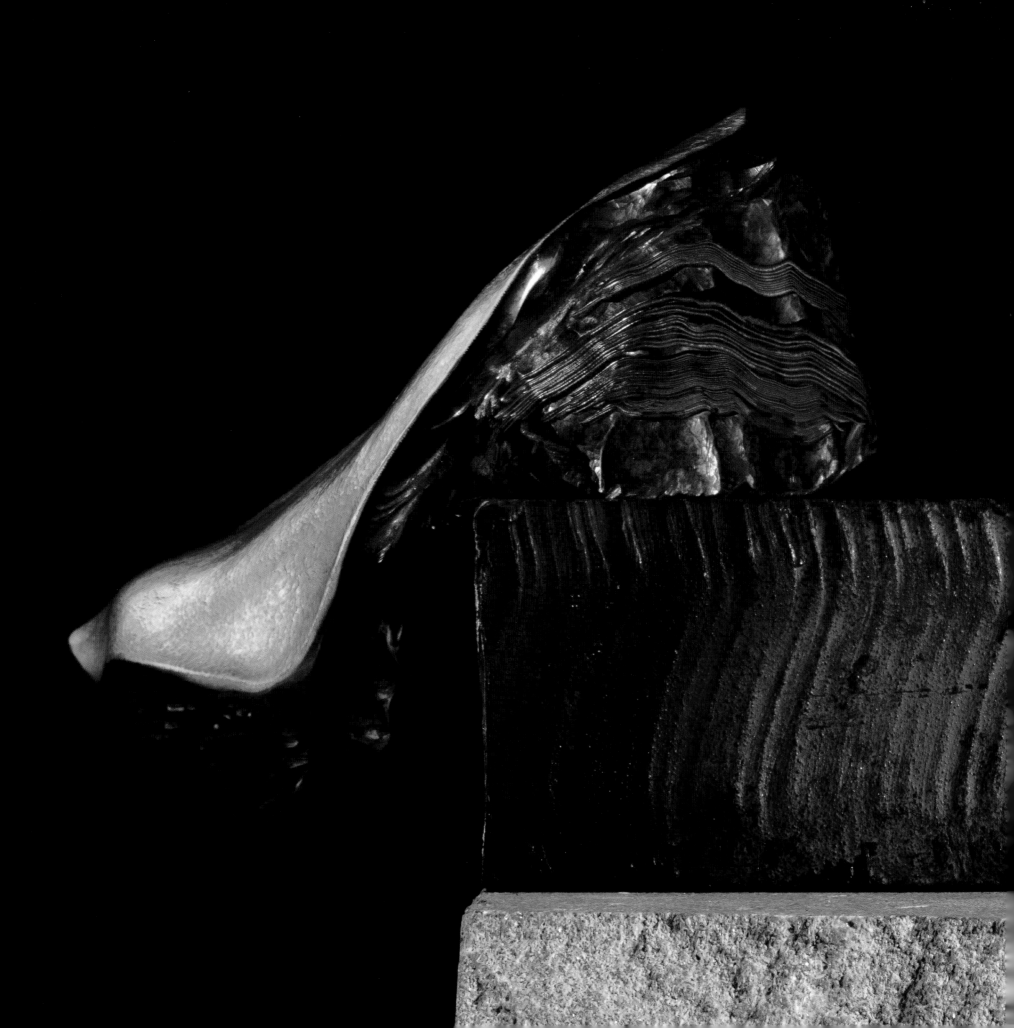

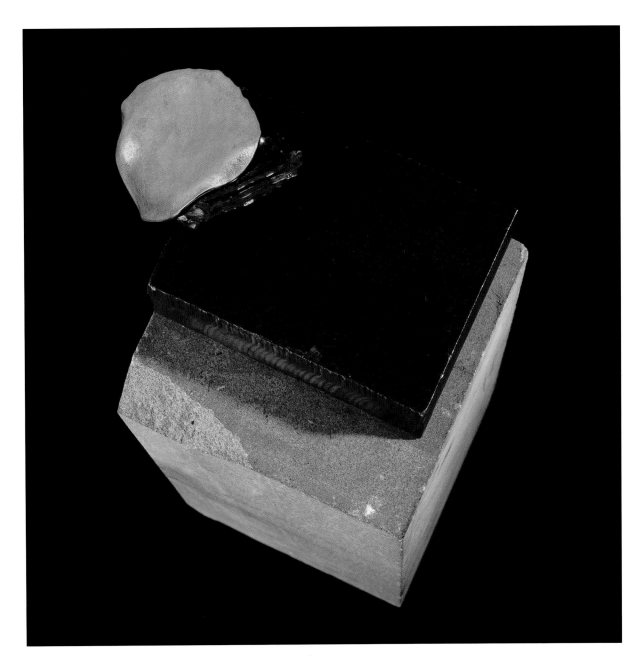

112. *Side.* 1997

Pure gold, steel, limestone

16 $\frac{1}{2}$ x 6 x 6 inches (41.91 x 15.24 x 15.24 cm)

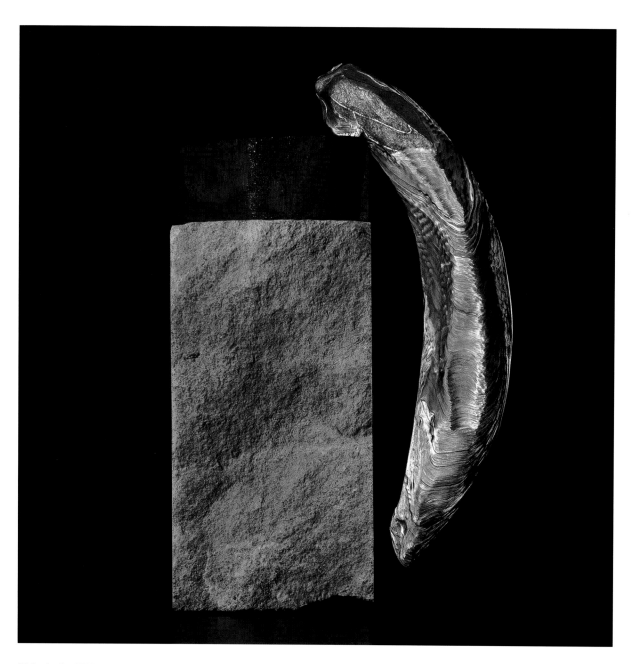

113. *Angle.* 1997

Pure gold, steel, limestone

13 ¹/₂ x 8 ¹/₄ x 5 ¹/₂ inches (34.29 x 20.96 x 13.97 cm)

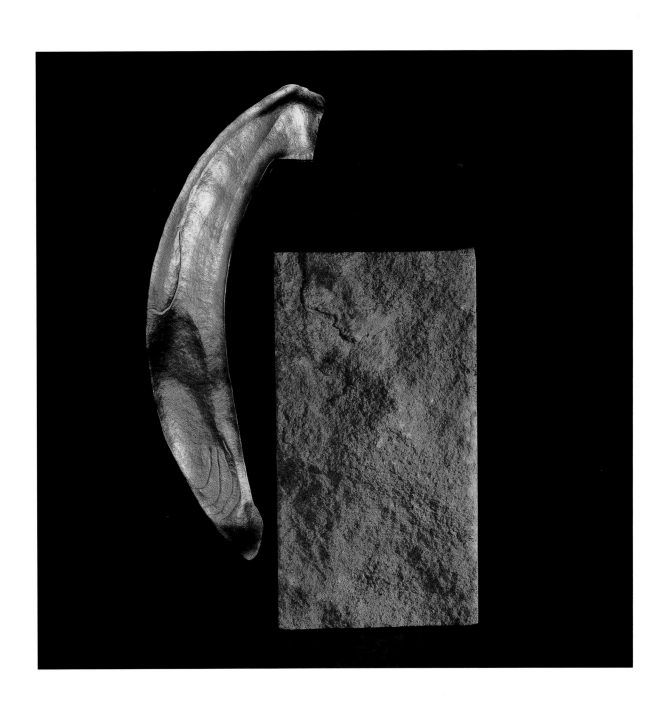

114. *End.* 1997

Pure gold, steel, limestone

6 ³/₄ x 12 x 4 ¹/₂ inches (17.15 x 30.48 x 11.43 cm)

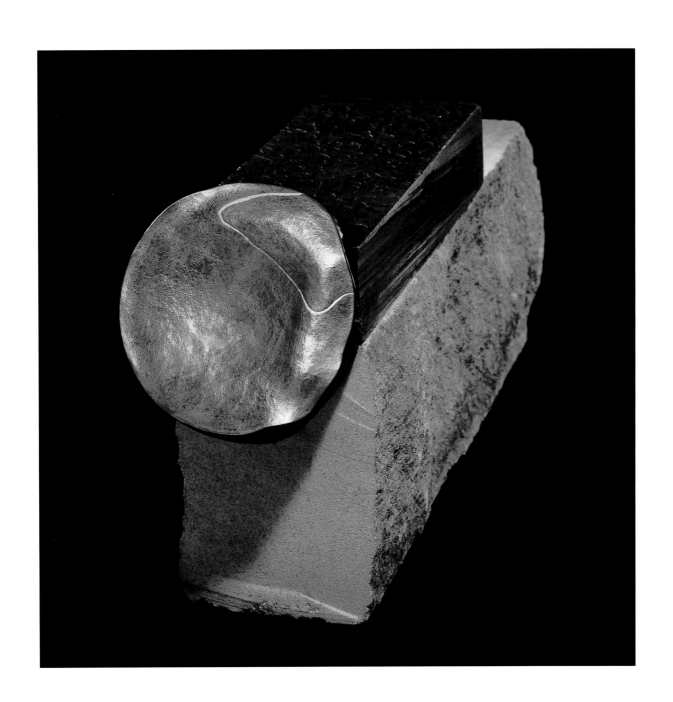

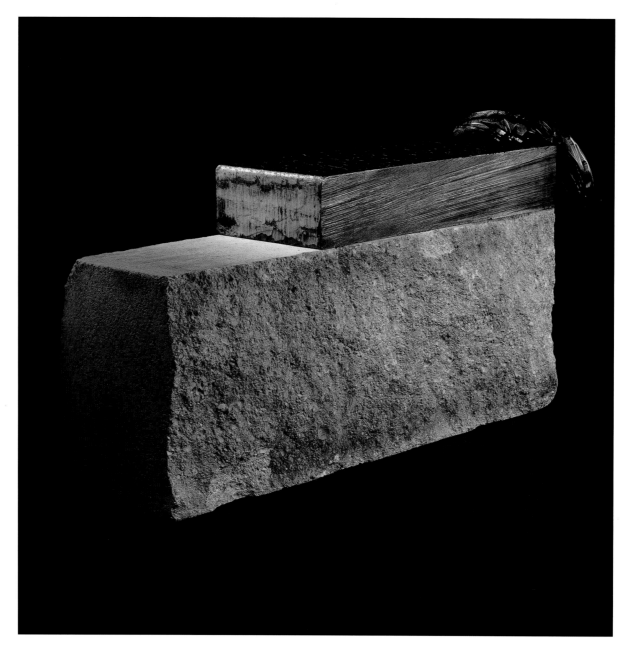

End

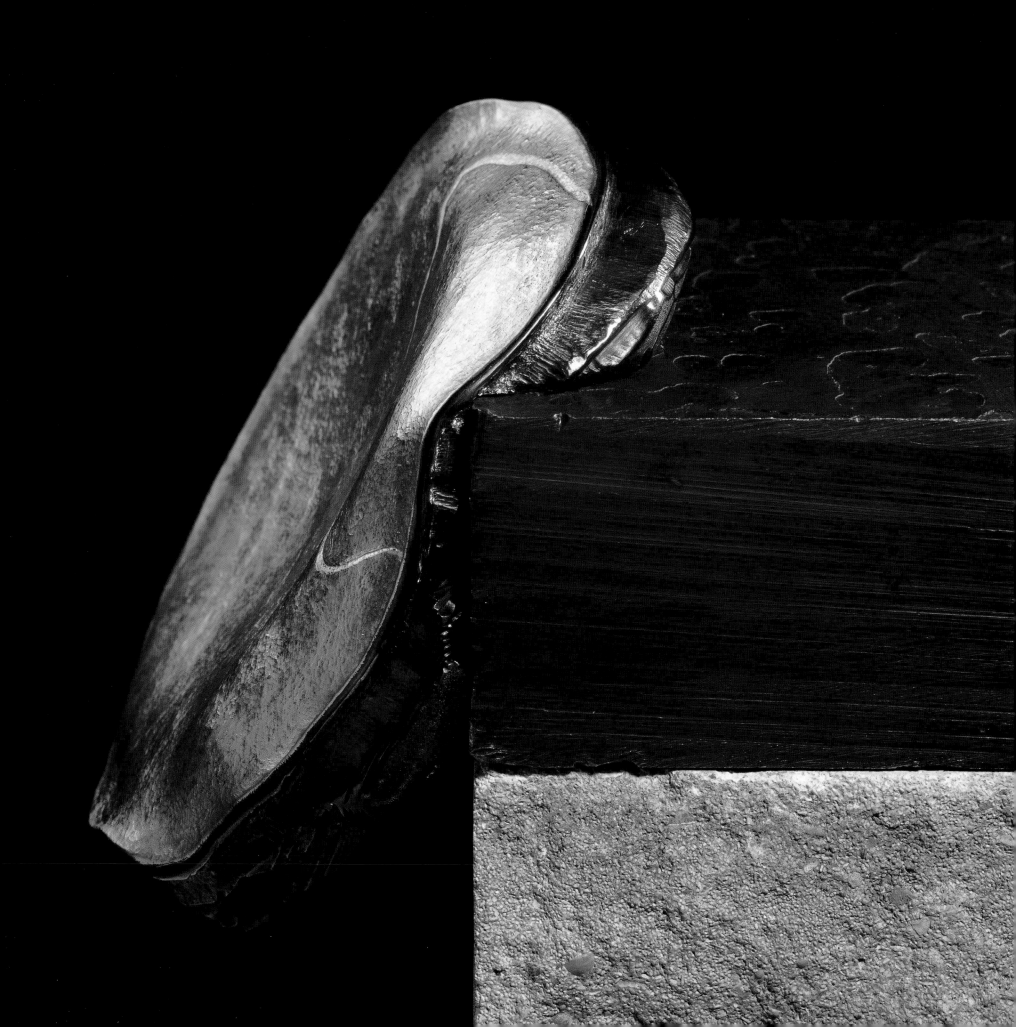

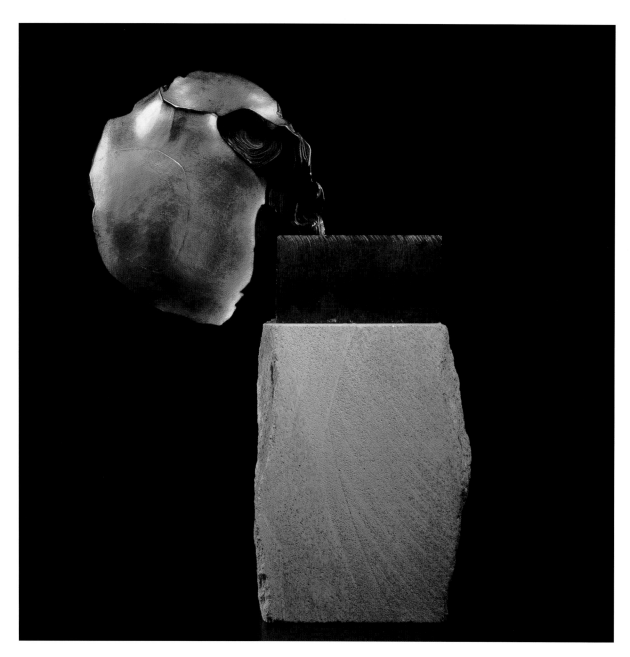

115. *Edge.* 1997

Pure gold, steel, hot-rolled steel, limestone

10 x 7 $^1/_2$ x 9 $^1/_2$ inches (25.40 x 19.05 x 24.13 cm)

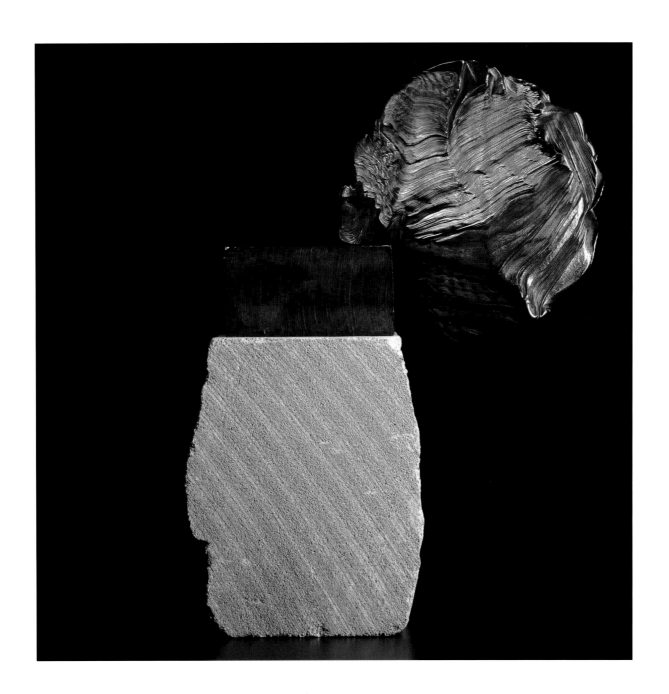

Edge

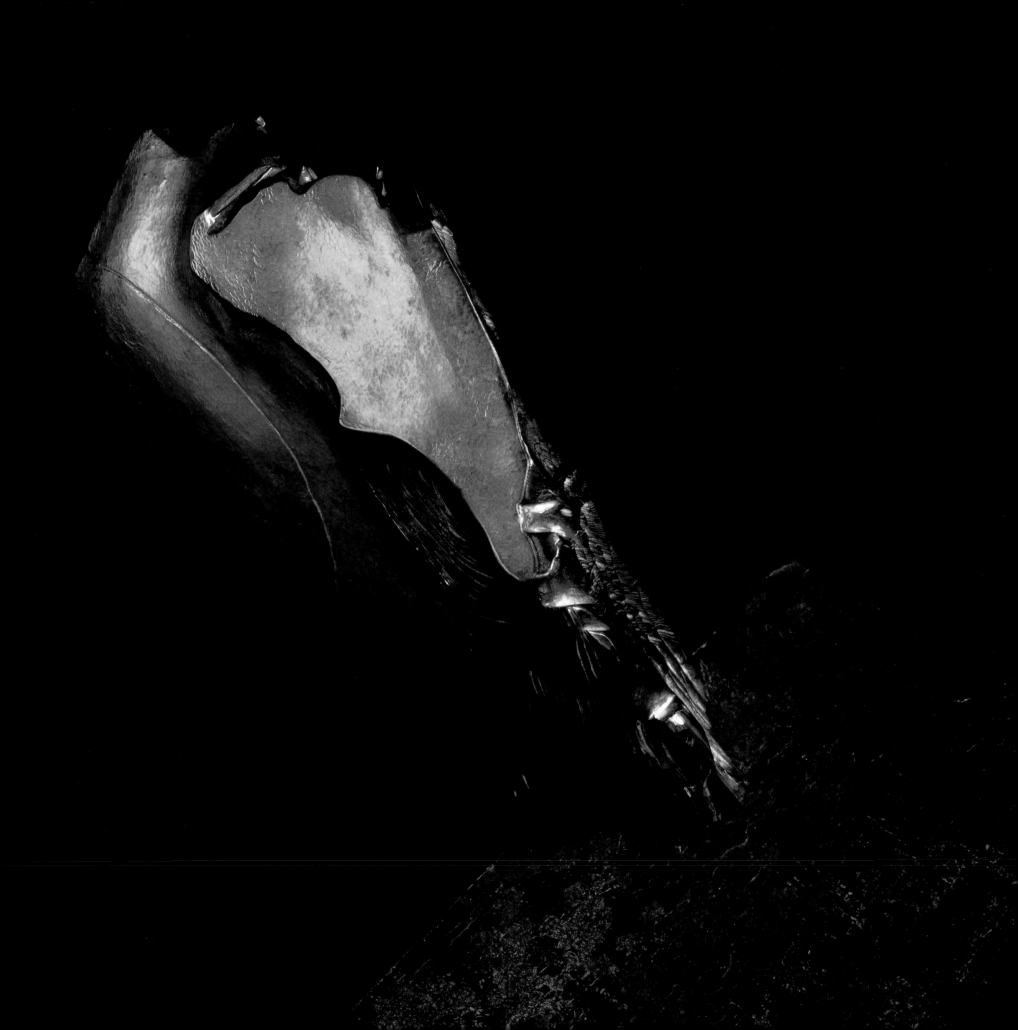

NINETY-NINE DRAWINGS

To a Painter
to Daniel Brush

In looking
one aims
to retell
 the seas
 mountains
 clouds
but to see
is to forget
the names
of things.

—Aleksis Rannit
Yaddo, 1975

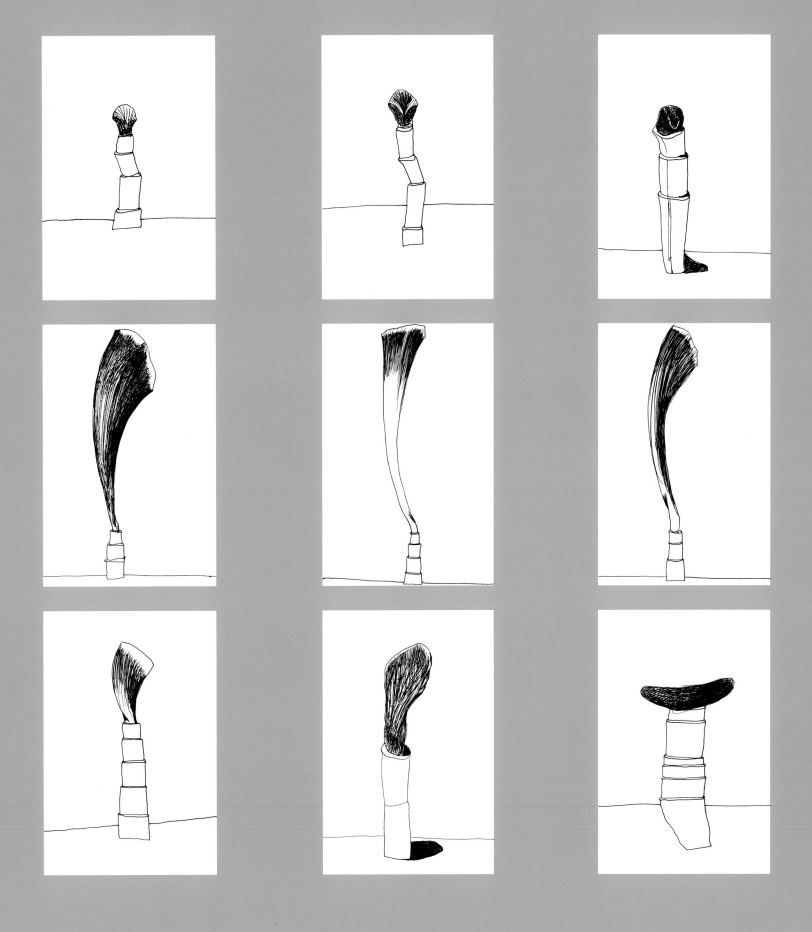

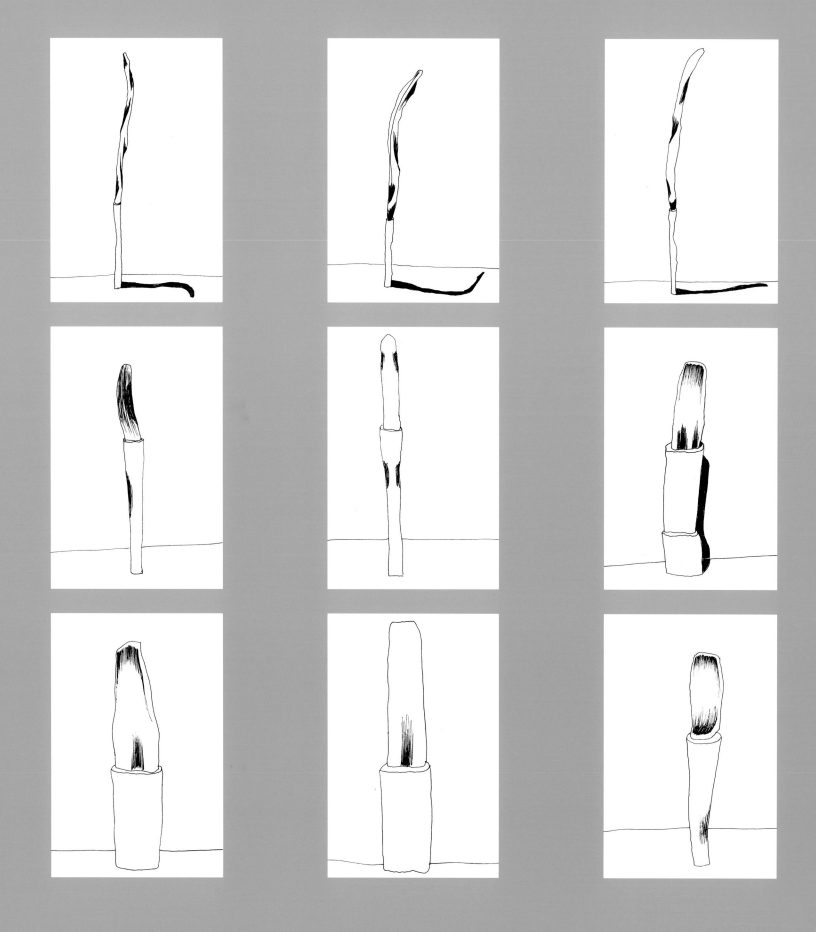

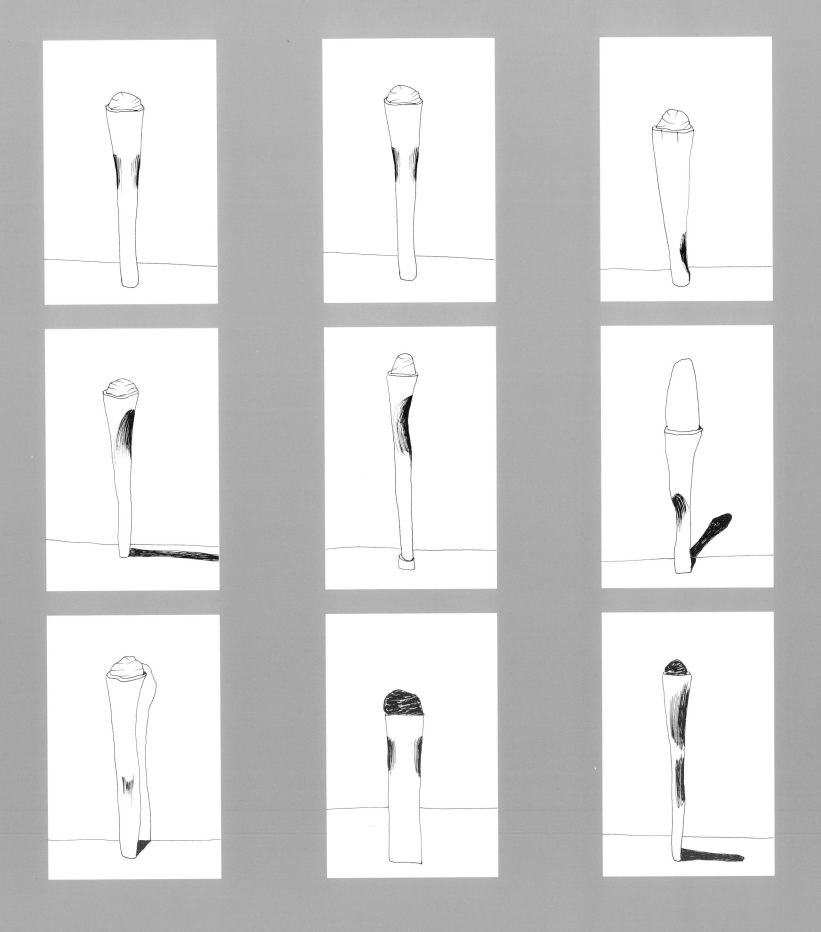

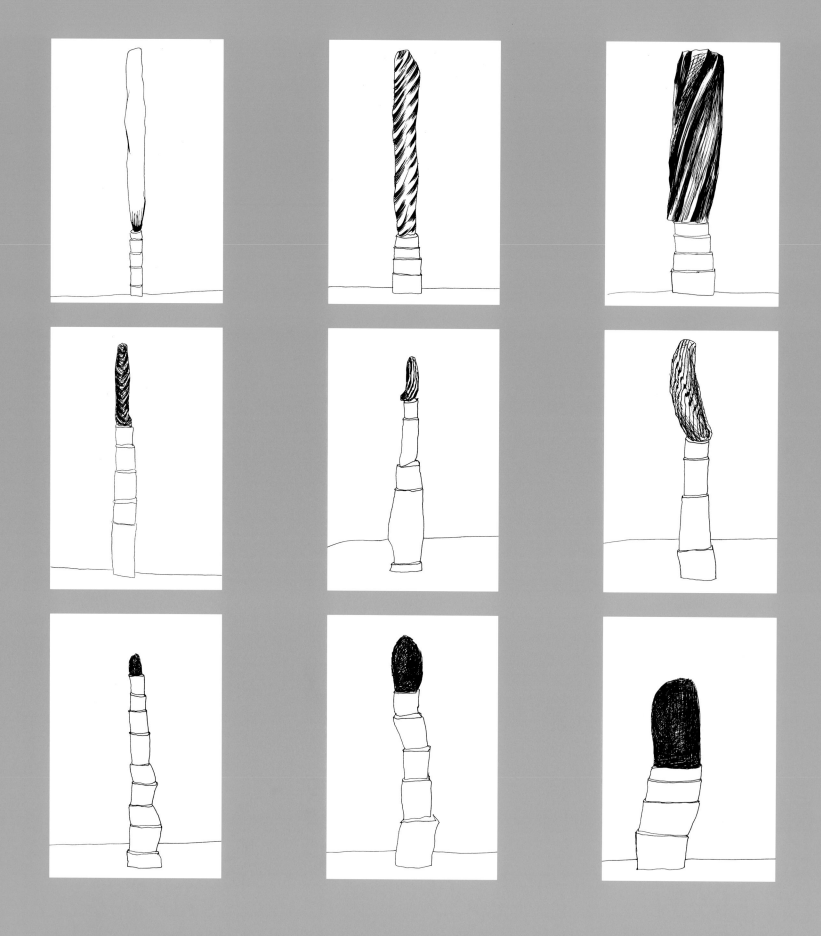

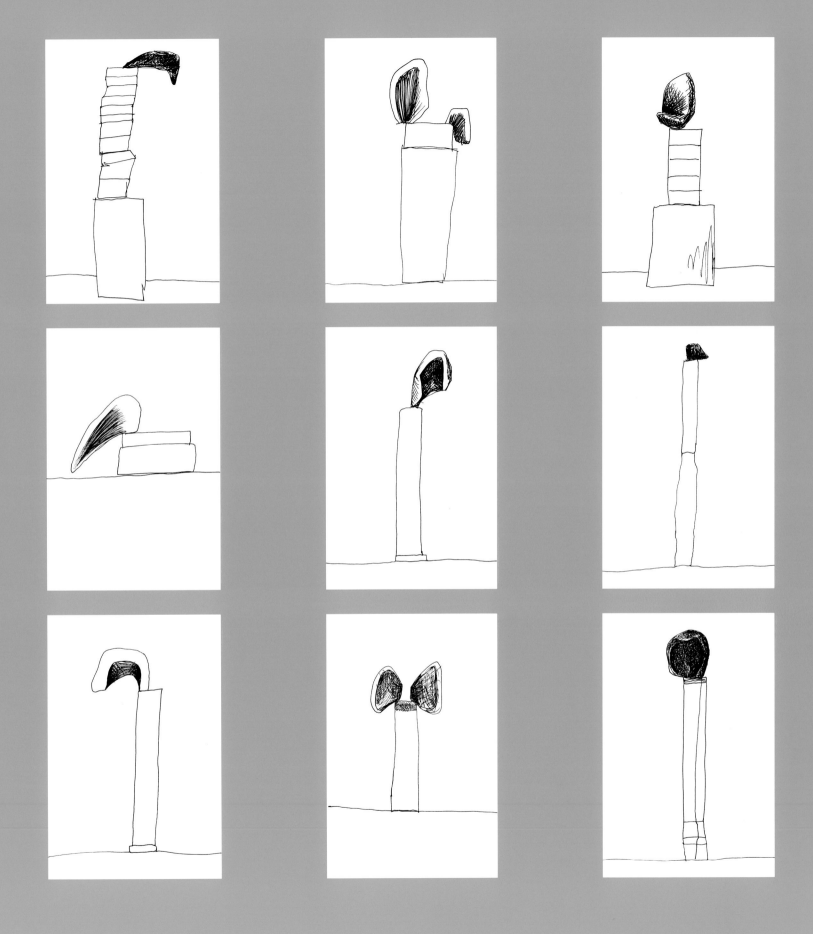

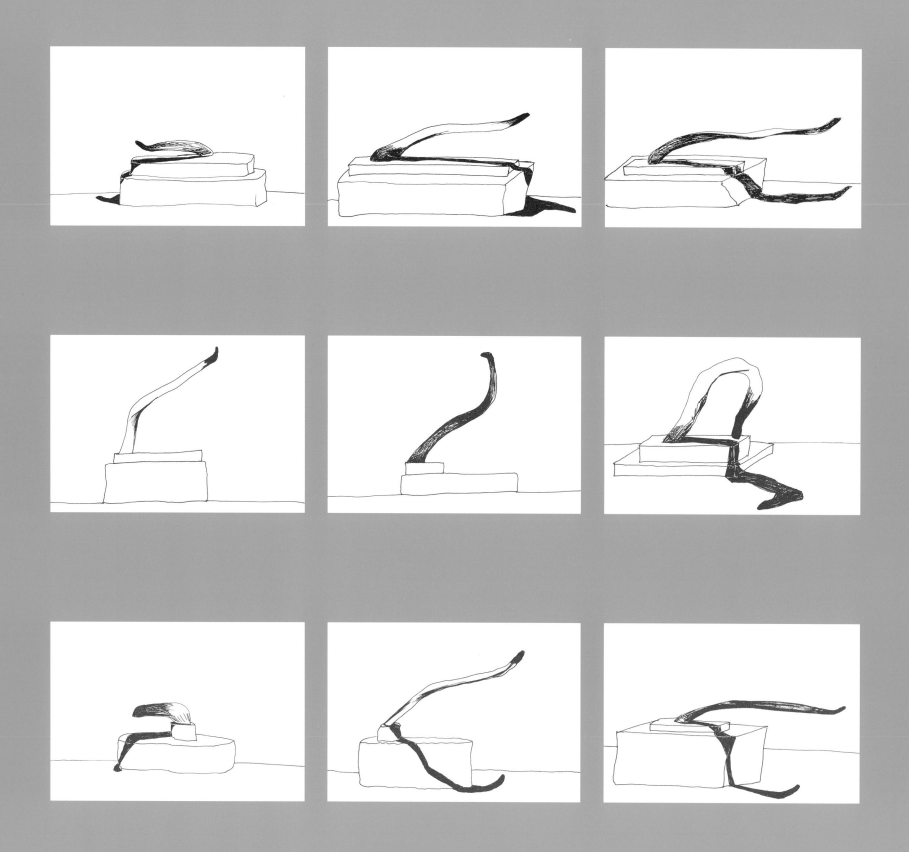

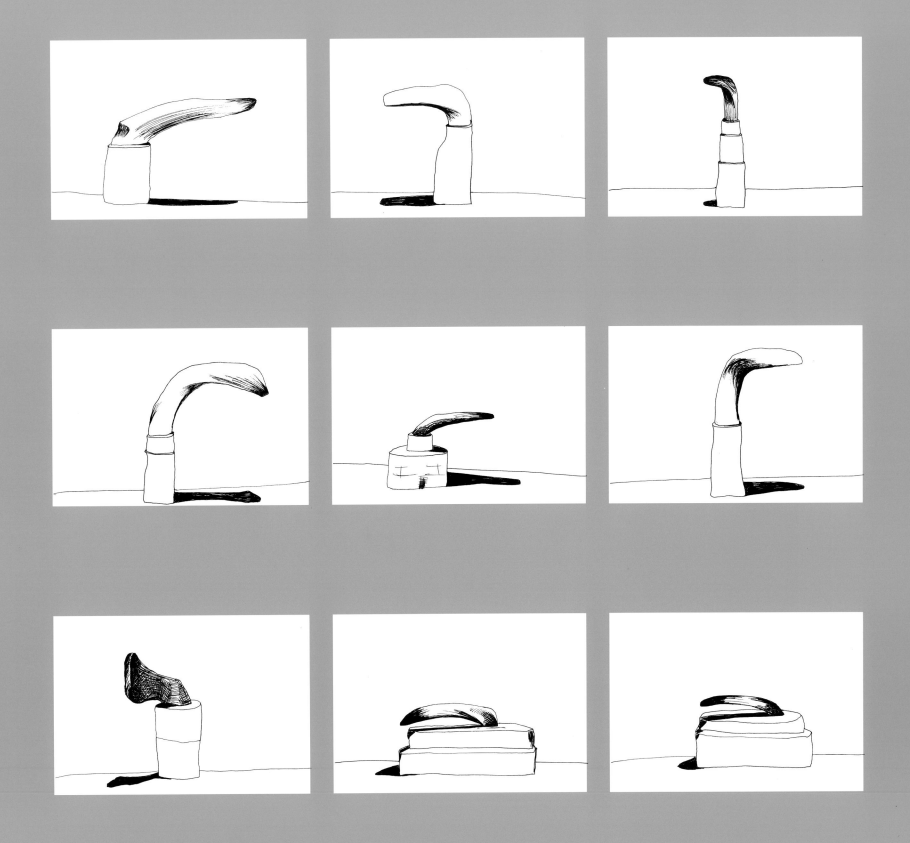

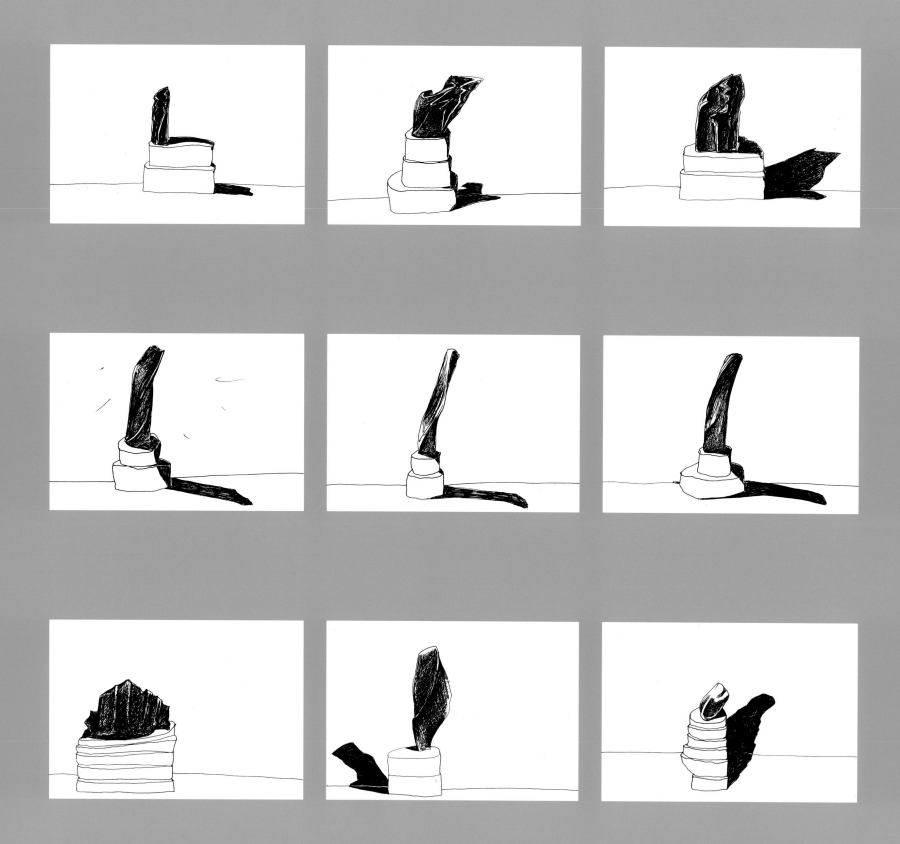

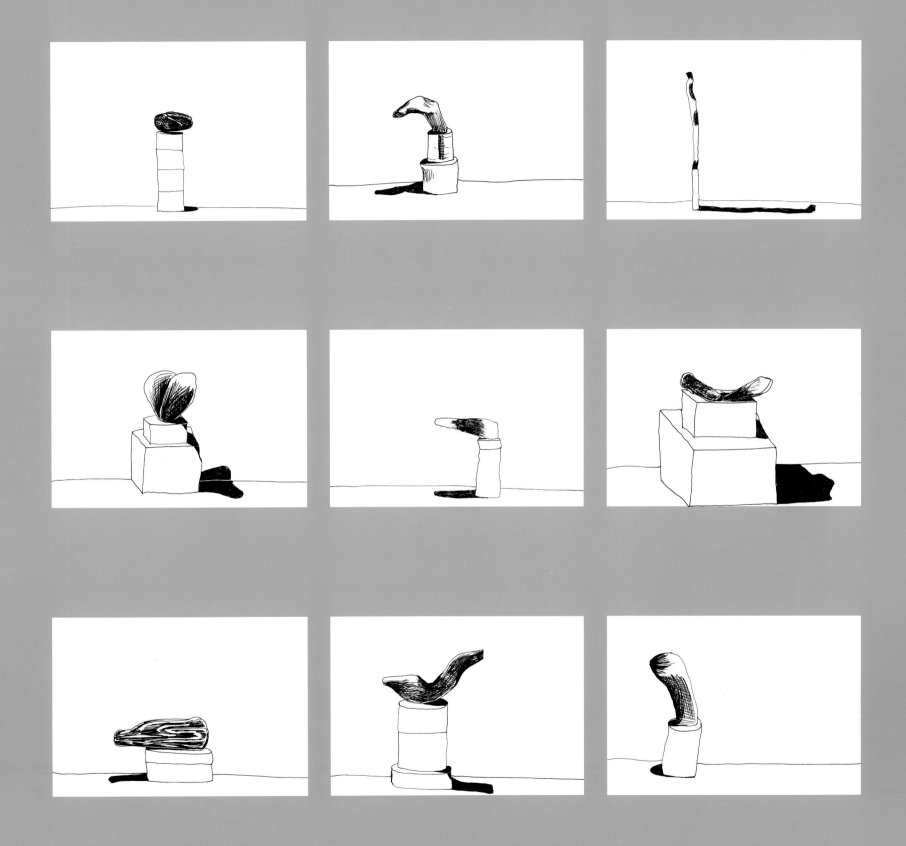

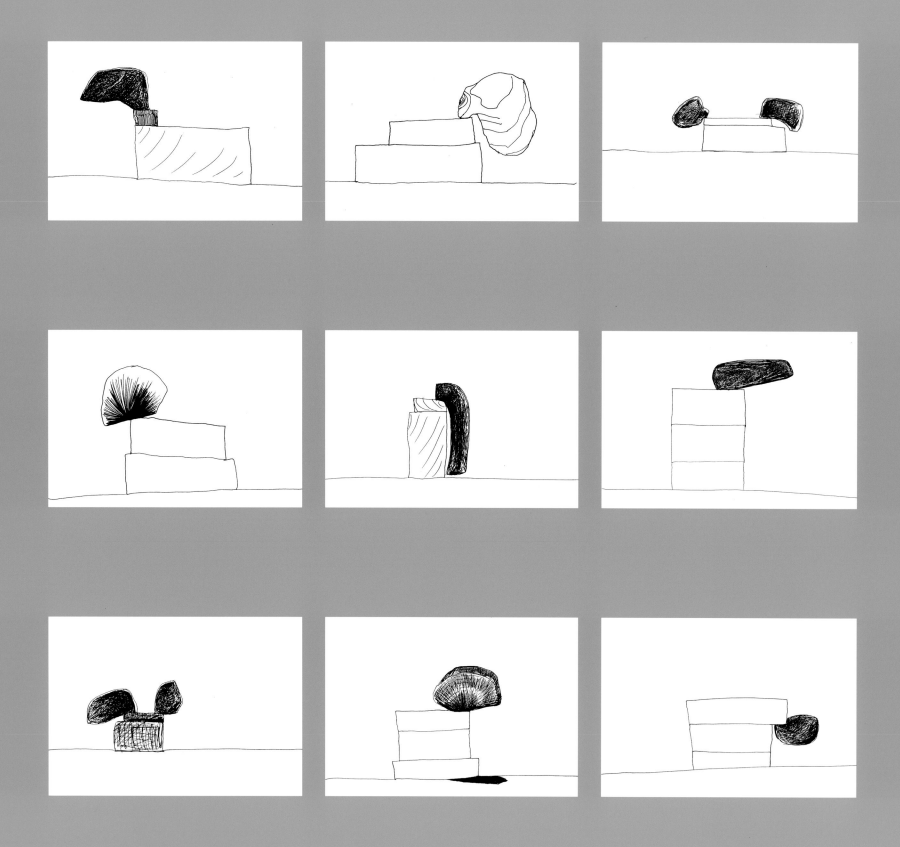

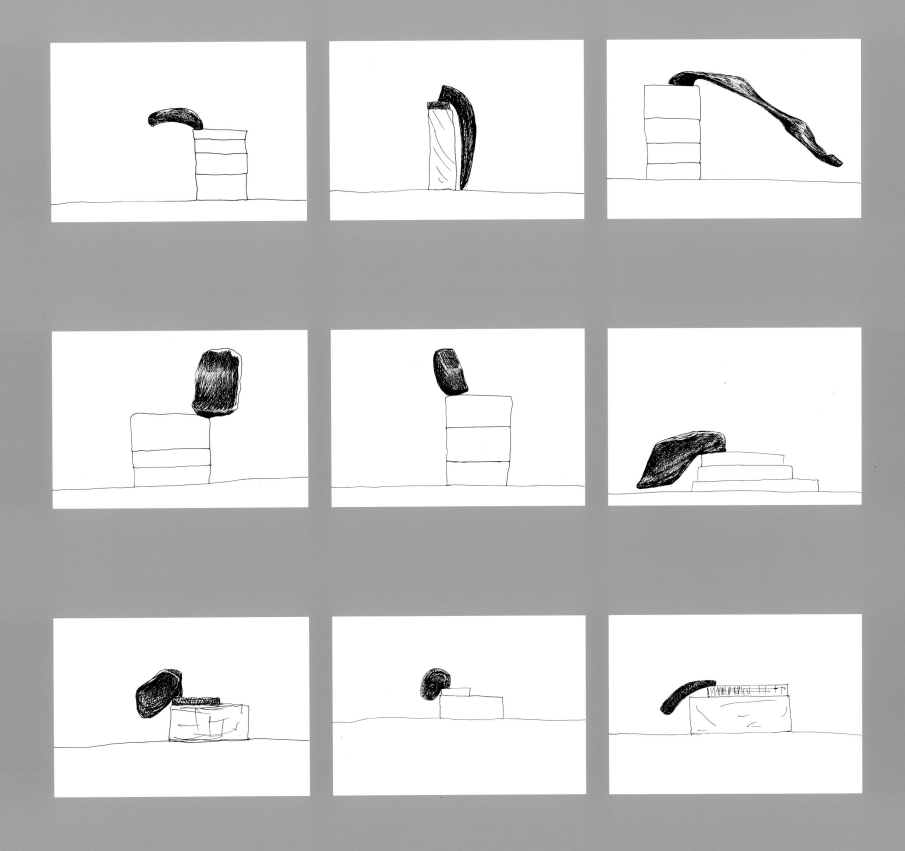

20. Face Necklace. 1977–80
Twenty-two-karat gold, Phoenecian glass mosaic beads
20 inches (50.8 cm). Private Collection

21. Nautilus Necklace. 1975
Twenty-two-karat gold, chambered nautilus shell, carnelian cylinders
17 inches (43.18 cm). Private Collection

Chryselephantine

22. Silla's Rattle. 1982
Twenty-two-karat gold, mastodon ivory, Burmese sapphires
4 x 1 inches (10.16 x 2.54 cm). Collection of Silla Brush

23. Top. 1982
Twenty-two-karat gold, mastodon ivory
1 1/4 x 1 inches (3.18 x 2.54 cm). Private Collection

24. Traveler's Toothpick. 1981
Twenty-two-karat gold, mastodon ivory
3 x 1/2 inches (7.62 x 1.27 cm). Private Collection

25. Traveling Sticks. 1980
Twenty-two-karat gold, mastodon ivory
3 x 1/2 inches (7.62 x 1.27 cm). Private Collection

26. Walking Stick. 1983
Twenty-two-karat gold, mastodon ivory, goncalo alves (hardwood)
38 x 1 1/4 inches (96.52 x 3.18 cm). Private Collection

27. "Barleycorn" Box. 1984
Twenty-two-karat gold, mastodon ivory (ornamentally turned in barleycorn patterns)
1 1/4 x 4 inches (3.18 x 10.16 cm). Collection of Ralph Esmerian

28. Container Within. 1982
Pure gold, twenty-two-karat gold, mastodon ivory, Burmese sapphire
4 7/8 x 1 1/8 inches (12.40 x 2.86 cm). Private Collection, New York

29. Snuff Bottle. 1984
Twenty-two-karat gold, mastodon ivory (ornamentally turned)
5 1/4 x 1 7/16 inches (13.34 x 3.66 cm). Private Collection

30. Gold Dust Wand. 1983–85
Twenty-two-karat gold, five ounces of pure gold dust, mastodon ivory (ornamentally turned and diamond faceted)
9 x 2 x 2 inches (22.86 x 5.08 x 5.08 cm). Private Collection

31. Anniversary Bouquet. 1983
Pure gold, twenty-two-karat gold, mastodon ivory (ornamentally turned and diamond faceted)
9 x 3 x 3 inches (22.86 x 7.62 x 7.62 cm). Collection of Olivia Brush

32. Table Pomander. 1984–85
Twenty-two-karat gold, mastodon ivory, horn
4 x 3 inches (10.16 x 7.62 cm), 7 x 5 inches (17.78 x 12.7 cm).
Collection of Ralph Esmerian

Precious Things

33. Yo-Yo. 1986
Twenty-two-karat gold, pink ivory wood, cotton cord
2 inches in diameter (5.08 cm). Private Collection, New York

34. Jelly-Bean Suite. 1991
Bakelite, pure gold, eighteen-karat gold, Burmese rubies, diamonds
3 x 4 x 1 inches (7.62 x 10.16 x 2.54 cm)
Collection of Kathleen and John Ullmann

35. Jeweled Hand (brooch). 1989
Bakelite, pure gold, eighteen-karat gold, blue diamonds, orange and white diamonds
2 1/2 x 1 3/4 x 1/2 inches (6.35 x 4.45 x 1.27 cm). Private Collection

36. Running Bunny (brooch). 1990
Bakelite, pure gold, eighteen-karat gold, pink diamonds, blue diamond
1 1/2 x 2 1/4 x 1/2 inches (3.81 x 5.72 x 1.27 cm). Private Collection

37. Snow Globe. 1991
Bakelite, pure gold, twenty-two-karat gold, eighteen-karat gold, stainless steel, pink (Argyle) diamonds, Colombian emeralds, mastodon ivory, glass, glycerine, water
2 1/2 x 3 inches (6.35 x 7.62 cm). Private Collection, New York

38. Cat Powder Box. 1990–93
Bakelite, pure gold, pink (Argyle) diamonds, swan's down puff
6 inches in diameter (15.24 cm). Private Collection, New York

39. Bunny Bangle. 1988–92
Bakelite, pure gold, pink (Argyle) diamonds, Burmese rubies
3 x 4 x 1 inches (7.62 x 10.16 x 2.54 cm)
Collection of Ralph Esmerian

40. Flamingo Frame. 1989–92
Bakelite, pure gold, twenty-two-karat gold, eighteen-karat gold, pink (Argyle) diamonds, Burmese rubies, Colombian emeralds, Mississippi River conch pearl, glass
6 x 5 x 1 1/2 inches (15.24 x 12.70 x 3.81 cm). Private Collection

Objects of Virtue

41. Black and White. 1975–85
Twenty-two-karat gold, mastodon ivory, African blackwood
2 x 1 1/4 x 1 inches (5.08 x 3.18 x 2.54 cm). Private Collection

42. Temple. 1987–88
Pure gold, twenty-two-karat gold, fire-blued steel
2 x 1 inches (5.08 x 2.54 cm). Private Collection

43. Rose Square. 1987–90
Pure gold, twenty-two-karat gold, steel
2 3/4 x 2 1/4 inches (6.99 x 5.72 cm). Private Collection

44. Swirls. 1987
Twenty-two-karat gold, Damascus steel, fire-blued steel
2 x 1 inches (5.08 x 2.54 cm). Private Collection

45. Zig Zag. 1987–88
Twenty-two-karat gold, steel, fire-blued steel
2 x 1 inches (5.08 x 2.54 cm). Private Collection

46. Blue Dome. 1988
Pure gold, twenty-two-karat gold, steel, mastodon ivory
2 3/4 x 2 1/4 inches (6.99 x 5.72 cm). Collection of Ralph Esmerian

47. Zig Zag Blue. 1987–88
Pure gold, twenty-two-karat gold, steel, chromium steel
3/4 x 1 1/4 inches (1.91 x 3.18 cm). Private Collection, New York

Grasping for the Rings of Infinity

48. Second Dome. 1983–89
Pure gold, twenty-two-karat gold, steel
3 x 3 x 3 inches (7.62 x 7.62 x 7.62 cm)
Collection of Ralph Esmerian

49. Gauze. 1988–89
Pure gold, twenty-two-karat gold, steel
3 1/2 x 3 x 3 inches (8.89 x 7.62 x 7.62 cm). Private Collection

50. 7110. 1984–89
Pure gold, twenty-two-karat gold, steel
1 3/4 x 2 1/4 inches (4.45 x 5.72 cm). Private Collection, Pennsylvania

51. First Dome. 1982–89
Pure gold, twenty-two-karat gold, steel
2 3/4 x 2 3/8 inches (6.99 x 6.05 cm). Private Collection, Pennsylvania

52. Largest Dome. 1983–87
Twenty-two-karat gold, mastodon ivory, fire-blued steel
3 7/8 x 3 3/8 inches (9.84 x 8.59 cm). Private Collection, New York

Ravenna and Tessellare

53. Daphne. 1989
Pure gold, steel
2 1/2 x 1 1/2 x 1 1/2 inches (6.35 x 3.81 x 3.81 cm). Private Collection

54. *Essence Bottle.* 1988
Pure gold, steel
1 3/4 x 1 3/8 inches (4.45 x 3.51 cm). Private Collection, New York

55. *Theodora.* 1988–93
Pure gold, twenty-two-karat gold, steel
2 x 2 1/4 inches (5.08 x 5.72 cm). Private Collection

56. *Justinian.* 1989–93
Pure gold, twenty-two-karat gold, steel
3 1/4 x 3 x 3 inches (8.26 x 7.62 x 7.62 cm). Private Collection

57. *Placidia.* 1988–89
Pure gold, steel
1 x 3 1/2 inches (2.54 x 8.89 cm). Collection of Ralph Esmerian

58. *Pillow Box.* 1989–93
Pure gold, steel
4 inches in diameter (10.16 cm). Private Collection

59. *Old Growth.* 1991–93
Pure gold, steel
4 inches in diameter (10.16 cm). Private Collection

60. *Black Carbide.* 1992–94
Pure gold, steel, carbide
3 x 3 x 3 inches (7.62 x 7.62 x 7.62 cm). Private Collection

61. *Palm/Sphere.* 1992–95
Pure gold, steel
2 x 3 1/4 inches (5.08 x 8.26 cm). Private Collection

62. *Palm/Egg.* 1992–95
Pure gold, steel
2 x 3 1/4 inches (5.08 x 8.26 cm). Private Collection, Pennsylvania

63. *Orb.* 1992–95
Pure gold, steel
4 inches (10.16 cm) diameter. Private Collection

Butterflies, Dragonflies, Bees

64. *"Pick-Up" Sticks.* 1988–89
Pure gold, twenty-two-karat gold, steel, iron
9 3/4 x 1 inches (24.77 x 2.54 cm). Private Collection, New York

65. *Cicada.* 1991–92
Pure gold, twenty-two-karat gold, steel, rare earth magnets
1 1/2 x 3 x 2 3/4 inches (3.81 x 7.62 x 6.99 cm). Private Collection

66. *Perfume Flacon.* 1990–92
Pure gold, twenty-two-karat gold, eighteen-karat gold, steel, rare earth
magnets, acrylic, cork
3 x 1 1/4 inches (7.62 x 3.18 cm)
Collection of Kathleen and John Ullmann

67. *Dragonfly Box.* 1989–92
Pure gold, steel, spring steel, rare earth magnets
5 x 4 x 4 inches (12.7 x 10.16 x 10.16 cm)
Collection of Kathleen and John Ullmann

68. *Hive* (night-light). 1988–96
Pure gold, platinum, steel, rare earth magnets, electrical fixture
3 x 4 x 4 inches (7.62 x 10.16 x 10.16 cm)
Private Collection, New York

69. *Ten Butterfly Box.* 1991–93
Pure gold, steel, rare earth magnets
3 x 3 3/4 x 3 3/4 inches (7.62 x 9.53 x 9.53 cm)
Collection of Ralph Esmerian

70. *Water Stone.* 1991–95
Pure gold, steel, rare earth magnets
2 x 3 x 4 inches (5.08 x 7.62 x 10.16 cm)
Collection of Dr. and Mrs. Charles T. Beaird

71. *Butterfly Bowl.* 1991–94
Pure gold, steel, rare earth magnets
1 1/4 x 3 3/4 inches (3.18 x 9.53 cm). Private Collection

72. *Beetle Bowl.* 1992–94
Pure gold, eighteen-karat gold, steel, stainless steel
1 1/8 x 3 3/4 inches (2.86 x 9.53 cm). Private Collection

73. *Dragonfly Bowl.* 1991–93
Pure gold, steel, rare earth magnets
1 1/4 x 3 3/4 inches (3.18 x 9.53 cm). Private Collection, New York

74. *Mountain.* 1990–93
Pure gold, steel, rare earth magnets
3 3/4 x 3 1/4 inches (9.53 x 8.26 cm). Private Collection

Black Boxes

75. *Black Box I.* 1991–96
Pure gold, steel
3 x 4 inches (7.62 x 10.16 cm). Collection of the Artist

76. *Black Box II.* 1991–96
Pure gold, steel
3 x 4 inches (7.62 x 10.16 cm). Collection of the Artist

77. *Black Box III.* 1991–96
Pure gold, steel
3 x 4 inches (7.62 x 10.16 cm). Collection of the Artist

78. *Black Box IV.* 1991–96
Pure gold, steel
3 x 4 inches (7.62 x 10.16 cm). Collection of the Artist

79. *Black Box V.* 1991–96
Pure gold, steel
3 x 4 inches (7.62 x 10.16 cm). Collection of the Artist

80. *Black Box VI.* 1991–96
Pure gold, steel
3 x 4 inches (7.62 x 10.16 cm). Collection of the Artist

81. *Black Box VII.* 1991–96
Pure gold, steel
3 x 4 inches (7.62 x 10.16 cm). Collection of the Artist

Scholar's Sculpture

82. *Sharp Edge.* 1995–96
Pure gold, steel
2 7/8 x 4 x 4 inches (7.32 x 10.16 x 10.16 cm). Private Collection

83. *Stones.* 1995–96
Pure gold, steel
Largest 3 x 1 3/4 x 1/4 inches (7.62 x 4.45 x .64 cm). Private Collection

84. *Rivulet.* 1994–96
Pure gold, steel
3 x 4 x 4 inches (7.62 x 10.16 x 10.16 cm). Private Collection

85. *Cobra Piece.* 1992
Pure gold, steel
1/4 x 5 3/4 x 1 1/4 inches (.64 x 14.61 x 3.18 cm)
Private Collection, New York

86. *Maze.* 1992
Pure gold, steel
2 3/4 x 2 7/8 x 3/4 inches (6.99 x 7.32 x 1.91 cm). Private Collection

87. *Slab.* 1991–93
Pure gold, steel
2 1/4 x 4 x 3/4 inches (5.72 x 10.16 x 1.91 cm). Private Collection

88. *Range.* 1991–94
Pure gold, steel
1 1/2 x 2 1/2 x 1 1/4 inches (3.81 x 6.35 x 3.18 cm). Private Collection

89. *Fingerprint.* 1993–94
Pure gold, steel
2 x 3 x 3 inches (5.08 x 7.62 x 7.62 cm). Private Collection, New York

90. *Diamond Egg.* 1991–93
Pure gold, diamonds, steel
2 x 1 ¹/₂ x 1 ¹/₂ inches (5.08 x 3.81 x 3.81 cm). Private Collection

91. *Polestar.* 1991–93
Pure gold, diamonds, steel
2 ³/₄ x 3 ¹/₂ x 2 inches (6.99 x 8.90 x 5.08 cm)
Collection of Mr. and Mrs. John H. Gutfreund

92. *Table Boulder.* 1990–93
Pure gold, steel
1 ¹/₂ x 2 ³/₄ inches (3.81 x 6.99 cm). Private Collection

93. *Hand Piece.* 1987–95
Pure gold, steel
6 ¹/₄ x 1 ³/₄ x ¹/₂ inches (15.88 x 4.45 x 1.27 cm)
Private Collection

94. *Pointing.* 1993
Pure gold, steel
2 x 3 x 2 inches (5.08 x 7.62 x 5.08 cm). Private Collection

95. *Leaning Boulder.* 1987–92
Pure gold, steel
2 ³/₈ x 3 ¹/₄ x 1 ¹/₄ inches (6.05 x 8.26 x 3.18 cm). Private Collection

96. *Colored Arch.* 1996
Pure gold, fire-blued steel
1 ¹/₄ x 4 x 1 ¹/₄ inches (3.18 x 10.16 x 3.18 cm). Private Collection

97. *Companion I.* 1990–93
Pure gold, steel
³/₄ x 3 ¹/₂ x 3 ¹/₂ inches (1.91 x 8.89 x 8.89 cm)
Collection of Ralph Esmerian

98. *Companion II.* 1990–93
Pure gold, steel
³/₄ x 3 ⁵/₈ x 3 ¹/₂ inches (1.91 x 9.22 x 8.89 cm)
Private Collection, New York

99. *Scholar's Table Piece.* 1994
Pure gold, steel
2 x 3 ¹/₄ x 3 inches (5.08 x 8.26 x 7.62 cm). Collection of the Artist

100. *Wave.* 1993–96
Pure gold, steel
2 x 3 ¹/₈ x 2 ¹/₂ inches (5.08 x 7.94 x 6.35 cm). Private Collection

101. *Palm Piece.* 1995
Pure gold, steel
1 ¹/₄ x 3 ³/₄ x 3 ³/₄ inches (3.18 x 9.53 x 9.53 cm). Private Collection

Mirrors

102., 103. *Mirror I and Mirror II.* 1993–96
Pure gold, steel
5 x 5 x ¹/₂ inches each (12.70 x 12.70 x 1.27 cm). Private Collection

Cantos

104. *Canto I.* 1994–97
Pure gold, steel
11 x 4 x ¹/₂ inches (27.94 x 10.16 x 1.27 cm). Collection of the Artist

105. *Canto II.* 1994–97
Pure gold, steel
11 x 4 x ¹/₂ inches (27.94 x 10.16 x 1.27 cm). Collection of the Artist

106. *Canto III.* 1994–97
Pure gold, steel
11 x 4 x ¹/₂ inches (27.94 x 10.16 x 1.27 cm). Collection of the Artist

107. *Canto IV.* 1994–97
Pure gold, steel
11 x 4 x ¹/₂ inches (27.94 x 10.16 x 1.27 cm). Collection of the Artist

Name Saying Place

108. *First Piece.* 1997
Pure gold, steel, iron, limestone
24 x 8 x 6 inches (60.96 x 20.32 x 15.24 cm)
Collection of Ralph Esmerian

109. *Leaf.* 1997
Pure gold, steel, travertine marble
16 x 6 x 5 inches (40.64 x 15.24 x 12.70 cm). Private Collection

110. *Marker.* 1996–97
Pure gold, steel, travertine marble
22 x 6 x 6 inches (55.88 x 15.24 x 15.24 cm). Private Collection

111. *Corner.* 1996–97
Pure gold, steel, limestone
9 ¹/₂ x 11 ¹/₂ x 8 inches (24.13 x 29.21 x 20.32 cm)
Private Collection, New York

112. *Side.* 1997
Pure gold, steel, limestone
16 ¹/₂ x 6 x 6 inches (41.91 x 15.24 x 15.24 cm)
Private Collection, New York

113. *Angle.* 1997
Pure gold, steel, limestone
13 ¹/₂ x 8 ¹/₄ x 5 ¹/₂ inches (34.29 x 20.96 x 13.97 cm)
Private Collection

114. *End.* 1997
Pure gold, steel, limestone
6 ³/₄ x 12 x 4 ¹/₂ inches (17.15 x 30.48 x 11.43 cm)
Private Collection, New York

115. *Edge.* 1997
Pure gold, steel, hot-rolled steel, limestone
10 x 7 ¹/₂ x 9 ¹/₂ inches (25.40 x 19.05 x 24.13 cm). Private Collection

Ninety-nine Drawings

pages 254–67:
Each drawing: ink on paper,
4 x 6 inches (10.16 x 15.24 cm). Collection of the Artist

ACKNOWLEDGMENTS

The sanskrit word *Saham* means "She I am." My companion, Olivia, has been on my side for thirty years. This work is as much her art as it is mine.

My son, Silla, has a determined quest for knowledge—a real treasure. His journey inspires me daily.

Paul Gottlieb, for having the unwavering commitment to publish this book about my private years.

Ralph Esmerian, for being there.

Michael Monroe, for being a passionate champion of my work.

Eric Nussbaum, for exquisite understanding.

David Bennett, Donald Kuspit, Paul Theroux, for giving me mirrors.

John Bigelow Taylor and Dianne Dubler, for compassion and beautiful photography.
Takaaki Matsumoto of Matsumoto Incorporated, for a book design of supreme elegance.
Shun Yamamoto, director of production, Alyn Evans, and the production department at Harry N. Abrams, Inc., for every attention to detail.
Harriet Whelchel, senior editor at Abrams, for uncompromising sensitivity.
Christine Edwards at Abrams, for a delicate touch.
Liz Robbins and Carol Morgan at Abrams, for creative publicity.

Susan Ip and Man-Kong Tsui, for acuity, clarity, and extraordinary friendship.

Dr. and Mrs. Charles T. Beaird, Kathleen and John Ullmann, for warm hands.

Barbara and Daniel Fendrick, Elise Wiarda, Lois and Jay Wright, for all the years.

Dr. Oliver Sacks, for heavy metal.

André Emmerich, for vision and generosity.

Jerry Aidlin, Philippe Arpels, Ruth and Walter Balliet, David Behl, Richard Biles, Herbert Black, Mace Blickman, John D. Block, Nancy and Ralph Blume, Alain Boucheron, Diana D. Brooks, Patricia Cardi-Calabrese, Diane Cifaldi Collins, Wynona and Theodore Crom, Daniel Cullity, James Demetrion, Jessica Deutsch, Sheila Donnelly, Robert Dunn, Roy Eagle, Jutta and Peter Eigen, Rachelle Epstein, Marion Fasel, Vincent Ferrara, Kathleen Fitzpatrick, June Freeman, Tina Gianesini, Gladys Goidell, Mr. and Mrs. John H. Gutfreund, James Hall, Raizel Halpin, Saskia Hamilton, Sir Frederick Hervey-Bathurst, Bt., Marjory

Horowitz, Carolina Irving, Ian Irving, H. W. Janson, Hilda Janssens, Lewis Johnson, Susan Jonas, Their Highnesses The Prince and Princess Sadruddin Aga Khan, Dorothy and Frank Knox, Baron and Baroness Philippe and Marion Lambert, Philippine Lambert, Lisa and Douglas LaPasta, Mr. and Mrs. Fred Leighton, Mara Leighton, Jane Livingston, Véronique Ma'arop, Edythe Alpert Malkin, Donald Manza, Barbara Marshall, Ronnie Morgenstein, Marilyn Nissenson, Warren G. Ogden, Jr., Helaine Posner, Deborah and Kevin Prisco, Penny Proddow, Mr. and Mrs. Aleksis Rannit, Dr. Keith Raskin, Willie and Geoffrey Roberts, Sharman and William Robertson, Pat and Robert Saling, Edward Saviano, Barbara and Michael Schwartz, Bonnie Selfe, Alex Sepkus, Saralee Smithwick, Michel Tcherevkoff, Trudy Tripolone, Nicky Vreeland, Baron Otto van Wassenaer, Gary Walther, Edward Weinberger, Phillip Weiner, Henry Wing, Jr., Townsend Wolfe, David Wood-Heath, Janet Zapata, for their support.

Carnegie-Mellon University
The University of Southern California
Georgetown University, for the privilege of teaching.

Elizabeth Broun, director, National Museum of American Art, Smithsonian Institution.
Kenneth R. Trapp, curator-in-charge; Jeremy Adamson, senior curator, Renwick Gallery of the National Museum of American Art.
John Zelenik, chief designer; Katie Ziglar, development officer; Melissa Kroning, registrar; Liz Selzer, public affairs officer, National Museum of American Art, for presenting the exhibition, *Daniel Brush: Gold without Boundaries,* September 11, 1998–January 10, 1999.

Finally, Clara and Arthur, for raising me up with their courage.

Thank you,

Daniel Brush
New York City, 1998

In the spring of 1995, Michael Monroe, then curator-in-charge of the Renwick Gallery, entered the director's suite and insisted we look over a set of large color transparencies he had just brought back from a trip to New York. He talked passionately about his visit to the studio of an artist he had lost touch with for twenty years and the extraordinary things he had seen there. As we viewed the eighteen transparencies on the lightbox, one after the other, our excitement grew—each object appeared more beautiful than the last. Neither of us had ever heard the artist's name—Daniel Brush—before, but we knew at once that his work would make a wonderful exhibition at the Renwick. With the enthusiastic support of Kenneth R. Trapp, the Renwick's new curator-in-charge, Daniel Brush's extraordinary works of art are today the subject of a major retrospective exhibition.

Before Monroe's visit—and subsequent ones we ourselves made—only a handful of individuals had been invited to enter Brush's Manhattan loft-studio and be shown his spectacular objects fashioned from gold, steel, gemstones, and other exotic materials. As the public at large can now discover for themselves, there is a mesmerizing quality to the meticulously crafted "intimate sculptures." To examine a piece close-up is to enter an imaginative realm far removed from the mundane world, and as one slowly surrenders to the intrinsic magic of the work—flawlessly conceived and precisely executed—time, place, and self lose significance. The work's intimacy is monumental, continually revealing itself in new ways. The experience is refreshing. The imagination feels enlarged, enhanced by the encounter.

The affective impact is difficult to objectify, but so, too, the individual pieces—a surprisingly diverse collection of different forms, ranging from archaeological gold studies to mysterious, hand-carved steel sculptures—are hard to define in conventional terms. They elude art-world and museum categories. Are they studio craft productions, decorative art, contemporary sculpture? Many are clearly *bijoux*—artistic jewels—but for others the inclusive term "objects of virtue" is the best description. The most recent works, distinctly, are idiosyncratic and contemplative sculptures.

Decidedly, they are works of contemporary art, but they remain resolutely outside the mainstream. Based on Brush's wide-ranging scholarship in the history of artistic forms—both Oriental and Occidental—and his fascination with historical and industrial methods of workmanship, they bear no relationship to the issues—social, cultural, or formal—typically addressed by late twentieth-century American artists. Only by setting the objects apart from preconceived categories and conventional artistic ideals and surrendering to them on their own individual terms can these unique creations freely work their magic on the aesthetic imagination. Once the viewer engages with them in a direct and unmediated fashion, Daniel Brush's pieces become works of art independent of any school or movement—works that whisper their own voice.

During the 1970s, Brush lived and worked in Washington, D.C. A professor in the art department of Georgetown University, he regularly exhibited canvases and large-scale drawings in the nation's capital. They, too, were elusive works, difficult to categorize conventionally, but they gained him critical respect. By 1977, the year he left Washington for New York at the age of thirty, his paintings had been the subject of two one-man shows at local museums—the Phillips Collection in 1974 and three years later at the Corcoran Gallery of Art. In the research library of the National Museum of American Art, a file marked "Dan Brush" contains announcements, press releases, and reviews of these solo exhibitions as well as a variety of other

gallery and museum shows of his canvases—not only in Washington, but also in Chicago, New York, and elsewhere. Yet there is no record in the file of his prodigious skills as a goldsmith. On that score it is mute—and for a good reason. Although the gold works were fabricated during the years he was creating and exhibiting paintings, they remained secret creations, never shown in public. In fact, only a small group of connoisseurs were aware of this aspect of his work, even after he moved to New York City.

The exhibition *Daniel Brush: Gold without Boundaries* represents the debut of a major American talent. Held in the Renwick Gallery, the historic building located across from the White House that serves as the Smithsonian Institution's showcase for contemporary American crafts and decorative art, it contains seventy objects. Dating from 1972 to 1997, they were selected by curator Jeremy Adamson from each of the artist's distinctive series of objects—from the archaeologically inspired early jewelry studies to the most recent sculpture. The layout of the exhibit, planned by chief designer John Zelenik, reveals through discrete groupings of objects Brush's remarkable artistic journey, from the earliest gold pieces, through the turned-steel and gold boxes, the diamond- and emerald-studded precious objects, the enigmatic sculptures hand-chiseled from steel billets, to the final, climactic work in the show—a freestanding iron, steel, gold, and limestone sculpture made in 1997. No longer related to the hand like the other intimately scaled works, this latest piece is displayed alone, connected now to the space around it, and clearly represents a new step forward.

As the retrospective exhibition reveals, since the early 1970s Daniel Brush has been engaged in moving forward along a path he has described as one of "awareness." Deeply influenced by Oriental philosophy, the journey has been a spiritual one, traveling on the road to *satori*, enlightenment. The record of that incremental, spiritual ascent is contained in his works—in his growing technical prowess, and in the unfolding clarity of his pieces. The story is one of evolving mastery—of tools and techniques, materials and machinery, of self and an expressive voice that is unparalleled. The National Museum of American Art is pleased to introduce our visitors to a hitherto unfamiliar American master. We look forward to Daniel Brush's onward journey as an artist, for whoever commits to such an ascent as he has must always continue the climb.

Elizabeth Broun, Director, National Museum of American Art, Smithsonian Institution
Jeremy Adamson, Senior Curator, Renwick Gallery of the National Museum of American Art